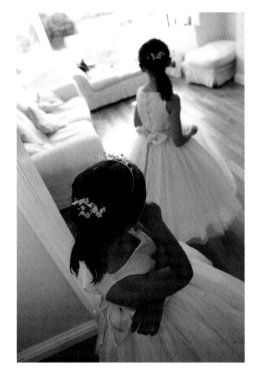

Wedding
Photography

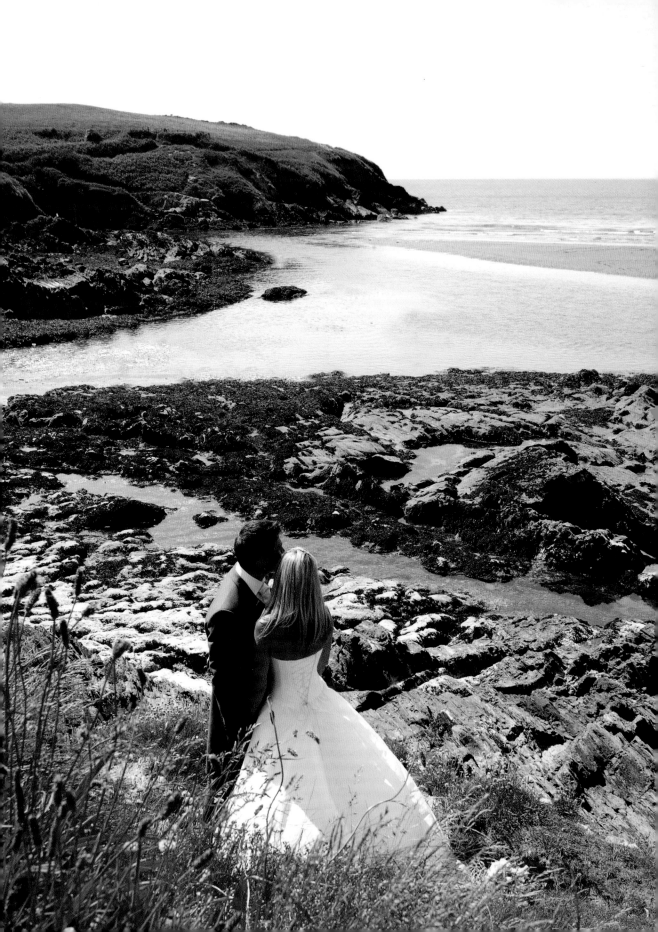

Wedding Photography

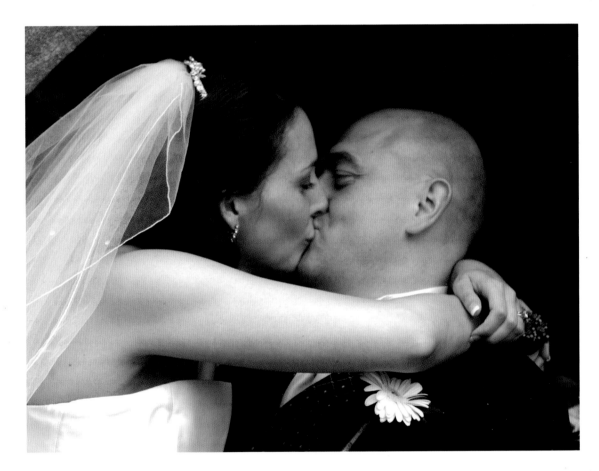

Mark Cleghorn

photographers'
pip
institute press

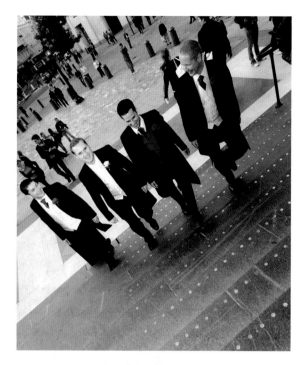
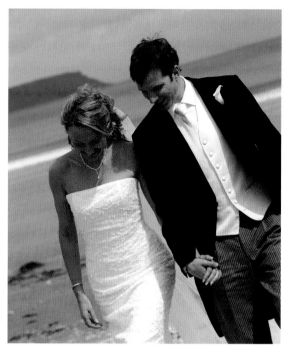

First published 2007 by
Photographers' Institute Press / PIP
an imprint of
The Guild of Master Craftsman Publications Ltd,
166 High Street, Lewes,
East Sussex, BN7 1XU

ISBN 978-1-86108-459-0

British Cataloguing in Publication Data. A catalogue
record of this book is available from the British Library.

Production Manager: Jim Bulley
Managing Editor: Gerrie Purcell
Photography Books Project Editor: James Beattie
Managing Art Editor: Gilda Pacitti
Designer: Ali Walper

Typefaces: Gill Sans, Edwardian Script

Colour reproduction by Altaimage
Printed and bound by Hing Yip Printing Company Ltd

Contents

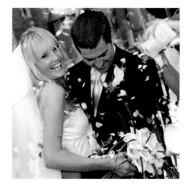

Introduction

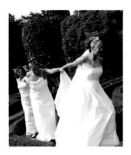

Being asked to photograph a wedding is a daunting prospect for all photographers. Even after 25 years I still get butterflies in my stomach on the morning of the big day. There is a lot of responsibility in being a wedding photographer, as there is no second chance, so you have to get it right on the day; but this is quite easy to do as long as you follow some simple rules.

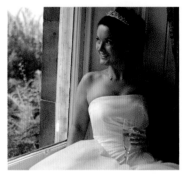

There is no single big secret to taking great wedding photographs, but there are many little ones. Each plays a part on the day itself, but it is when everything is brought together in a wedding album that you realize how much you have added to a couple's big day.

The point of this book is to direct you down the road of great wedding photography, whether you are an experienced wedding photographer or not, whether you are shooting an entire wedding on your own, or you just want to take a few special shots in addition to those of the main photographer. I hope this book gets flicked through before every wedding, giving you inspiration for images and the confidence to do a great job.

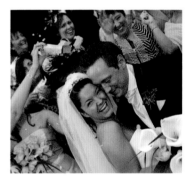

I will cover the preparation before the wedding day, the skills that you will need on the day itself (not all of them photographic), how to perfect your images on computer, and finally how to present them beautifully. By pulling together the elements that I feel really make for great wedding photography, whatever style of image you want to shoot, I hope that you will find yourself enjoying the experience almost as much as the couple.

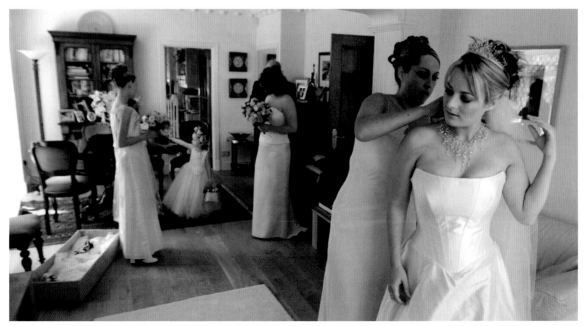

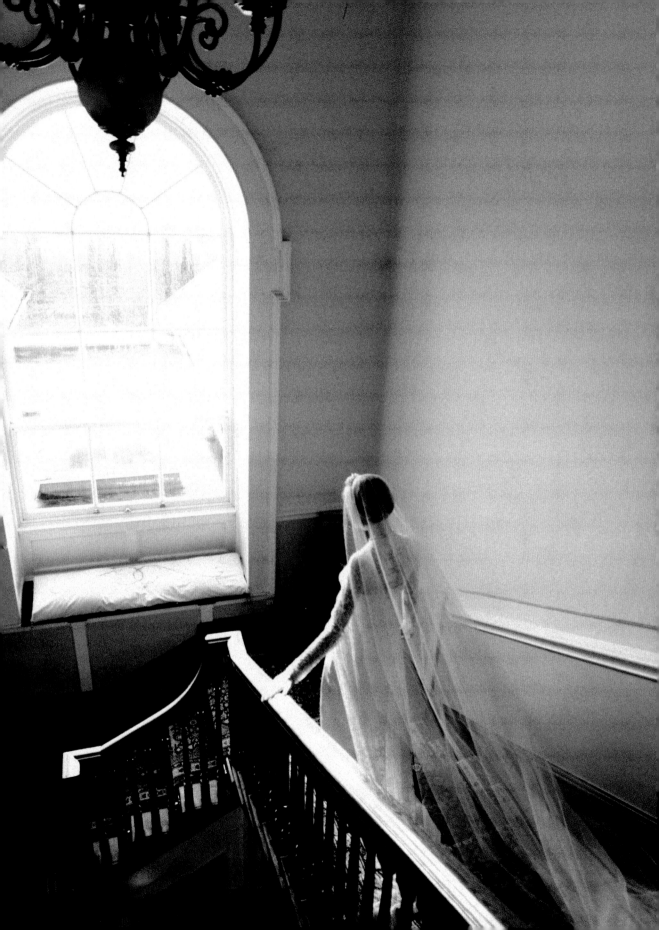

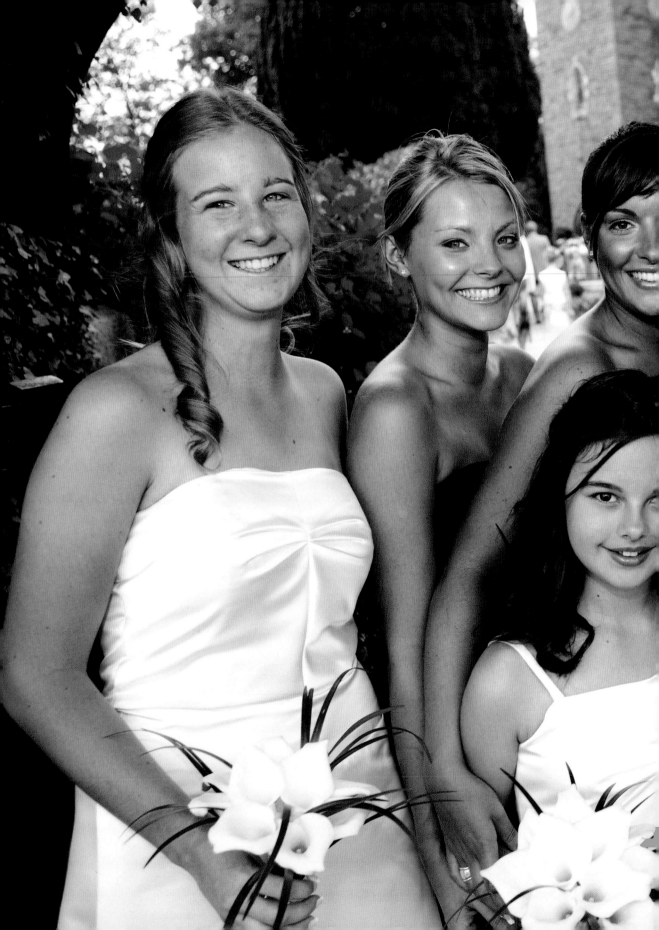

part one

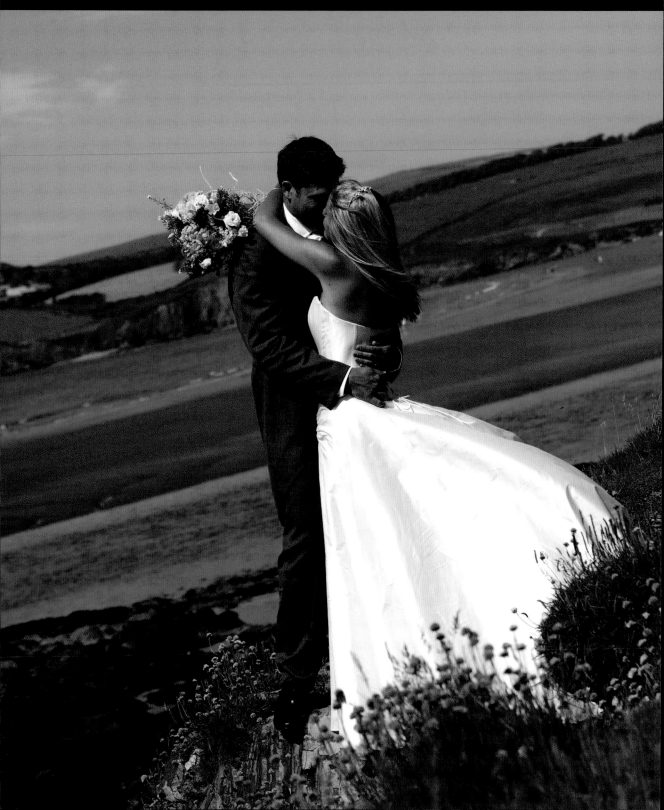

'What equipment should I buy?' is one of the questions I am asked most often when teaching wedding photographers of all abilities; this is usually followed up with 'How do I use it?' So, in this opening chapter I aim to provide the answers to these common questions.

To begin with, I recommend that you look at the big picture: are you in wedding photography just for fun, or are you looking to turn it into a second income or even become a full-time professional? Well, whichever route you decide to take, I guarantee that you will always complain about your equipment being lacking in some way, so let's start with the basics of what you need.

As a wedding photographer you will need at least one camera plus, if possible, a spare camera just in case. In addition you will need a flash of some kind to light the subjects, as you will be working inside and outside. A tripod is important for low-light situations, a reflector or a piece of card to manipulate light is essential, as are sufficient memory cards; and of course not forgetting a computer and software to edit and enhance your images before printing.

You will probably have most of these things already, but what you shouldn't do under any circumstance is to try and shoot a wedding without knowing your equipment inside out. So, if you are investing in new equipment, don't be tempted to buy today and shoot tomorrow.

The camera

Choosing the right camera is about getting good value for money. If you are shooting for fun there is no need to pawn the family jewels, though an aspiring pro should perhaps aim a little higher. A camera should allow you to shoot quickly and with little fuss, so you can spend more time on the pose and the expressions, but still have a few creative options at your fingertips.

It is essential to have the right equipment for the job. For a wedding photographer this means that the camera has to do quite a lot. The camera is going to have to give excellent image quality up to a print size of approximately 15in (40cm), it should have a wide usable ISO range to allow for both bright and low-light conditions, and it will need the facility to be able to fire a flash from a hotshoe or a sync-connector. It also has to be right for you as far as its weight and handling are concerned.

DIFFERENT CAMERAS AND FORMATS

It's obvious that different cameras do different things and that there is no perfect camera, but without doubt some cameras will do a better job than others, especially when it comes to speed and quality.

Left A consumer DSLR generally offers good value for money, although it will not quite have the specifications or robustness of a professional model.

CONSUMER DSLRS

Consumer DSLRs are the most popular kind of camera for the amateur enthusiast. They have optical viewfinders, allowing more accurate composition than compacts; they also employ larger sensors and are therefore able to offer higher quality and higher resolutions. Although most are built to a good standard they are less robust than professional models.

PROFESSIONAL DSLRS

Pro DSLRs are solidly built and can withstand heavy usage; at most weddings I shoot around 500–800 images. They usually have more advanced autofocus and exposure systems, and the resolution will generally be higher. The buffer will allow you to shoot more frames without pause, and the number of frames per second you can capture tends to be greater.

There are several things you should consider before buying equipment. Probably the biggest issue of recent years is the choice of film or digital. Realistically there is little choice now: digital compact and SLR cameras offer more flexibility than film ones, and at reasonable prices. This book includes advice that is applicable to both film and digital photography, but because of the prevalence of digital technology that is where the emphasis will be.

Most modern cameras offer you a lot of useful technology, but there are some things to look for in particular. Choose one with at least 8 megapixels, preferably more, as this will allow you to print large images for an album or to hang on the wall. A good autofocus system is vital, as is a manual-focus option; while an accurate and flexible exposure system will give you control of aperture and shutter speed. A usable ISO range from at least ISO 100 to 800 will allow for a variety of lighting without relying on flash, although you will need a flash-sync connection or hotshoe for an external flash. Finally, you may hold the camera for long stretches, so check it's not too heavy.

DIGITAL COMPACTS

Digital compacts are great if you don't want to take a full DSLR kit with lenses, flash units and so on; however, they generally sacrifice quality and a degree of control. A high-end compact is perfect for point-and-shoot photographers who want some creative control but prioritize ease of use, and it is also an ideal backup camera.

Below A professional DSLR will offer better specifications as well as a tougher build quality than consumer models.

Left Compact digital cameras are still capable of offering plenty of functions and good-quality images, although they typically cannot match a DSLR.

Lenses

Speed is of the essence for the wedding photographer. Trying to get as many different shots as possible in a small amount of time means that ease of use is crucial, which is why most opt for zoom lenses rather than fixed focal-length (prime) lenses. The benefit of a zoom lens soon becomes apparent when you are able to zoom in or out quickly; however, prime lenses are normally lighter and most offer wider maximum apertures, which can be useful in low-light situations.

There is little difference in quality as far as sharpness and contrast of the image are concerned when comparing a good-quality zoom lens with a good-quality prime lens, although a prime lens will normally have a slight edge. A zoom lens makes sense for the majority of photographers, as it allows minor alterations in composition to be made quickly under pressure.

WHICH LENS?

I mainly use two lenses at a wedding: a 24–70mm and a 70–200mm – as these tend to cover all scenarios. My 24–70mm f/2.8 lens is the one with which I shoot the majority of the wedding. It is great for shooting everything from candid wideangle shots, through to the groups and some of the portraits. I use the 70–200mm f/2.8 lens mainly to shoot the bride and groom images. It allows me to get close without being intrusive – which is great for the speeches – and it also allows me to throw the background out of focus in portraits. Generally a lens or a collection covering a similar range, should be sufficient, but I occasionally use a 16–35mm zoom for creative shots or in small spaces.

CAMERA TIPS

Lens quality

A good lens is a key part of image quality. A poor-quality lens will cause a slight loss of contrast and resolution, impinging on the quality of the image.

Another consideration is the maximum aperture of the lens; remember that a wider maximum aperture will give you access to faster shutter speeds and also enable you to create more diffuse backgrounds.

Below Using a wideangle lens allows me to stay closer to the subject while making the most of a wide field of view.

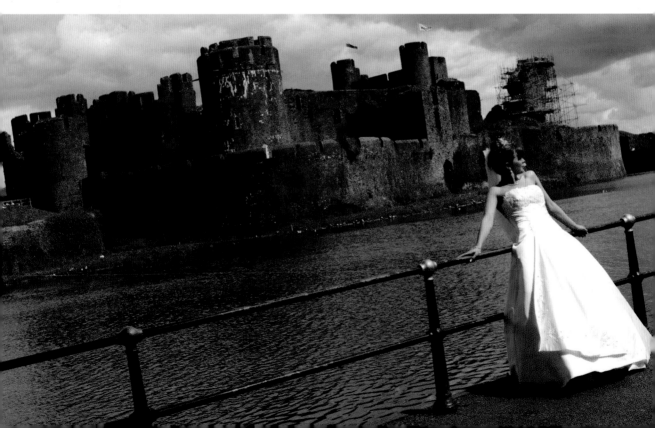

Left *Standard lenses allow you to stay close to the subject and give instructions.*

Below *Long telephoto lenses are great for more tightly cropped portraits.*

CAMERA TIPS

Perspective

Perspective changes when the camera position is changed: moving further away will compress the foreground-to-background perspective, while moving closer will exaggerate it. This is not in itself a function of the focal length, but altering the focal length will allow you to alter your position and therefore the effect of perspective.

FOCAL LENGTHS

A wideangle lens will create a wider angle of view than the human eye, a standard lens sees more or less what we see, while a telephoto lens has a narrower angle of view. Digital photography has confused exactly what focal length has what effect, as this now depends in part on the sensor size, so the information is best grouped in the following broad categories.

Wideangle lens Offers a great field of view and allows objects, architecture and even people that would have been cropped out to be included – good for large groups in small spaces.

Standard lens Mostly used for three-quarter and full-length portraits, as it gives a natural perspective and does not distort subjects. It also allows you to stay close to subjects and instruct them in a normal tone; however, standard lenses have a greater depth of field than telephotos, so the subject will not separate as clearly from the background.

Short telephoto lens Excellent for closely framed portraits that fill the frame. A short telephoto gives a more natural perspective than a standard lens, with no exaggeration to features, which makes for more appealing portraits.

Long telephoto lens Throws the background out of focus at wide apertures. Makes subjects look natural and can be used from a distance to allow for a compressed perspective.

Below *A long telephoto lens makes it easier to isolate details against an out-of-focus background.*

On-camera flash

Flash is essential for weddings, as they can take place at any time of day, as well as in a wide variety of locations where you can't always rely on the natural light to illuminate the subjects. A flash that can be accurately controlled will not only light the subjects, but can also be used to control the amount of shadow and contrast on the subjects caused by ambient light.

BUILT-IN FLASH

Built-in flash is a handy accessory, particularly when you have no other option; but don't rely on it to give you professional-looking images by itself – both its power and flexibility are extremely limited.

EXTERNAL FLASH

An external camera-mounted flash is known as a speedlight, and it is the most commonly used portable flash because it offers increased flexibility and power, while still being portable and affordable. Most speedlights are powerful enough to light a small group and flexible enough to offer subtle control over shadow detail.

The technology in a speedlight flash is designed to operate in harmony with your camera, giving you a high degree of control over the power of the flash. A good model will also offer you control over the direction of the burst and include an optional diffuser to soften the flash output.

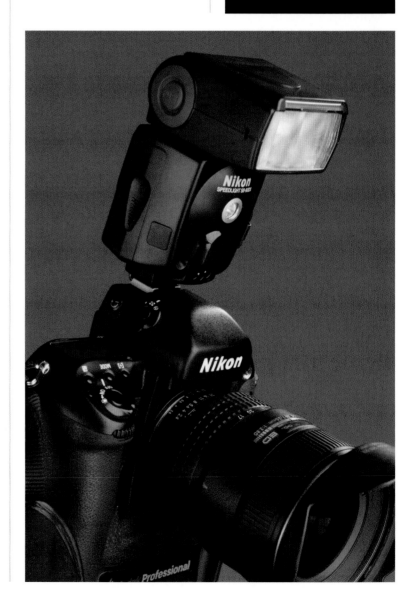

Right A speedlight is essential to the wedding photographer, for lifting shadows, controlling contrast and offering additional illumination.

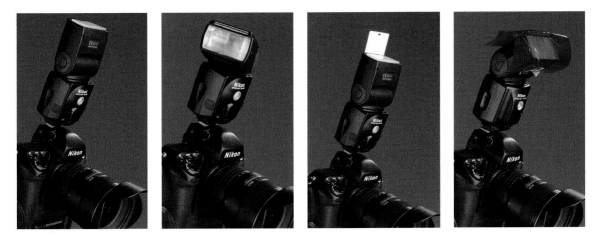

Left to right *The tilt facility can be used to bounce light off the ceiling. • Swivel allows the flash head to be angled and bounce the flash off a wall or a reflector. • The key-light card can be used to light a small group, but is principally designed to add a catchlight to the eyes. • Coloured gels can be added to change the colour of the flash output.*

BOUNCING THE LIGHT

Get used to not just pointing your flash directly at your subjects; most have tilt and swivel functions to allow you to change the direction of the flash. It can be aimed so that it bounces off a wall, a ceiling, a reflector or even a mirror. By bouncing the flash off a ceiling, a much softer-looking image will be achieved, due to the wider spread of light compared to a direct flash; also there will be no harsh shadows behind the subject, as the bounced flash will also illuminate some of the background behind the subject.

I mainly bounce the flash off the key-light card attached to the speedlight, especially when working close to the subject. This card pulls out from the top of the flash unit and is used to put a 'catchlight' into the eyes of the subject, lifting their colour at the same time as illuminating the subject. You can also use this technique to light small groups, if your speedlight is powerful enough.

MULTIPLE SPEEDLIGHTS

Linking two or more speedlights together can result in more professional-looking images, as you have greater control over the power and direction of the light source. One speedlight, the 'master', tells the other others, the 'slaves', when to fire. The one mounted on the camera's hotshoe usually acts as the master and the others act as slaves. The connection between the units can be via cables, but is now more commonly via an infrared link. This allows you to place the units as you wish, and more advanced speedlights can even have their output controlled individually by the master unit once set up.

FLASH ACCESSORIES

A simple way to soften direct flash from a speedlight is by using a diffusion box, which will reduce the harshness of the light. Another useful accessory is a battery pack, such as those made by Quantum, these allow your flash to recycle faster and last longer.

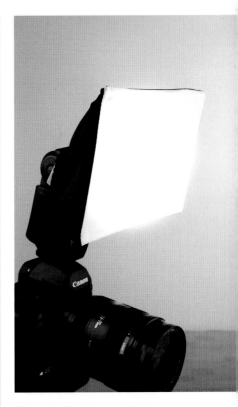

Above *A softbox for a speedlight is a cheap and flexible accessory that is great to soften the light from your on-camera flash.*

Professional flash systems

If flash starts to dominate your wedding photography it is a good idea to start to look at professional flash systems, as they will give you more power and flexibility, with accessories like softboxes and snoots to dramatically change your use of flash.

PORTABLE FLASH KIT

A more professional portable flash system such as the Quantum Qflash sits between a simple on-camera speedlight and a full studio lighting system. The benefits compared to a speedlight are the ability to change the quality and shape of the light with accessories, which can be quickly interchanged over a bare bulb. Wideangle, diffused and even telephoto reflectors give lighting

that is close to studio quality without the restrictions of size or needing mains power. The units can be used independently or together, or even dedicated to your camera. Systems like the Qflash give out far more flash for your buck and, due to this greatly increased power output, the flash can be used over greater distances and hence bigger groups. This is particularly useful when bouncing the flash, as the light has further to travel to the subject. Combine these qualities with the simple design and portability of units like the Qflash, and they are ideal for wedding photographers of all levels of experience. The Qflash needs to be powered externally by a battery pack, but this can also be used to power an ordinary flash unit, improving its recycle time.

Right The Qflash can be set in either manual or automatic mode, with fine adjustments available via its panel of buttons. It can even be controlled from your camera, with the right cable.

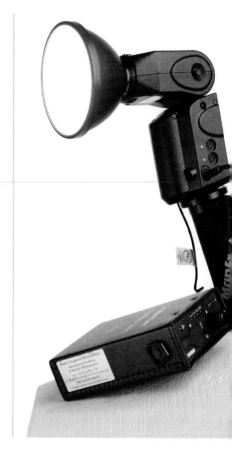

Below Because the Qflash is so portable, an assistant can hold it almost anywhere and flood the room with directional light.

STUDIO FLASH SYSTEMS

In the winter or on wet wedding days I require a more professional use of flash, especially when taking the group and bride and groom shots inside. Professional studio flash systems offer a large, highly controllable amount of flash and also a bright modelling light to help you see exactly what the effect of flash will be. There are a number of different types of studio flash, but a monobloc flash head is my preferred choice as it incorporates power controls and its portability allows me to use it in studio or in a reception – even on location when attached to a special battery pack.

Two studio flash heads are ample for weddings: one as the main light to light the subjects, and the other as a fill or background light. The two-head kit I use comes complete with lighting stands, a standard umbrella, a softbox and a carry case. The umbrella is used to bounce the light for a really soft, wide spread of light, and the softbox is used to give a soft but more directional light source.

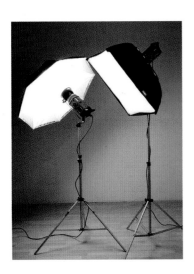

Below Choose a softbox with at least two layers of diffusion.

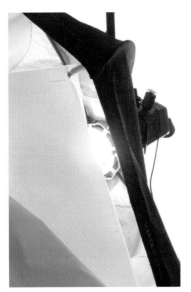

SOFTENING THE LIGHT

To produce professional-looking portraits you will have to soften the light for the majority of your images. This is because direct flash gives a harsh look and exaggerates the subject's flaws, such as lines and bags, as well as the facial features like the nose. You can soften flash easily with either a photographic umbrella or a softbox.

Umbrellas A photographic umbrella is a cheap but effective light softener. It is also very portable, as it just folds down. Different types of umbrella allow you to soften the light in different ways; however, an umbrella will always spill the light, due to its simple design. The most popular is a standard umbrella, which reflects the light back to the subject and gives a wide spread of light from its reflective interior.

Left Portable studio flash kits make it easier to take professional-looking portraits, as you have greater control.

Softboxes A softbox will give the best results for small groups and bride and groom shots, due to its design, which gives fantastic softening and control of the light. A softbox produces very natural lighting, like light from a window when the subject is positioned nearby. It also produces beautiful catchlights in the subject's eye that mimic the softbox's shape.

Below (top to bottom) A standard umbrella is designed to reflect light efficiently, softening its effects, which is good for most reasonable-sized groups.

A directional 'shoot-through' umbrella provides more contrast, which is good for individuals, couples and small groups for a more dramatic image.

A 'brolly box' provides a very soft light source due to its design – great for individuals and couples.

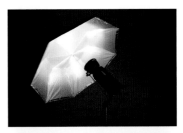

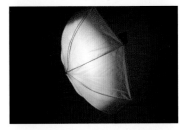

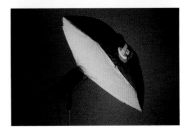

Reflectors

A reflector is a must-have for any wedding photographer, as its ability to reflect or diffuse light makes it the perfect tool to enhance subjects by either adding or subtracting natural light or flash.

A reflector can be as simple as a piece of white card or a white wall. I use fold-away Lastolite reflectors, as they are quick to open and convenient to store. They come in different styles, sizes, colours and reflective materials. On a cloudy day I use a silver or sunlight reflector as this will sharpen and slightly warm the light. This same reflector can be used on sunny days, but because of the mirror-like reflectance a harsh light will be directed onto the subject for a more dramatic image; however, beware of the 'horror film' effect when the light coming from below is brighter than the natural light hitting the subject.

A reflector is simple to use. It is usually best placed in front of the subject to bounce the light coming from behind or to the side of the subjects. When angled correctly, the

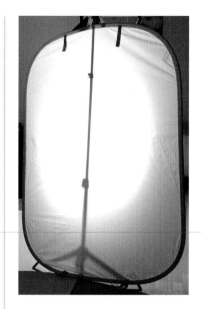

Above *Used to diffuse harsh sunlight or off-camera flash, a large diffusion panel can make a real difference to the quality of light.*

light will bounce back onto faces, lifting shadows naturally and creating a professional look to the image.

If you want to create a soft, natural look when the sunlight is falling directly onto the subject then you should use a large diffusion panel placed between the subject and the sun. This will soften the harsh light's contrast and reduce the amount, helping to prevent the subject from having to squint.

If the quality of light is not good enough in an interior location, think about using a silver reflector from a window far across the room to add light in the correct quantity.

The largest reflectors are usually rectangular panels, while the more popular, smaller reflectors are generally a disc shape. If I am working alone on a wedding I use a small tri-grip, reflector which is a triangular reflector with a handle that makes it easy for me to hold,

CAMERA TIPS

Using reflectors

Avoid putting a reflector on the opposite side of the light source as this will give an unnatural direction, which will flatten the light and make the subjects appear fatter due to the lack of directional light.

CAMERA TIPS

Reflector colours

White – Useful for very sunny climates when a soft reflection is needed.

Gold – Gives an exaggerated warm feeling.

Silver – Has a mirror-like reflectance.

Sunlight – Gives the light a slightly warm glow.

Sun fire – Gives warm light with specular highlights.

Black – Subtracts light and enhances modelling.

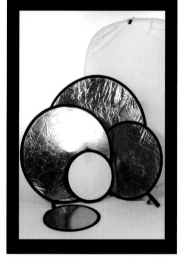

and direct the light onto the subject. If I am working with an assistant I use the larger tri-grip, as the assistant can stand further away and reflect more light, allowing them to illuminate small groups as well as just the couple.

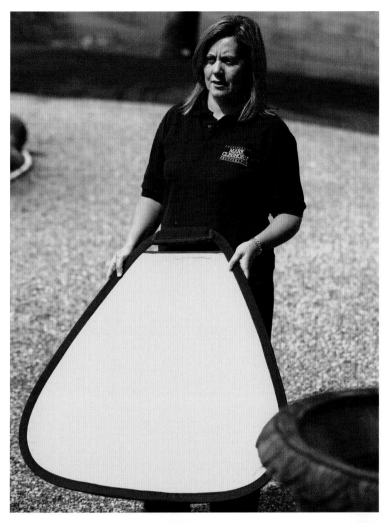

CAMERA TIPS

Subtractive lighting

In some circumstances a black 'reflector' can be used to deaden the light on one side of the subject; this is called subtractive lighting. This technique also increases the modelling on the face.

Left When working with an assistant you can direct them as to how you wish the light to strike the subject. This leaves you with both hands free so that you can concentrate on composition, pose and expression.

Below If you are working alone, then a reflector with a handle allows you to direct the light without the need for assistance, stands or supports.

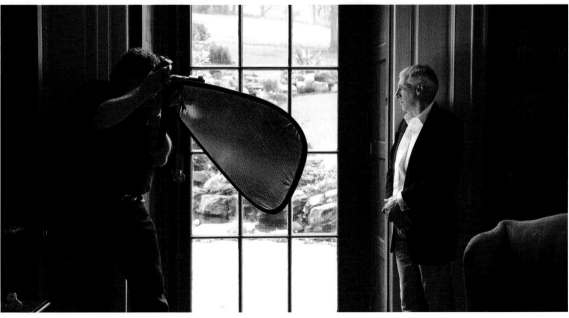

Tripods

A tripod is not an essential tool for all weddings, but it is vital when shooting in low-light conditions, especially during the winter and at wedding receptions when you need to record the ambient light in the photograph to capture more of the atmosphere.

Even the most basic tripod will allow you to set the camera height and position, which will allow you to leave the camera to walk back and forth to the group to adjust the pose or adjust a flash unit. A tripod will also allow you to use slower shutter speeds and avoid camera shake in low-light locations indoors or out.

There are several types of tripod design and consequently build quality. As a guide try to buy a tripod that is not too heavy to carry around. If weight is a problem then opt for a carbon-fibre model as they are about two-thirds lighter than a metal tripod, although more expensive. The tripod should be able to take the weight of your heaviest camera, lens, and flash. Auto-adjustment legs, with little triggers, are a luxury, but a great bonus when working fast and on location. Locking legs will stop the tripod from falling over, while sealed tripod feet are also useful for wet locations like the beach. If you plan to shoot low to the ground, check that the tripod will drop that low; many of the more expensive models will drop practically flat.

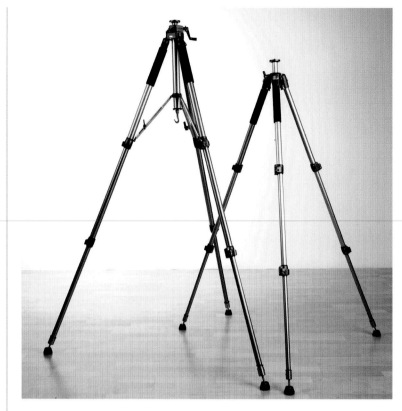

Above *There is a large selection of tripods available, but try and buy the best you can, as it will probably outlast all your other equipment. The Calumet tripods shown here each have two extendable sections per leg to increase the height. The larger model has a hook on the centre column to allow for weights to be hung from it for extra stability; the smaller tripod allows the camera to be closer to the ground if necessary.*

MONOPODS
A monopod offers some protection from camera shake, but less than a tripod; however, it is a great tool when you need to retain flexibility, and is ideal at the end of a long day when you are shooting speeches using a long lens.

TRIPOD HEADS
Tripods are often sold in separate parts and you can often buy the legs and head separately. There are three main types of tripod head: ball-and-socket, trigger-grip and pan-and-tilt. Most tripod heads are relatively light, but you should make sure that you do not buy one that compromises on build quality.

Above *Monopods help to reduce camera shake, but aren't as restrictive as tripods. Note how this telephoto lens has been attached to the monopod via a collar.*

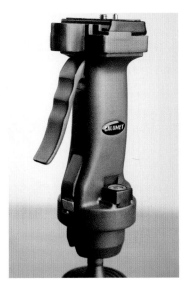

Trigger-grip tripod head

Pan-and-tilt tripod head

The pan-and-tilt head allows you use individual handles to tilt the camera forwards and backwards, from left to right and to pan the camera around its vertical axis.

A ball-and-socket head allows you to rotate the camera around a sphere, locking it in place with a single lever; the trigger grip is a variant, releasing the lock when the trigger is squeezed and applying the lock when the trigger grip is released.

QUICK-RELEASE PLATE

Most heads are fitted with a quick-release plate to allow the camera to be taken on and off the tripod quickly and easily. The quick-release facility is excellent if, like me, you spend most of the time hand-holding the camera in order to be able to capture more candid images. However, look out for a model with a simple lock on the release, so you cannot accidentally knock the camera off.

The **BIG** Day

A church is a typical place in which to use a tripod, because the lighting is usually low. By using a tripod I can set my shutter speed down to around 1/4sec or even as low as one second, to record the natural light and candles with a low ISO setting. Using a tripod will help to prevent camera shake.

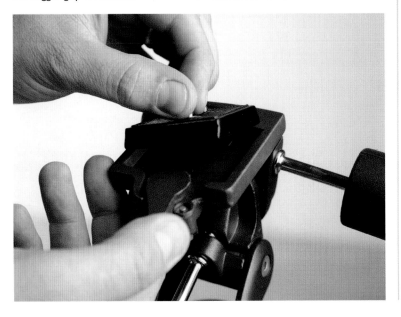

Left *Quick-release plates allow for a speedy transition between hand-held and tripod-mounted photography.*

Exposure

Most cameras offer the option to set exposures automatically, but as your photographic skills improve you will want more control over an image. To do this you will have to apply your own exposure alterations, both for creative purposes and to obtain the ultimate in accuracy.

Exposure is a complex subject, and there are many books that cover in depth the relationship between aperture and depth of field, shutter speed and the representation of motion, and the interrelation between all the different variables. For that reason I will leave the fundamentals of exposure to other books and concentrate instead on how they are applied to wedding photography.

For the wedding photographer a correct exposure is a combination of a technically accurate exposure and the creative application of the exposure variables. Creatively, you should pay attention to the depth of field in order to position the envelope of sharp focus correctly, while the choice of shutter speed can be used to freeze movement or create motion blur as desired. The ISO rating can also be manipulated, not just as a subsidiary of the other variables or in order to obtain a correct exposure, but also to create noise. How the creative variables can be used is covered, where relevant, throughout this book.

Right Even with the flexibility of a RAW file, when an image is overexposed by more than two stops (top) there is really no recovery, as the highlights will be pure white, with lost detail and excessive contrast making the corrected image almost unprintable (bottom).

Technically, wedding photographers should aim to retain as much detail as possible within most images. This can be challenging when faced with white dresses and black suits. Overexposed images lose detail in the highlights and generally suffer from too much contrast, giving little transition to tones and resulting in white blotches instead of graduated highlights. Underexposed images will appear muddy with little contrast and will need to be printed lighter, which can add to the flat look due to the lack of a true black in the photograph. Although some digital correction is possible, and even though RAW files allow more leeway, it is best to get it right in camera.

Right As you can see from this high-key image the correct exposure is giving detail throughout all the whites and creams, as well as in the shadow areas of the hair. A perfect exposure, and consequently a perfect print.

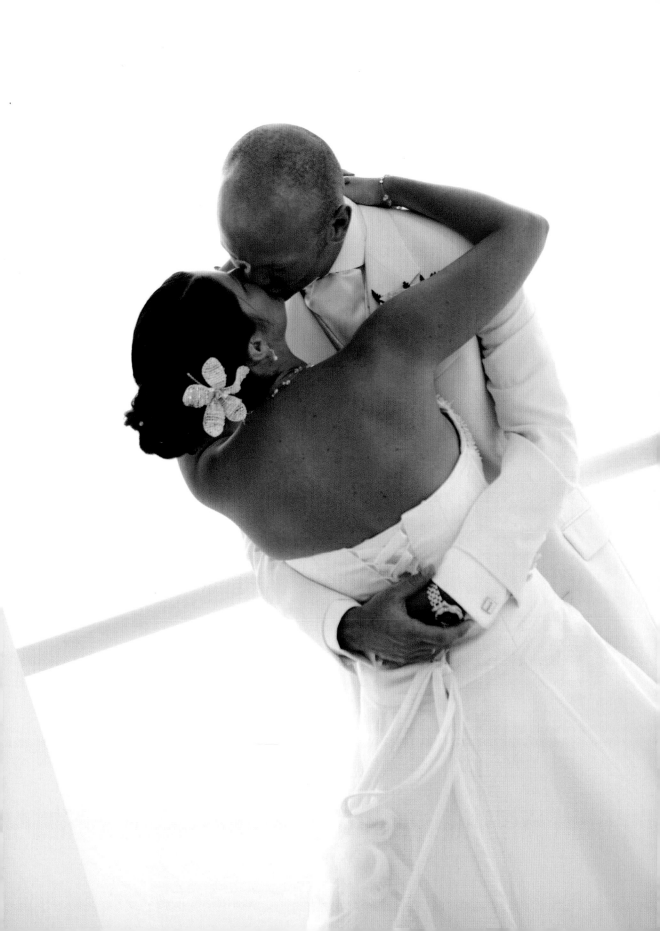

Metering and exposure

If you are to make full use of your camera's technology, it's essential to understand its metering and exposure options. Aperture-priority and shutter-priority modes are both good wedding options, offering a balance of flexibility and automation. I tend to use manual mode so I can control the aperture directly, obviously keeping an eye on the shutter speed, particularly in low-light levels, in case a tripod is needed.

I won't go into too much detail here – again, there are enough books out there already if you need to brush up on the basics – but suffice to say most hand-held and in-camera meters are calibrated to expose for the average mid-tone, referred to as 18% grey. In principle, the meter is trying to set an average exposure over the whole scene to allow for a mid-tone image. However, the scene is not necessarily always mid-tone – for example, a white wedding dress or a black suit can dominate an image – and this is why it is necessary to understand the different systems of metering.

IN-CAMERA METERING

There are several in-camera metering modes and these determine how your camera takes a reading from the scene. Multi-segment metering takes several readings across the image and combines them for one reading. It's an ideal setting when you have to just point and shoot, as the multiple readings will allow for large areas of dark and light, but the system can still be fooled by high-contrast situations. Some systems also incorporate distance and even colour information, which all improve the accuracy.

Centre-weighted metering takes readings from across the image but gives emphasis to the centre of the image, which makes it good for a close group shot, it is also a good option when using filters like a polarizer. Spot metering is the most precise of the options; but it is the hardest to use. It meters from a central spot or from the selected autofocus point, which makes it ideal for portraiture as it will ignore areas around the main subject; but it can be time-consuming to position the spot accurately.

HAND-HELD LIGHT METERS

My preference is to take the exposure reading with a hand-held light meter rather than using in-camera metering facilities. This is because I am then able to measure the incident light (that falling on the subject) rather than that reflected from it. This takes difficult subjects out of the equation and is more consistent from shot to shot. To take an exposure reading manually I simply position my meter close to the subject's face and point the meter towards the light source to get the correct incident light reading. The reading shown on the meter is then simply set on the camera to give a correct exposure.

HISTOGRAMS

Exposure is still important, but digital technology allows a little more leeway than film. One very useful tool on most digital cameras is the histogram. This allows you to check the range of tones, making sure that you do not lose shadow or highlight detail. Simply take a test shot of the subject under the appropriate lighting, check the histogram and make adjustments before shooting the main sequence.

Above Some meters come with accessories to take both incident and reflective readings.

Above Hand-held light meters are still used by most professional wedding photographers to get accurate flash and ambient exposure readings. A perfect exposure will record all the detail from the shadows to the highlights, which will result in whites and blacks that are rich and full of detail.

BRACKETING AND COMPENSATION

The practice of bracketing was more common with film cameras than digital, as digital cameras allow you to check the exposure via the histogram; however, bracketing an exposure by shooting a sequence of frames at the recommended exposure, above it and below it can still be useful. This can be time-consuming when done manually, but when the camera does it automatically, the sequence of exposures is complete in a second or so. However, if care is taken to obtain a correct exposure initially you can dispense with bracketing, and avoid the risk of losing an otherwise good shot because it is incorrectly exposed.

Exposure compensation can be a more useful tool, enabling you to set a constant level of exposure adjustment for a sequence of images. When metering for digital it is generally safer to be slightly underexposed to maintain detail in the highlight than overexposed and risk losing details in the highlights. This is particularly the case because of the importance of accurately exposing subjects such as white wedding dresses.

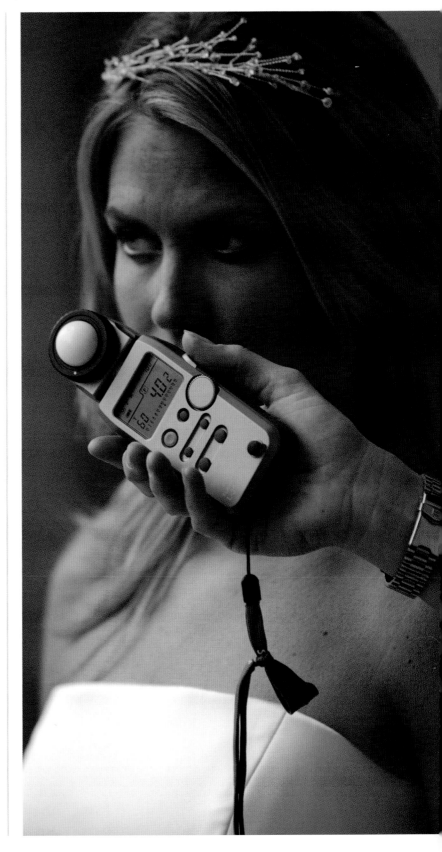

Right When taking a hand-held reading for incident light, point the meter toward the light source for an accurate exposure.

Choosing the ISO rating

Left *To maintain quality try to keep to a maximum of ISO 400 in low-light scenes, this will also help freeze movement, as it allows faster shutter speeds.*

A simple solution to different lighting conditions is to adjust the ISO setting to suit each situation. When shooting weddings you will have to choose the right ISO for the conditions that you are faced with. With digital cameras you can change the sensitivity of the camera at any time, so if you move from a very bright to a very dark location you just change the ISO setting on the camera to instantly allow for the sudden change in exposure that is needed.

The ISO represents the sensitivity of the sensor, but it also affects the quality of the image. At lower ISO ratings, cameras will give less noise as well as greater colour saturation in the final image when compared to higher ISOs.

Assessing the conditions is the secret to which ISO to use. For instance, an image taken with flash or sunlight will need a maximum ISO of 200. If the location is dark you may need a faster ISO like 400 or 800 for a correct exposure, but remember the faster the ISO the more noise will be visible on the finished print.

Above *ISO 100 or below will give the best results with little noise and smooth skin tones. It is used in good lighting inside and out.*

Right *Higher ISOs such as ISO 800 will start to make noise a bigger issue as you don't have to look too hard at the print to see the granular texture in the smoother toned areas.*

Left *On some pro DSLRs, high ISO settings of around ISO 1600 still give very acceptable results and you will be able to shoot in very low light conditions without flash. However, for many cameras, visible coloured dots of noise in an image can be a serious problem.*

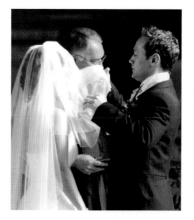

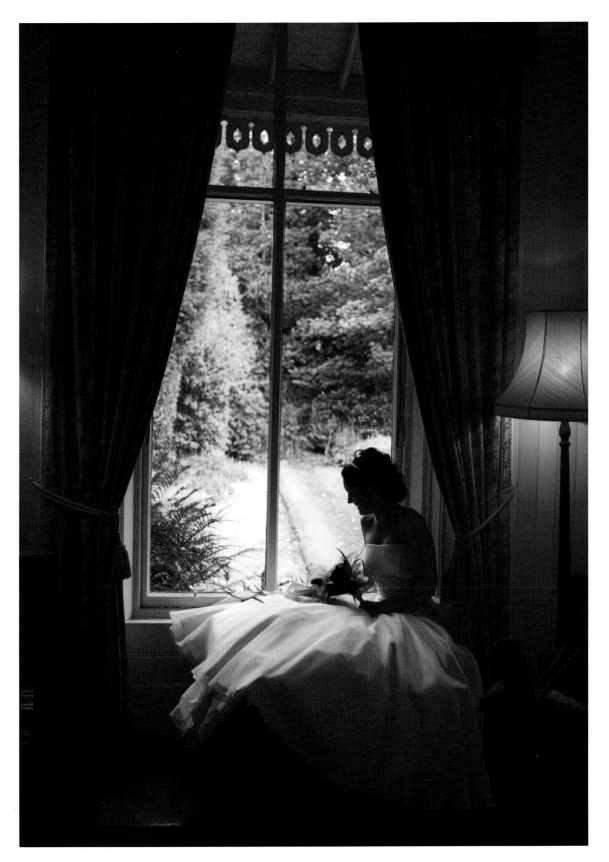

File management

Most cameras offer two main types of digital file format – the way in which the image is stored after shooting – RAW and JPEG. A RAW file is much bigger and also needs post-processing on a computer, although it is more flexible; while a JPEG can be used as shot and, although less flexible, is more convenient.

RAW files simply retain all of the information captured by the sensor. This means that they can have extensive changes made in post-processing without degrading their quality. They can have the basic exposure adjusted by up to + or –3 stops. The colour tone and white balance can be corrected or altered to taste, which is very useful when large numbers of similarly lit pictures have been taken at a wedding, where colour can fluctuate slightly and you want to make the collection of images more consistent; however, the downside is that this post-processing all takes time. The RAW file is also larger, so the number of images that can be stored on a card is reduced.

JPEG files are the most common format, as they can be used straight from the camera with almost any software, as well as being sent directly to print. A JPEG is a compressed file, making it smaller than a RAW file, but the loss of information due to compression is small, and with a high resolution, the loss of quality is practically invisible. The file can be stored at different compressions, but making it too small can cause the quality to really drop off. Generally, however, it is the inflexibility that is the disadvantage compared to a RAW file.

WHITE BALANCE (WB)

One of the key factors in deciding between RAW and JPEG is the ability to control the white balance after shooting. Digital cameras allow the photographer to change the white balance to suit the lighting conditions. The auto white balance can provide good results, but it can also be variable. If you are shooting RAW files the secret to simple colour balance is to keep all the images to a similar tone and not allow the camera to deviate

slightly between images; just set a white balance preset of, for example, 'flash', then all the images will have a similar colour tone. Then in post-production all the images in a series can be corrected in seconds with a simple click of the white-balance picker, and this setting can be applied to all images. If you are shooting JPEG files, then getting the colour near-perfect in camera is essential, but auto white balance is not the answer as it will deviate slightly from one image to the next. Most cameras offer custom white balance settings, which is a starting point, but can be time-consuming to get perfect, especially in the middle of a busy wedding day. This is easier to set, however, with the aid of a gadget such as the Expodisc – an easy-to-use custom white balance target – and this should provide greater consistency than relying solely on the auto white balance.

MEMORY CARDS

Once you have chosen the format of your files, this will determine, to a certain extent, the card you require. Memory cards come in many sizes, but you should strike a balance between being able to fit a lot of images on a single card and not putting all your eggs in one basket. The other consideration is that your card should allow you to use your camera to its full potential; this means buying one that has a read/write speed fast enough to cope with the camera's buffer.

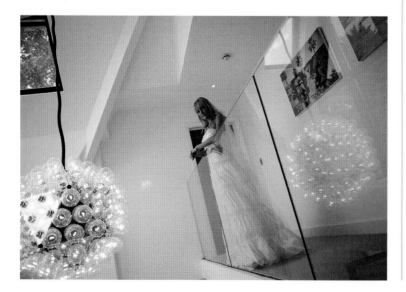

Left *Because I shoot RAW files, in post-production I can simply click to balance a large quantity of images at the same time. To make this even easier, I set my camera to the 'flash' preset so the camera doesn't vary slightly from one image to the next.*

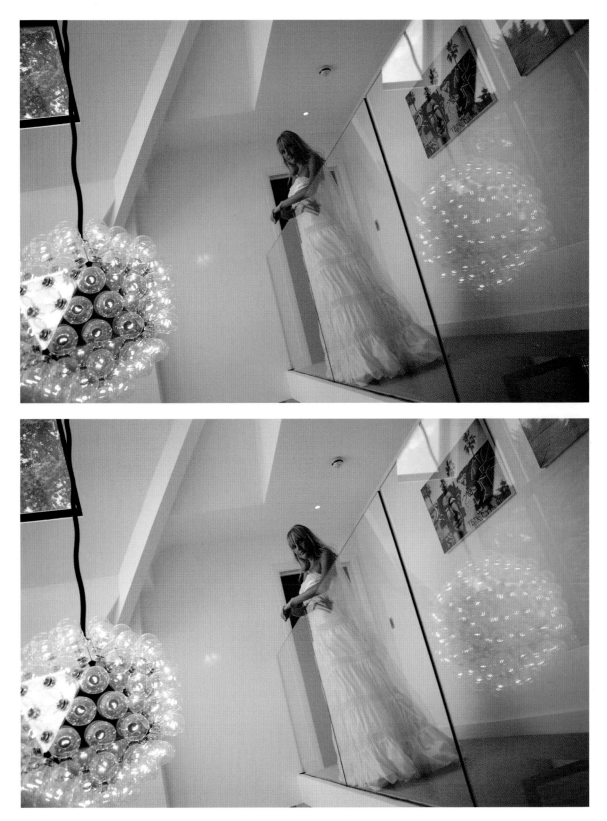

Above These two images have different colour casts. This is OK while there is no dominant colour, but when images contain a single colour that dominates, such as lots of green grass, this can cause visual confusion and give an unpleasant effect.

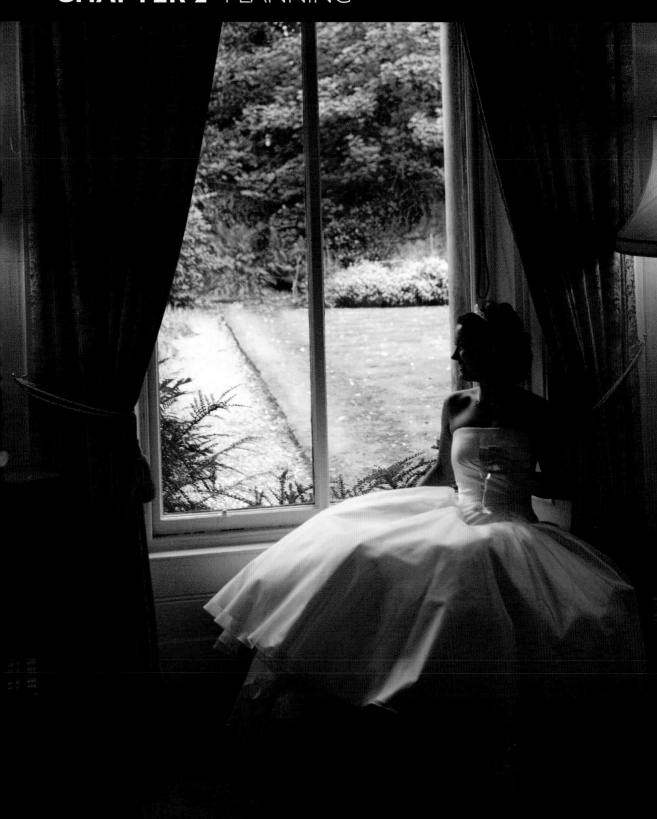

CHAPTER 2 PLANNING

Success in any discipline always has its foundation in planning and preparation. This is particularly the case with wedding photography, and, as most weddings are booked six to twelve months in advance, there is no excuse not to be fully prepared for the big day, both technically and mentally.

In this chapter we will look at some more secrets of great wedding photography. The emphasis is on getting ready for the wedding day by discovering what the couple would actually like in their wedding album, covering how to apply basic poses and lighting techniques to achieve a range of different styles.

Weddings have changed so much over the years in both style and function. Up until the 1990s there was little choice for the bride and groom, as most wedding photographers shot relatively formal images. With many couples now arranging their own weddings, the events themselves have generally become a little more informal, hence the style of photography has also become more relaxed and fashionable.

I believe good wedding photographers should be able to handle everything that is thrown at them, from the most traditional wedding to the avant-garde. Each wedding is different and I try to mix the variety of styles for each wedding day, giving a little taste of each to the collection. This allows me to tell the tale of the wedding in different ways; however, no matter how many different styles you want to try, the foundation is always in good planning.

Key skills – formal style

I believe all wedding photographers should learn the art of formal wedding photography. It is a great foundation for other styles, and almost every wedding will have a formal element in it.

The problem with more formal wedding photography is that it can take slightly longer to perfect each shot, especially to get the pose and use of light right. Most wedding couples fear formal wedding photography because formal photographs can look stiff and the expressions lacking in life. This is usually just due to the photographer taking too much time over the finer details, and missing out on capturing the moment as they fuss with little distractions in the search for the perfect shot.

Above The full-length bride and groom portrait will always be a best-seller. Here the couple have been moved from the bright sunlight at the church door into the shade of a tree to soften the light.

Left A formal group is simple to put together: just make sure all of the bodies are turned slightly in towards the middle.

1 The secret to formal wedding photography is to use it as a starting point. With each new set-up or location, you should decide on the variety of images you are going to take before posing the couple. Also decide on what part the formal selection will play in their overall collection of images. By making these decisions before starting, you will be able to select the right location with the lighting and backdrop that suit the couple and the style.

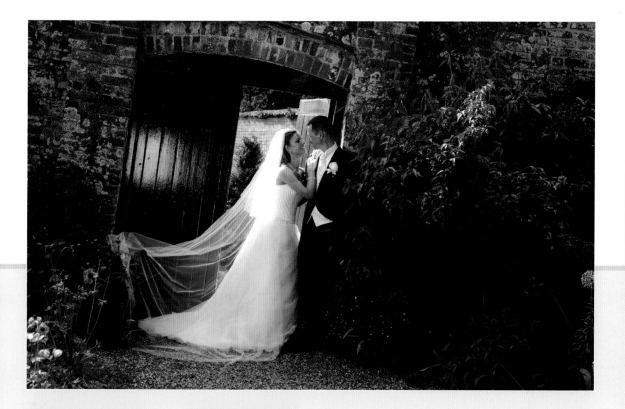

2 Formal photography, when done well, can be classical and timeless. This requires all of the elements – pose, light and backdrop – to be combined well; so don't be afraid to use formal photography as a part of a wider repertoire.

3 Once you have covered the basic shots that a formal shoot requires, then you can start to think a little more creatively; however, it is important to start simply and then build up. This will ensure that you spend the most time creating the most important shots, while you can assess what you are able to take in the way of more creative ones later.

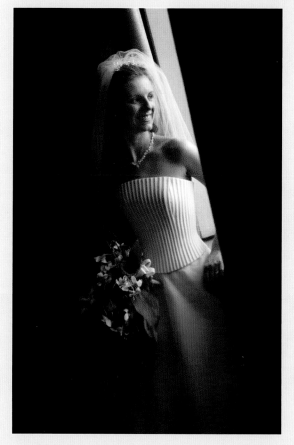

Top *To add a little bit of creativity to a formal pose, look for interesting backdrops and just add a slight camera tilt.*

Left *When all else fails, look for a window; you will never go wrong with a classically lit and posed bridal portrait.*

Reportage style

Reportage or documentary photography is how most wedding photographers begin. Almost all photographers start out as the relative with a camera, becoming an unofficial photographer for the day, shooting to one side of the wedding photographer who is commissioned.

The problems with being the second photographer at a wedding are that there is no pressure to come up with images, and there is no element of control when shooting. This means there is little learning curve to help you eventually become a great wedding photographer – except for the opportunity of seeing how a professional copes.

Reportage photography demands the skill of being aware of what is

Above The panoramic crop, when used with a wideangle lens, is a useful tool for successful reportage.

The **BIG** Day

If you plan to only shoot 'off the wall' reportage-style images, make sure the couple know that you will not be arranging any groups or posing them for portraits. Most couples will need this to be made clear to them.

happening all around you. So, if you are someone that enjoys talking to people all the time, it's probably not the style for you. This style incorporates many techniques that both formal or informal wedding photographers might use, like split focus, the use of stronger lighting, or even selecting a higher ISO for more noise; the major difference is that there is little or no interaction between photographer and subject.

Above and right The secret to good reportage is timing, as you can see in these two images: one is flattering and one is not. I am always worried about missing the moment, so I always tend to overshoot, capturing the first image as my safety net and then hoping that the following shots will just get better as this one has.

Informal style

No matter what style of photography you decide to go with, the images should always represent the fun and intimate atmosphere of the day, and this is particularly the case with informal images. Poor expression often kills an image, usually because the photographer takes too long over a specific pose or fusses with equipment, causing the couple or guests in the group to lose interest. So always shoot quickly if you want to keep your images fresh and fun.

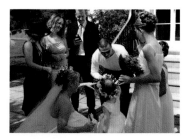

Most weddings have a really fun feeling to them, especially those in which young children are a part of the wedding party. You are almost guaranteed some fun images as they get bored or tired with what is going on, so keep a look-out for funny moments as they start to make their own entertainment. The bride's and groom's friends are also good to watch for fun moments – as they usually act larger than life – especially if the alcohol flows before the reception! That does not mean you are looking for embarrassing moments, as these can be funny but are seldom purchased, just images that will make people smile, and will add variety to any selection of wedding photographs.

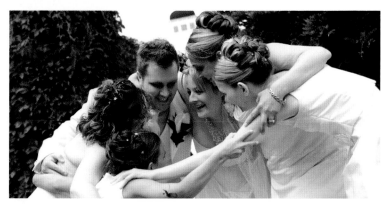

Top left When shooting an informal style, try to keep an eye on what is going on all around you.

Above You can gain some great informal shots if you pay careful attention to the way in which groups interact.

Left Sometimes as the photographer it will pay for you to instigate a little fun in the images.

The **BIG** Day

Keep your images fresh and fun by deciding on the pictures you are going to take in advance. Have a prompt list in your bag or car, so you can have a quick check before you start each set of photographs, but be discreet, you don't want the couple or guests to see you doing this.

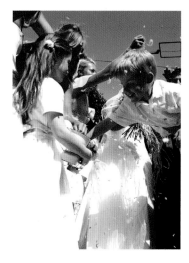

Above Grabbing some candid shots is a great way of adding life and variety to an otherwise traditional collection of images.

CANDID SHOTS

Guests play a big role on the day, so make sure you capture candid images of them as they come out of the ceremony, when their spirits are high, as well as during the drinks reception and, of course, during the speeches. If you choose your timing well, you will come up with a large variety of candid shots when the guests are interacting.

Meeting and discussing

The initial meeting with the bride and groom is crucial because first impressions count, whether it's your first wedding or your hundredth, and whether you know the couple personally or not. There will be many questions they want to ask you as well as seeing your portfolio of work. If you have never shot a wedding before, this is a little more problematic so your portfolio of portraits will have to convince them to trust you. Never take a wedding for granted, as each one is different, They may follow a similar theme, but each features a different couple with their own ideas, so always listen to what they are saying.

QUESTIONS FOR THE COUPLE

The questions you should first ask the couple are:

1 Who is getting married? Don't assume it's the person before you.

2 When is the wedding? Clarify the date, time and year, and double-check your availability.

3 Where is the ceremony and where is the reception? You will need to know travelling times and any extra costs.

4 What are the coverage requirements? Have they thought about style and how long they want you present?

5 What are their photographic likes and dislikes?

6 Do they have a budget? If so, how much?

QUESTIONS FOR YOU

These are the 20 questions that I am probably asked the most frequently by couples, and they are the ones that they may ask you initially; however, if you ask your questions first, then many of these following ones will be answered naturally during the course of your discussion.

1 Who will be photographing the wedding? Will you be on your own or with an assistant?

2 What makes you different from other photographers?

3 Have you shot a wedding at this venue before?

4 What variety of packages do you offer, and what are the differences in price?

5 Are there any hidden extras within the pricing structure?

6 When do we pay?

7 How long will you be at the wedding?

8 Will we meet to discuss the photographs, and can I say who is in each group?

9 How will I be able to view my wedding proofs?

10 Who selects the photographs for my album?

11 How long do I have to make a selection for my album?

12 What happens if my pictures don't come out or I don't like them?

13 Who will I deal with after the wedding day?

14 Can we order reprints and parents' albums?

15 How much will reprints cost? Are there any discounts available for ordering certain quantities of reprints?

16 How long will it take for the final album to be delivered?

17 Will my album have inkjet or real photographs?

18 Will my pictures fade or mark?

19 How long have you been in business? And how long do you plan on staying in business?

20 Do you have indemnity insurance?

The **BIG** Day

Check that you have the couple's contact information correct so you that can follow up their enquiry easily.

Time requirements

Wedding photography packages can be broken down into five different allocations of time. These provide the rough outline of the day within which you can work out the various timings for each individual part of the day.

These first two time allocations allow for arriving at the venue half an hour before the ceremony starts to capture arrivals.

1–2 hours civil ceremony or single location only.

2–3 hours from ceremony through to reception.

The next three allocations allow for the fact that most brides now like to start off the day with some informal shots and details at their home on the morning of the wedding. These allow enough time to shoot a good variety, including some formal shots. You will need to allow about 45 minutes for this, then sufficient travelling time to allow for about 30 minutes at the location of the ceremony to photograph arrivals and details.

3–5 hours from bride's home to reception.

5–8 hours from bride's home to reception, including speeches and possibly the first dance.

8–10 hours from bride's home through to leaving the reception.

As a rule of thumb, a day's shooting – starting half an hour before the ceremony and finishing just before sitting down for the wedding reception, including mocking up of the cake cutting – takes about three hours. Over this period I usually aim to shoot between 400 and 600 different images.

On the other hand, some services, such as Jewish and Greek Orthodox weddings, need the full eight- or ten-hour coverage to allow for the extended ceremony and reception, and I will shoot anywhere from 800 to 1,200 shots as the party goes on deep into the night.

THE VARIETY OF PACKAGES

Most photographers work in packages; it's an easy way for you to come up with a fixed price. Some photographers do offer attendance-only fees, but this can work out more expensive in the long term for the couple if they are not made aware of the rest of the pricing structure before the wedding.

Right and below It can be a long day's work when you are photographing a wedding, so try to keep things varied and fun for yourself to keep you fresh.

The **BIG** Day

If you are asked to cover more than five hours of a wedding day make sure the couple have arranged for food for you and any assistant, I usually ask for just a simple plate of sandwiches and served in another room away from the guest as half an hour of time relaxing on your own helps to keep you fresh and enthusiastic.

Pricing and packaging

When you are meeting a couple for the first time, one of the most important areas for discussion is the question of 'How much?' I never avoid this question as it is a key part of all negotiations and sales. This question is easier to answer if your pricing and packaging is simple for everyone to understand and put in plain English. I try to avoid placing too many hurdles in a couple's way, so I keep my packages simple and easy to understand, with no hidden extra costs.

Always discuss and decide on what the couple actually want, because it is pointless shooting 600 images on the wedding day if they are only looking for a few small pictures in an album or small frames. That is why I have broken my packages down by time and products. By presenting my options in this way I can give couples the option of a basic coverage, but with a luxury wedding album or the opposite extreme of extended coverage with a more basic album. At the end of the day the couple will have to decide one way or another, and

it makes sense for them to do so before the wedding in order to set their budget.

ALBUMS

There are hundreds of different manufacturers of wedding albums and they all offer a variety of styles and sizes, with something for every budget, from a simple small album to something fit for royalty. There are basically three different styles: a print on a page, a print with overlay, and a print as the page.

The classic print stuck on a page with a tissue protection has been popular for many years and even though it has had a revival recently it is a less expensive option and still considered to be a more basic way of presenting images.

The 'print behind an overlay' style allows for a range of single and multiple prints to be presented on each page, with the overlay adding to the presentation as well as protecting the print and making the album heavier and more luxurious.

The graphic album has come on to the wedding scene since digital photography has come into the

ascendancy. It allows for a whole double-page spread to be used for presentation, combining the photography with design elements in order to give a magazine-style or more avant-garde layout to the whole album.

COVERS

There are a range of covers, from basic to luxury, available for most wedding albums, and of course this is reflected in the price. A basic cover will usually be smaller and consist of a simple cloth or fake leather. At the other end of the scale large albums up to 20in (50cm) are finished with metals, coloured plastics, real woods and leathers to give them a real touch of luxury.

Left The 'print as a page' style allows interesting layouts to be created combining the photography with design elements.

Below Covers are available in a wide range of different finishes and colours, enabling you to choose one to suit the couple's tastes and budget.

HIDDEN EXTRAS

Try and package everything so that the cost structure is easy to understand and there are no hidden extras. This can make your initial prices seem expensive, particularly if you only deal with luxury albums, so some photographers charge for upgrades, specifically on the album covers as the albums can differ in price drastically.

HOW TO SHOW WEDDING PHOTO PROOFS

Proofing has always been an additional and expensive cost to the photographer and eventually to the couple, so in recent times we have seen an explosion of internet or computer proofing. This is great for friends and family viewing and selecting images, but it can very difficult to design a wedding album on this basis. I include large proof contact sheets in most of my packages, combined with a DVD to distribute and view images on screen. The printed images are much easier to select from and compare and the DVD is a clear way to see the images bigger. There is no single best way, just different ones; however, you should remember that in one way or another the couple is paying for the proofing, and you should factor in this cost.

WHEN TO TAKE PAYMENT

The couple will usually pay a booking fee; this is generally non-refundable, so make sure they know this before booking you, when they part with their money.

The purpose of a booking fee is to ensure a photographer's availability for that day. Unfortunately, weddings are cancelled from time to time, but if this happens the photographer is justified in keeping the booking fee because he or she would have been refusing work for that date.

I take the final balance one month before the wedding day, as do most photographers. This allows for a speedy pick-up and collection of the proofs and eventually the wedding album after the wedding. Of course, the couple can still upgrade after the event if they want to.

SELECTING PHOTOGRAPHS

I always encourage the bride and groom to select their own images to go in the final album, as it is a very personal item, a story of their day – not how I think it should be. If the couple chooses a less-expensive package then you may need to make the selection for them, but this should be clarified before booking.

REPRINTS, PARENTS' ALBUMS AND GIFTS

Most weddings will result in extra prints being ordered for friends and family. I finish my reprints in a slip-in folder; these are available in different sizes, thicknesses and colours. How much to charge for reprints is always left to the photographer; my reprints are relatively expensive, but they are album quality, not a cheaper quality like an inkjet print, and I offer a substantial discount when they are ordered within eight weeks after the wedding.

Parents' albums are very popular and I have a variety of album size options, 8 x 8in (20 x 20cm) to 16 x 12in (40 x 30cm) and in different

numbers of pages. The albums and the prints are the same quality as those for the bride and groom, as the quality always reflects on the photographer. I have found that the most popular albums for parents are single prints on a page with an overlay.

I also offer a range of wall- and desk-framed images, which are very popular, especially with parents. Framed desk portraits are an alternative that sometimes replaces an album for the parents.

Above *Typically I offer parents' albums in a variety of sizes from pocket-sized up to 16 x 12in (40 x 30cm).*

The **BIG** Day

If you do not want to do any finishing – perhaps if you are simply taking wedding photos as a present for a friend or relative – then you can just offer all the images on a CD or DVD so the couple can get prints made themselves.

Booking information and deposits

When booking a wedding shoot, even for friends or family, you need some basic information for the day, such as where the bride is leaving from, the name and address of the ceremony venue as well as where the wedding reception will be held – not forgetting, of course, the exact time of the ceremony – you don't want to be late!

You need some of this information straight away, such as contact information for the bride, groom and parents. Don't forget to take a mobile telephone number and an email address. I also recommend rechecking all this a month before the wedding, when all times and plans are fixed. Remember to clarify whether the couple want you at the reception, so you don't make your own dinner plans on that day. Get the couple's parents' contact information in case the bride and groom move – which is likely before a wedding – as well as getting the address of were the bride is leaving from on the day itself. Take a deposit or booking fee to secure the date and time; this is the first point of business when the couple decide to book you as their photographer.

INSURANCE – LIABILITY AND INDEMNITY

If you are planning to shoot for more than just friends and family, you may need to start thinking about liability and indemnity insurance, just in case the couple do not like the photographs or in the event, however unlikely, of something going wrong.

Right Making sure that you have all the details sorted out before hand will allow you to concentrate on images on the day.

INFORMATION REQUIRED ON BOOKING

- Coverage requirements – style and time required.
- Date, time and year of wedding.
- Bride's name, address, home, work and mobile telephone number and email.
- Groom's name, address, home, work and mobile telephone number and email.
- Groom's parents' details, address and telephone. Plus whether either is divorced, remarried or deceased.
- Bride's parents' details, address and telephone. Plus whether either is divorced, remarried or deceased.
- Ceremony venue, as well as religious and cultural considerations.
- Person officiating at the ceremony.
- Address and telephone number of the ceremony venue.
- Permission for photos during service.
- Mass or special activity (approximate extra time).
- Address, telephone number and contact of reception venue.
- Time of sitting down for the meal.
- Best man's name.
- Bridesmaids, pageboys and flower girls – names and ages.
- Dress code for the day – dinner suit, morning suit, tails or other.
- Car(s) on the day – company details.
- Video on the day – company details.
- Couple's address after wedding.
- Photography – likes and dislikes.
- Budget.

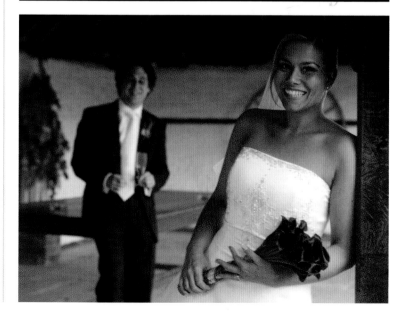

Pre-wedding shots

Almost everybody hates being photographed, so to help build up the confidence of all my customers I offer them a pre-wedding shoot, either in the studio or on location. This session does several things: it boosts their confidence in how photogenic they can be when photographed properly, as well as boosting their confidence in you as the photographer. The pre-wedding shoot will also get them used to your style of shooting, as well as the amount of direction you give them and help to strike up a rapport between you.

The pre-wedding shoot is also a great exercise to see how the couple interact. Some couples are very tactile and some are not, and this is the time to find out which they are. This will help you plan the wedding selection and understand their likes and dislikes.

LOCATION IDEAS

When you have not shot at the location before – provided it is not too far away – it is a good idea to have the trial shoot at the wedding venue. Alternatively, a park can be a relaxed and versatile location, particularly if you don't have a studio. While a couple will often feel at their most vulnerable in a studio, at least you won't be subject to the wind and rain, and there will be less external interference.

Right *Taking a range of different photographs will help you to gauge how a couple interact, and will help both parties used to working together.*

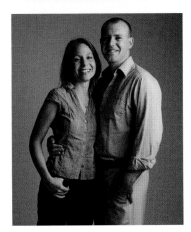

A month before the wedding

A month before the wedding day I like to meet up with the couple to finally plan the day's photography in detail. By this time most of the guests should have responded, even those who can't make the day, so planning people shots is possible. Prior to setting up this meeting I would ask the bride to bring with her some 'tear outs' from magazines – around half a dozen or more photographs she loves, as well as some photographs she hates – this allows me to get an idea of her preferred styles.

FINALIZING THE DETAILS

Make sure you have all the booking details to hand so you can clarify when and where the wedding is taking place. You would be amazed just how many weddings fluctuate slightly in time and sometimes date, and the couple may forget to tell you, so check again.

Discuss what mixture of styles your photography should take. If, for example, a couple want more relaxed and informal shots, then you don't want to waste too much time on formal images, though for most weddings it is worth including a little of everything. Also discuss the ratio of colour photography to black & white; even though with digital you can make simple changes, it helps when shooting to know what the final outcome is intended to be.

Finalize, in brief, what package or options the couple want. As the options will specify a set amount of time and variety of images. If the couple don't commit to a package then you don't know for how long you will be needed at the wedding.

Once you have covered the basics you should make a shooting list – on a wedding day, a list of planned photographs is essential. It is looked at continually throughout the day, to check for special groups of people as well as unusual events – such as surprise presents – and to keep a running check on the clock so you don't fall behind schedule. The main reason for writing a list with the couple, is to know how many small or large groups you will be shooting on the day, so you can allow enough time to gather and shoot them, as well as knowing exactly which friends or family should be involved. Make sure the couple have also asked the parents about special groups to avoid too many surprises on the day itself. Finally, it is important to know what time you are due to finish, so you can make plans for your night.

No matter how many times I shoot at the same wedding venues, I like to know about the service and what the couple have planned. This prevents me missing any unique readings, singers or musicians and so on, because I am in the wrong spot. I always check with the officiator of the service for their ideas about what I can and can't shoot.

Once you have discussed the day itself, you should also talk about proofing times. Proofs can be ready within a few days of the wedding, even quicker if need be, but most couples go away for a honeymoon, so get an idea of when they will be returning to ensure that the proof prints or proof DVD will be ready for them. This is the time to check whether they want to authorize anyone other than themselves to be able to pick up the proofs; it can cause problems if you do not give the couple the first view of their own images.

Finally, ask the couple for their final payment for the package they have chosen, so that when they return from honeymoon there are no delays in album orders because they have spent their photography budget while away!

Above *'Tear outs' from magazines are a simple way to understand what the couple likes and dislikes. Ask them to bring a selection of images from magazines when you discuss photographs the month before the wedding day.*

Leading up to the wedding

You should always check your information at least one week prior to the wedding. This will give you time to clarify any uncertainties and make sure that you are fully prepared for the big day.

One factor that needs careful attention before shooting a wedding is the cleanliness of the camera's sensor. Just how you approach this will depend upon your camera, and some DSLRs now have self-cleaning sensors that make this less of a problem.

There are many sensor cleaning kits available, but personally I use the Green Clean Sensor Cleaning System, as this can be used for cleaning all parts of a camera, not just the sensor. It is a contact-free cleaning system that works on a vacuum principle, allowing the user to gently remove dust, fluff and friction particles from the sensor and camera housing.

Using compressed air from a can, the 'Mini Vac' creates a vacuum and gently hovers dust off the sensor, mirror box, lens barrel and other areas of the camera and lens. If there is any kind of dust left on the sensor, the wet and dry sweepers included are used. The swab, which is pre-soaked with a cleansing fluid, is used to dissolve dirt, which is then lifted off by the 'wet sweeper' with its pre-treated textile, leaving a streak-free sensor surface.

THE DAY BEFORE THE WEDDING
- **Check information** – times and dates.
- **Check equipment** – make a list.
- **Charge batteries** – camera and flash.
- **Format memory cards** – double what you think you'll need.
- **Pack reflectors** – summer/winter.
- **Camera** – reset ISO/file format/white balance.
- **Light meter** – reset ISO.
- **Studio flash kit** – needed or not?
- **Tripod** – check over and ensure you have quick-release plate.
- **Wet cover** – camera cover and umbrellas.
- **Extras** – filters, batteries, wipes.

THE MORNING OF THE WEDDING
- **Take information** – including phone numbers.
- **Check equipment** – from list.
- **Take lunch** – it's a long day!
- **Drinks** – pack extra water for the couple, especially in summer.
- **Reception** – if en route, check it out.
- **Smell fresh** – take a small sample bottle of perfume or cologne.
- **Leave early** – arrive early, allow for traffic and distance.

Above The Green Clean Sensor Cleaning System allows you to suck small dust particles from the sensor, or, for more stubborn dust, to remove it with a wet-or-dry swab.

Posing basics

Knowing the basics of how to pose a man or a woman is a skill that every photographer should learn, especially wedding photographers. Knowing how to position limbs quickly and change body language will allow the natural curves of a body line to add impact to the overall photograph. The effects of posing are so great that the way in which you pose the body can even be used to slim the subject if it is done correctly. Thinking about these different poses should be one of the main aspects of your planning, as by this stage you should already know what the couple's photographic preferences are.

FULL-LENGTH POSE

Start every wedding pose as if it is a full-length portrait. This the pose will be good for a range of shots, from full-length to head-and-shoulders portraits. This is the first secret to posing subjects quickly and effectively. Traditionally the subjects are turned to a three-quarter position to the camera; by doing this the bulk of the torso will naturally be at an angle to the camera, making it appear slimmer. The pose also allows the couple to fit together better, as any gap between their bodies is eliminated. This same pose should be used when you are grouping subjects together.

FEET

Every pose starts at the position of the feet. Get it right and the subjects look natural; get it wrong and they will look uncomfortable due to the imbalance of the body. The back foot, which all the weight is placed on, should be turned almost at 90

degrees to the camera; the front foot, which is used as the balance or 'show' foot, is positioned to point towards the camera. By applying this technique the body is naturally turned to the three-quarter position.

Above *The classic stance with the back foot turned 90 degrees and with all the weight on this leg; the front foot is just used for balance.*

Above *This feminine stance is achieved by tilting the front foot slightly to the side, allowing the ankle to bend, which creates a graceful line.*

Above *This wide-open stance is, as you can tell, unflattering, and the resulting pose looks aggressive and heavy.*

HEAD

With the body posed in the three-quarter position, the head will naturally have to turn back a little to face the camera. Because the weight of the body is on the back foot, the pose will already look relaxed. To complete the pose allow the head to tilt slightly towards the

front shoulder. If the head is tilted to the front shoulder the chin will drop and the eyes will be given more impact; if you are not careful this can look almost aggressive.

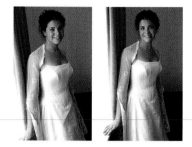

Above *With a directional light source like a window, if the head is not turned back correctly to camera the far side of the face will be in deep shadow.*

EYES

To get the best out of a subject's eyes it is best to have the camera position a little higher than their chest, as this will allow the eyes to look in a direction that will show a small amount of white under each pupil. When you ask the subject to look away from camera, you should control the direction of the gaze so as not to lose sight of the pupil of the eye, as, if this happens, it will appear very strange in the final photograph.

Above *When the subject is asked to look away from camera they will usually look too far away, which shows too much white in the eye. To correct this, ask them to look at a specific point to show more of the colour in the eye and make it look much more natural.*

HANDS

Badly posed hands can ruin a photograph, and you should pay particular attention to what they are doing. Hands can be used expressively to add drama to the pose or expression and character to certain portraits, but initially you should keep them simple. If in doubt hide them. Remember, the side of the hand is more elegant than the back.

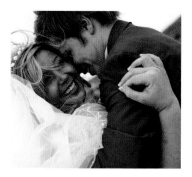

Above *A badly posed hand can easily dominate a photograph.*

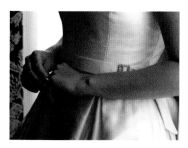

Above *The side of the hand is always more flattering and more feminine as it is less visible to camera. Above the waist the wrist should be slightly bent to enhance the gracefulness of the pose.*

The **BIG** Day

As a quick reminder to a relaxed pose, just think: 'If it bends – bend it.' this rule can be applied to a head position, the leg and knee, as well as the elbows and wrists.

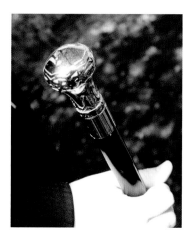

Above *A cane is a prop to a groom as much as a bouquet is to the bride, so don't forget the detail.*

CANE

A cane is an excellent prop for a groom, if he has one. You can always take it away from time to time to allow for more animation in the pose, especially when shooting the couple together. The basic full-length pose is holding the cane by the top knob with the bottom near to the front foot. The three-quarter pose is similar to that when holding a hat: with the hand upside down and the cane under the arm.

BOUQUET

Ensure that when the bride and the bridesmaids hold their bouquets they look natural, not forced. Subjects have a tendency to hold them higher than necessary, which can obscure the details on dresses.

Below *Try and keep the bouquets low to make them look natural.*

Above *This is a perfect example of a 'before and after' when I have asked the bride's mum to slightly raise her chin so her eyes are more visible to camera.*

HATS

Ladies' hats can often be positioned too low on the brow, which can result in them cropping an eye. To avoid this in a photograph, ask the subject to slightly raise their chin. If that does not work then lower the camera position slightly, but remember the face could be slightly in shadow so the use of a reflector or fill-in flash may be necessary.

If the men have top hats, there are only two basic positions: full-length and three-quarter length. In the full-length pose the hat is held in the outside hand with the fingers gripping the top brim and the arm allowed to drop straight. Any gloves should be held in the palm of the same hand and made visible by holding them on top of the brim. The three-quarter-length pose should be achieved by turning the hand upside down and positioning the hat near the waist with the fingers gripping the bottom brim, showing only the thumb.

Below *For the full-length pose the gentlemen grip the top brim of the hat. You can see how the image looks more finished when the cuffs are visible than when they are not.*

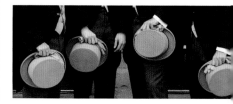

Lighting basics

To get a variety of images on a wedding day it is best to use any natural light available, whether it is sun through a window, the shade of the first tree in the wood or a spotlight in a reception room. The use of the ambient light will give a natural variety to your pictures because of the various different situations; however, the way in which the light illuminates the face is the most important aspect, especially when the subject is close-up and looking at the camera, as any flaws will be exaggerated if the lighting is unflattering.

There are three main things to consider when using natural light: the direction of light, the quantity of light and the quality of light. While you cannot always control everything, this should be part of your planning, so you should not be surprised when you arrive and you should be equipped for whatever the weather may throw at you.

DIRECTION OF LIGHT

The direction of light is determined by the position of the light source. The most flattering direction is a 45-degree angle in both height and direction, as this will give a highlight to the five planes of the face: the forehead, the two cheeks, the nose and the chin. This lighting pattern will give a natural three-dimensional feeling to the face in the final image. Also, due to the direction of the light, the shadow caused on the far side of the face will help the face look more slender and will naturally flatter the subject.

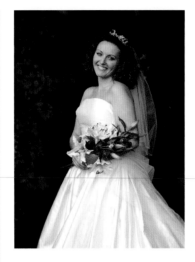

Above When the subject is at the edge of the first tree in the wood and the main source of light is coming from behind the camera, a flat lighting effect will result. This will make the subject look slightly heavier than he or she actually is.

Above The bride is in the same location, but now with her body turned away from the light source so that a natural shadow forms. The camera position has been moved under the tree canopy. The five planes of her face are now lit and a more flattering portrait can be taken.

The quantity of light is very important, and there can be both too much or too little light: too much light and the subjects will

Above With the bride in the same position as in the shot to the left, I have moved the camera under the canopy of the trees to shoot back towards her for this profile portrait.

look too bright with heavy shadows; too little light and the photographs will look dull with little or no contrast, so somewhere in between is generally better. The quantity of light will also have a direct result on aperture, shutter speed and ISO, so you should bear in mind the effect that this will have on the creative side of your photography.

The quality of light is frequently confused with the quantity, but even on very sunny days or in dark locations the quality of the light can be either good or bad. The quality of the light is more to do with the sharpness of the light, as the harsher the light source, the sharper the definition between highlight and shadow. This can be demonstrated near a window. If the subject walks slowly towards you from the deep shadow, they will initially be hardly illuminated at all, with a very soft contrast. As they move slightly into the light from the

window, a sharpness will appear in both highlight and shadow, giving a good quality to the light. This is very similar to positioning a subject under the first tree in the wood – when the subject is positioned under the canopy of the first tree the harshness of the overhead sunlight is taken away, but when the subject moves further under the trees the light starts to lack in contrast, and take on a green hue due to the foliage.

STRONG SUNLIGHT

Strong sunlight can be used very creatively at the beginning and at the end of the day, when the sun's low position allows the subject's face to be lit from the side. When the sun is high in the middle of the day, its position directly above the subject causes a darkening of the eye sockets, giving the effect of 'panda eyes' with large, unflattering dark shadows. The light can of course be interrupted or redirected to soften the harsh shadows – this can be done either with a reflector or with a diffusion screen. A high light source like the midday sun is the most common problem at a wedding, due to the time of day many of them take place. A simple solution is to turn the subjects' backs to the sun, but if the sun is very high it is essential to choose a location that will lessen the sunlight from above, such as under a tree or an awning. If this isn't possible, then flash has to be used to fill in some of the shadows on the face and add some brightness, especially to the eyes. On very sunny days when the sun is directly overhead, use flash to bring out detail in the subjects' faces. This is essential if ladies' faces are in very dark shadow because they are wearing hats.

Above I love to use strong sunlight in a portrait. To get away with the ugly shadows cast on the face I get the subjects to look away from camera so I can add drama with the higher contrast.

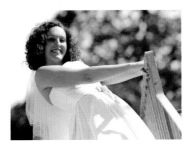

Above If the subject looks towards the camera in strong sunlight, strong shadows make it difficult to retain both highlight and shadow detail.

COLOUR OF LIGHT

At certain times of day or year a colour can be seen in the light source. With cool light sources, when the light has a blue cast, you can see a cold effect in the final portrait, while yellower light will create a warmer, arguably more attractive cast. Other factors can affect this; as mentioned, the light will appear green if you are too far in under foliage, as the natural light hitting the couple is first being coloured by the leaves. Artificial light can be used creatively, especially inside a venue, where just using the room lighting can add to the mood of the photograph. You can even change the colour of light by directing it off a highly coloured surface like a painted wall; the light will then take on the characteristics of the painted surface.

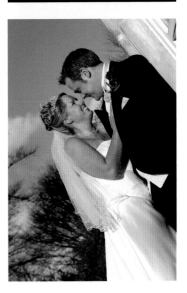

Above In winter the colour of direct sunlight on the subjects will be an exaggerated yellow, compared to in the shade, where the subjects would be in a cold blue light.

Window lighting

If you master the use of window light you will be able to produce professional-looking images every time. A window acts as a large light source that can be used just like a studio flash with a large softbox attached. The window will allow for some control of the light direction, by moving either the subject's position or that of the camera. By doing one or both of these things some control can be applied to the contrast of the light as well as the quantity and quality of light.

When shooting inside a client's home or at a reception I always try and use the largest possible window for portraits and informal shots, as the bigger the window the bigger the light source. Depending on the size of the window, you can take not only head-and-shoulder shots but also full-length portraits and

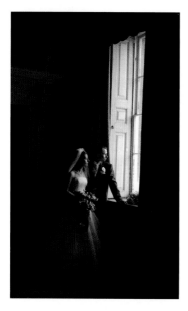

Above Large windows can act like a natural softbox on location, and also offer a natural vignette to the image, helping to draw the eye to the subjects' faces.

Above A portrait lit by natural light through a window has a unique and timeless quality, especially when the window is used to frame the subject.

even small groups. Where possible I try to find a large window with a simple background.

Try to apply a 45-degree lighting pattern to the subjects' faces where possible, but when trying to light more than four people with a small window a reflector or even a flash might have to be used as well. This will depend on the depth of the shadows on the subjects. To obtain this lighting pattern, the camera should be very close to the wall with the window in, and the subject or subjects should be positioned so that the light from the window strikes them at 45 degrees. If the subject is close to the light source, turn their shoulders away from the window to avoid any loss of highlight detail, particularly on the

bust of the bride's dress. This pose should not only be attractively lit, but also look naturally feminine.

The height of the sun coming through a window has to be taken into account, even when it is softened by cloud, as the angle at which the light falls through a window will make a dramatic difference to the end result. Often, just standing the bride next to the soft light coming through the window is not enough, as the angle of sunlight may bring exaggerated attention to the lower portion of the body – although this is typically disguised by the bouquet of flowers. When this is done, the flowers can often be overexposed if the meter reading is taken from the face of the main subject. It can be even worse if you are shooting a young bridesmaid next to the bride, as the angle of light can cause a loss of detail in the face of the child.

To take an exposure by a window with a hand-held meter, remember to hold the meter near the subject's face and point the meter toward the window. This will expose for the highlights, which is essential in digital

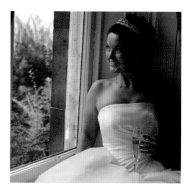

Above Because of the angle and the direction of the light coming through windows, the majority of images are best lit if the subject is seated.

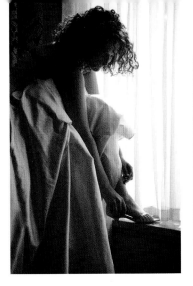

Above Where possible, try and get the subject near to the light source to make the best use of the natural light.

photography as any overexposure will result in burnt-out highlights leaving no or little detail in the dress.

Most of the time, the best pictures are achieved by sitting the bride down next to the window so that the angle of light will bring her face into the brightest point of light in the picture, instantly allowing the rest of the portrait to fall into a slight shadow area.

Fill-in flash is best added to subjects, such as a small group, that are turned away from the window and therefore looking into a darkened room. Unless another large window is available to put light back into their faces, they will be in shadow. If you try and take an image by just adjusting the exposure for the now darkened faces, the image will, at best, be flat; at worst, it will have a large amount of flare coming in from the window as well, as you are overexposing the background. Using fill-in flash will help to balance this.

On a sunny day you can use the strong sunlight coming through a window to create more dynamic results. This could be to add drama

with the spotlighting effects, or, with the high sun coming through a large window, dramatic shadows can be cast on the floor. If the sun is low, the shadow of the window can at times be seen on the opposite wall; this is another great spotlighting effect in which you can stand the couple. A simple dramatic image can also be achieved by split-lighting the groom – putting just half of his face in sunlight. It is best to place him either right next to the window, looking along the line of the wall toward camera, or just away from the light source, using a reflector to redirect the light. If the sun is high, the subject will need to be seated slightly lower than the window sill, to get a better quality of light on the face. Look for large, frosted windows which will give very diffused lighting, or you can use a large diffusion panel on sunny days to cut down the harshness of the light.

With younger brides you can turn them away from the window to soften the light on the face; however, if photographing an older woman or a mixed group that includes a mother or grandmother, then turning her face towards the window light will flatter the skin.

Below Finding one window that is frosted is great; finding a whole corridor of frosted light is unbelievable. This location that I use in a modern hotel's reception corridor can be used no matter what the weather conditions are, as it diffuses the light source and gives a great quality to the light.

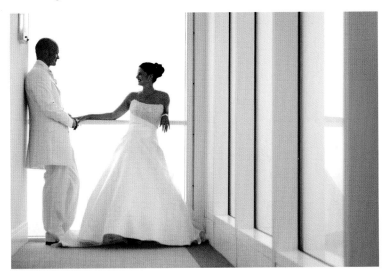

Key skills – complete shooting list

These next four pages show what I think are the 48 shot types needed to
cover the photographic basics of a wedding day. They are the foundation
on which to build your wedding photography. Use the variety of ideas and
lighting techniques in this book to expand on these basic ideas.

Left Dress details.

Centre Flower details.

Right Shoes and jewellery.

Left Bride getting ready.

Centre Bridal full-length
portrait.

Right Bridal three-quarter-
length portrait.

Left Bridal head-and-
shoulders portrait.

Centre Bride with
bridesmaids.

Right Bride, bridesmaids
and parents.

Left Bride with parents.

Centre Individual parents
with bride.

Right Reportage details.

Left *Groom arriving.*

Centre *Groom three-quarter-length portrait.*

Right *Location details.*

Left *Groom with best man.*

Centre *Groom, best man and groomsmen.*

Right *Groom with parents.*

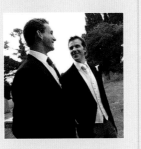 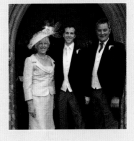

Left *Groom with special family members.*

Centre *Guests arriving.*

Right *Bridesmaids arriving.*

 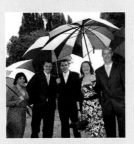 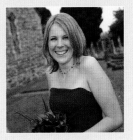

Left *Bridesmaids with bride's mother.*

Centre *Bride with father in car.*

Right *Bride arriving at ceremony.*

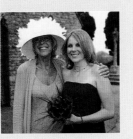 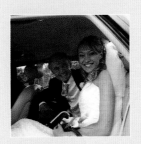 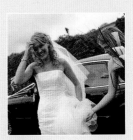

Key shots – complete shooting list (cont.)

Left Bridal party.

Centre Ceremony.

Right Signing the register.

Left Walking back down the aisle.

Centre Bride and groom full-length portrait in doorway.

Right Bride and groom – three-quarter-length portrait in doorway.

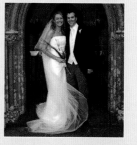
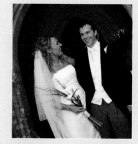

Left Bride and groom kissing in doorway.

Centre Bride, groom and parents.

Right Bride, groom, parents, bridesmaids and best man.

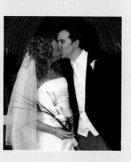
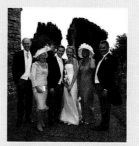
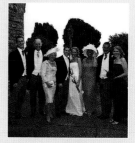

Left Bride, groom, groomsmen and best man.

Centre Bride, groom and special family members.

Right Confetti throwing.

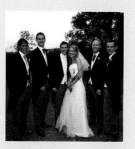
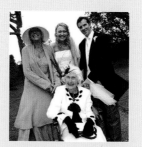
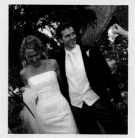

Left Bride and groom with car.

Centre Bride and groom full-length portrait.

Right Bride and groom three-quarter-length portrait.

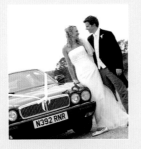

Left Bride and groom head-and-shoulders portrait.

Centre Bridal full-length portrait.

Right Bridal three-quarter-length portrait.

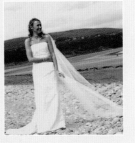
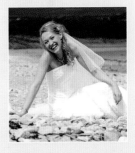

Left Bride and groom creative shots.

Centre Family groups.

Right Back of bride's dress.

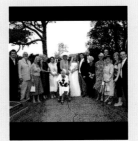
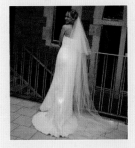

Left Special friends.

Centre Reception room.

Right Cake cutting.

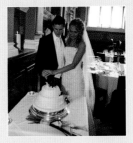

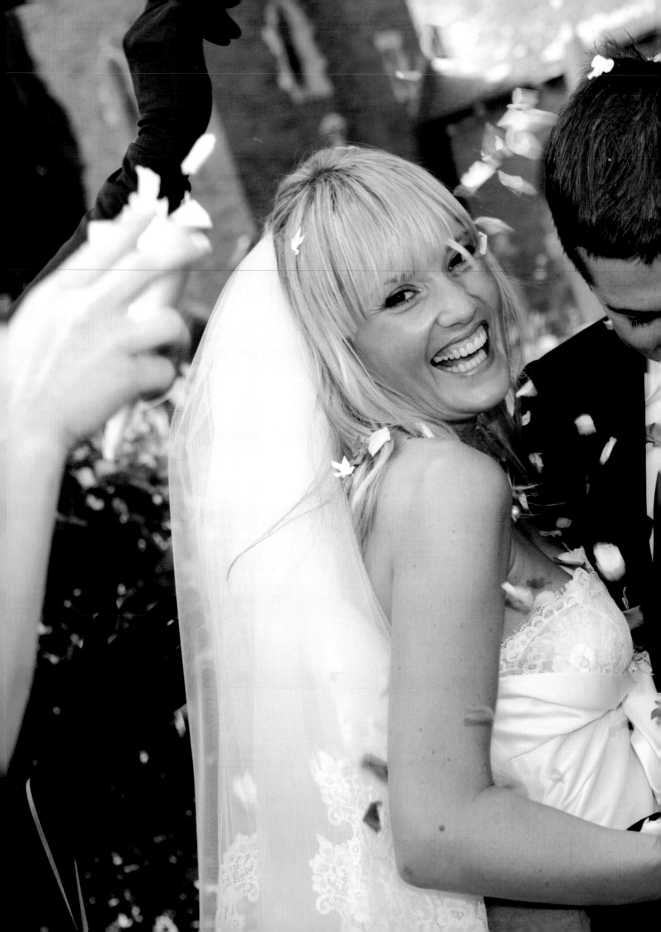

part two

**This part is dedicated to the wedding day itself, using examples
from different weddings, so we can see how the event develops
for different couples on the big day. Remember, each wedding
is different, and while the structure of images taken may be
similar from one wedding to the next, the overall shoot will
differ because of the different locations, ceremonies, receptions
and, of course, the couples themselves.**

Using these different wedding days as a basis I have divided the process
into time slots based around the ceremony. The times mentioned
throughout will be a good guide to give you an idea of how the day
develops, and will help you to understand the importance of time
management. We start at the bride's house and finish at the end of the
wedding day; obviously every wedding is different, but this should give
you a useful overview.

This chapter covers the part of the wedding day that falls before the
ceremony. Typically, this will involve shooting at the bride's house or a
hotel – wherever she is getting ready – then leaving ahead of the bride
in order to arrive in plenty of time to capture the run-up to the
ceremony at the location.

Details

The first things that I like to shoot as soon as I arrive at the bride's home, or wherever the bride and the bridesmaids are getting ready, are the details. This is usually around an hour and a half before the ceremony is scheduled to begin, and you should be able to dedicate around a quarter of an hour to capturing these little snapshots of the preparations, which are a great start to any album.

I usually ask one of the bridesmaids, or even the bride herself, to show me to where the dresses are hanging. This is so I can start off with the items that are going to be needed first. By shooting the dress first I can make sure that nobody is waiting for me to be finished with it. There are times when I arrive and the bride is already dressed, which is a pity because the dress hanging by itself is a great start to the album. If possible, include the bride or a bridesmaid in the first preparation shots.

ACCESSORIES

These are the next on the list to shoot. Again, asking the bride to get you all the little details of the day can create a bond that will carry on through the rest of the day. Use window light to light the items. If the room is dark, or it is a very late wedding, try using a table lamp with or without fill-in flash, depending on the colours you would like to end up with. If you are shooting RAW files you will be able to correct the colour balance later in post-production.

Top When shooting the shoes, try and look for a variety of shots and creative patterns.

Left When photographing the dress, try and find some natural light to bring out the detail gently.

Below The back of the dress can have as much detail as the front, so don't forget it.

CARDS AND GIFTS

Be on the look-out for any cards, especially any from the bride's parents, or even a 'thank you' card from the bride to her parents. It's a great excuse to be nosy, but it is also essential if you are going to capture the story of the day. Another tip is to be prepared in case any gifts are being given to the bridesmaids and parents, as this can be a time for naturally animated images.

FLOWERS

The flowers are often kept in a cool place like a garage or porch and are usually stored in water, so when you ask for them make sure you have something to dry the stems with, like a paper towel. Again I shoot the detail of the flowers as well as the bouquet itself, as there are often gems or attractive ribbons decorating the stems of the bouquet; at times some are even hidden in the flowers themselves.

The **BIG** Day

People will naturally be thinking of the leaving time rather than the time when you need them to be ready by. If it looks as though everyone is running a little late, remind them that you need them ready about half an hour before they leave, so that you can start the formal portraits. If the bride's brothers are present, but will be leaving before the formal shots, make sure you capture some informal images of them with their sister.

Above Bouquets can be made even more interesting when the framing is cropped in close.

Top right Photographing flowers as a group can be difficult. Look out for vases to pop them in, and never be afraid of using additional colour even when you are photographing very colourful flora.

Bottom right 'Colour touch' is a popular way to bring attention to one object, and can be achieved quickly in post-production (see page 154).

Far right Champagne glasses can be made interesting if shot against the light and cropped closely.

Getting ready

A quarter of an hour before you need the bride dressed to start her portraits – about an hour and fifteen minutes before the ceremony – ask one of the bridesmaids to tell you when the dress is being buttoned up. This should take about ten minutes. If the make-up and the hair are still being fiddled with, this is a perfect time to get some reportage shots. Don't worry if the room is a mess, just turn the image to black & white to hide most clutter – but watch out so that you don't include more personal items like underwear in the frame.

GETTING DRESSED

The buttoning up of the dress is a good shot to include, as it often involves the bride's mother or the chief bridesmaid; I like to include close-up shots of the fingers doing up the dress as well as a wider shot of the event. Where possible, try to position the bride and helper near a window to make use of the natural light. If possible leave enough room to shoot from next to the window as well as towards the window, this will give you a large variety of shots from a silhouette when shooting directly towards the window, to beautifully lit images when shooting from near the window.

While the bride and bridesmaids are off in their room getting fully dressed, you will usually find the father of the bride or a brother getting the champagne and glasses ready to pop the cork. This is a good event to capture, and a detail shot of the bottle along with the glasses being filled is often chosen for albums.

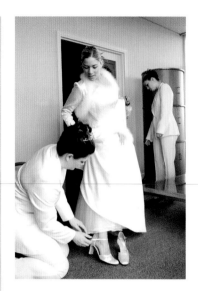

Above *Using a wideangle lens with a low viewpoint will instantly add an element of interest to 'getting ready' shots.*

Above right *Watch out for unexpected little moments occurring, such as when this bride popped her own champagne cork.*

Right *Colour seems to be playing a much bigger part in wedding albums today, and capturing little details as you go along is a great way of emphasizing this in the final collection.*

Above *Because the window is behind the bride I have had to use fill-in flash, especially as the subject is looking directly at the camera. This adds to the reportage style of the shot. .*

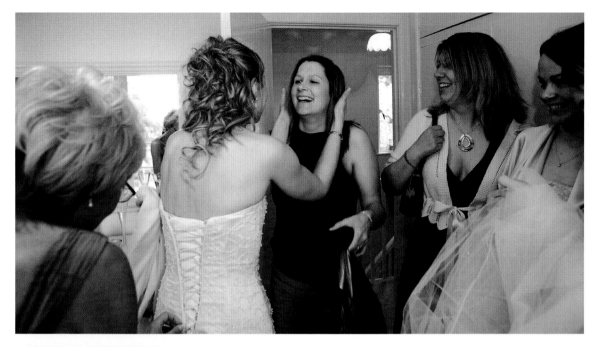

The BIG Day

Don't leave shooting any details to the last minute, in case you start running short of time. If the bridesmaids are ready first, photograph them as soon as possible; the last 15 minutes before you leave will fly by.

Usually an older bridesmaid or the bride's mother is ready first, so suggest that they help put the father's buttonhole onto his jacket. Again it's another little detail for the album, and one that often sparks off some reaction between the subjects.

Top I try and shoot against the window light to cause some natural softening in the image.

Far right I try and shoot against the window light to cause some natural softening in the image.

VISITORS

If friends arrive, try to get more reportage-style shots, especially if the bride is not ready. You should have a list of special people who are expected at the house, which was made at the final meeting a month before the day, just in case a friend or a grandparent, for example, can't come to the ceremony, but is able to visit before.

Below Try and use any mirrors in the room to add extra depth to an image.

Above The bride's mother placing the buttonhole on her husband is a nice moment to capture.

Bridesmaids' portraits

An hour and five minutes before the ceremony you should start the bridesmaids' portraits, which will take about five minutes. The last-minute panic is the best time for reportage shots – the last few moments before you need the bridal party to be ready are always the most frantic. Don't be afraid to take control at this point; if the bridesmaids are ready, just get straight on with their formal portraits to save time later on.

Make sure to capture any candid moments still going on – especially if young children are involved, as they can create some funny scenes. No matter what age a bridesmaid is give them as much privacy as you would expect; so, if little ones are being dressed, you should be discreet, embarrassing images don't sell anyway. With young children it is better to look for the fun and mischievous images as these help to bring a wedding album to life.

I try and get all the individual portraits of the bridesmaids shot at the home, especially for very young ones as they often fall asleep

Above When choosing a location with very strong sunlight, generally try to avoid the sunlight hitting the face directly.

in the car on the way to the ceremony. They also tend to be the first to start taking off accessories, such as tiaras and clothing, as they get tired. My first choice for shooting the individual portraits is window light, using a large window, preferably either with a ledge or full to the floor. A window ledge is a natural prop to sit or lean the subjects against; however, if the sun is streaming through you will need to position the subject at the edge of the light so as not to cause too much contrast in the portrait and burn out any detail. I always try and get a head-and-shoulders portrait as well as a full-length one, paying attention to details like the hair and dress in case anything has slipped since being dressed. It is a good idea to get a parent or older bridesmaid to adjust anything, so the child does not get upset by you as a stranger.

Once all the bridesmaids have been photographed individually, if the bride is still not ready it is usually a good idea to take a group shot of all the bridesmaids together, again using the same window light where possible. A reflector can be used to soften any dark shadows on the subjects furthest from the light source. Follow the classical pose with all of the group turned in towards each other, and stagger the heights to form a pyramid-like shape, with the tallest subject in the middle. This will give a cohesive structure to the group and make the image look professional.

Once all of the posed pictures have been shot it is a good idea to try and get some life back into the images with some posed candid shots or more animated portraits. By this I mean getting some interaction between bridesmaids.

If the garden is dry, perhaps some shots running away from the camera and then running towards the camera can be tried. Spinning shots are good fun, but these can result in falls, so be careful not to get the dresses dirty. The series of images to the right is a perfect example of the variety that I try and obtain in a short space of time.

Above Try to strike up a good a rapport with young bridesmaids, as it is a long day and you may demand a lot from them.

Above I positioned a chair near to the window for this bridesmaid's portraits, starting initially with a simple portrait with her standing up and then coaxing her to sit for the second shot.

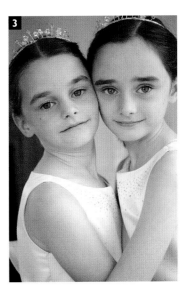

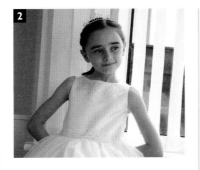

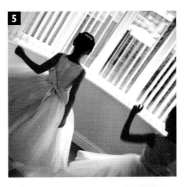

This page *I always start with the posed portraits, first full-length (1) then three-quarter-length (2), followed by portraits of the two bridesmaids looking at camera (3) and with interaction (4). To finish off the series I had these girls spinning around allowing them to blur with motion (5), and finally I shot in reportage mode just to capture the atmosphere rather than specific expressions (6).*

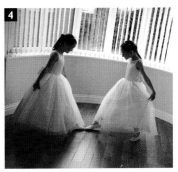

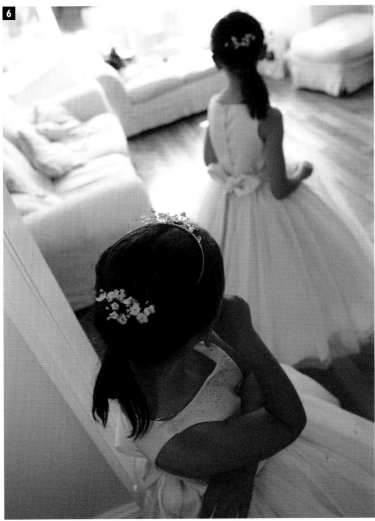

The **BIG** Day

If some of the bridesmaids are sisters then you should photograph them alongside each other as well as each on their own.

Key skills – bridal portraits

If you have prompted the bridal party enough, you should be on time. About an hour before the ceremony, once the bride is ready, one of the first photographs to take if you are not photographing in a bedroom is the 'coming down the stairs' shot.

The next five minutes are perhaps the most important to use efficiently, so you can get both formal and informal shots of the bride in the minimum time. First, decide where you are going to shoot the portraits – probably near the same window you shot the bridesmaids at, if it offers the best light and background.

1 For the shot on the stairs it is not necessary to stop the bride as she descends – it is not very easy to walk in a wedding dress at the best of times, never mind coming down a flight of stairs dragging a train of material behind you. Before the bride comes down the stairs, make sure of your exposure, which will usually be based on a combination of natural light from a window and the hallway lighting, along with a burst of flash in order to get the correct exposure. Check your image on the camera screen to make sure the flash has had enough power to reach up the stairs. If you are happy that your exposure is correct, you can then be ready for when the bride descends. I always try and get two or three shots and then choose the best. I sometimes use long exposures combined with flash to freeze the subject, but allow for some natural motion blur. When using long exposures it is best to take the shot between steps so the body is not moving.

2 Once the bride has reached the bottom of the stairs, if this is the first time her father has seen her in the dress it will be an emotional time for both of them, so be ready for some candid shots. However, you shouldn't let this drag on as you have a lot to shoot in the short time before leaving. I usually lead the bride into the main room and then over to the

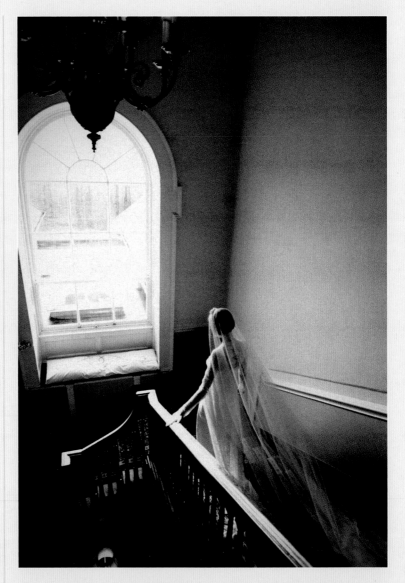

Above In manor houses where the windows are very large, the classic shot of the bride walking down the stairs trailing her veil behind is an image never to be missed.

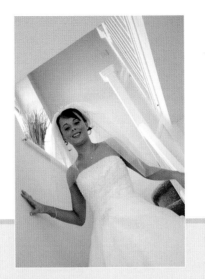

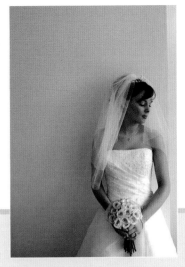

window so I can once again make use of the naturally soft window light. Once the bride has been put into the classical full-length pose, body turned away from the window and all the weight on the back foot, you can then billow the dress to complete the set-up, with perhaps a final adjustment to a long veil. To billow the bride's dress, take hold of the base of the train with open arms, then lift the dress swiftly a short way and allow it to fall naturally to the floor. When this is done correctly a pocket of air will be trapped under the dress to create a smoother shape. If you waste too much time after this procedure the dress will go limp again, so speed is of the essence. Remember to check the veil after each adjustment to the bride's pose, as a messy veil will spoil the picture.

3 A quick sequence of images can now be taken: the full-length portrait to make use of the billowed dress, looking first at the camera, then at the bouquet and finally out of the window. You should remember to pay attention to the whites of the eyes when the bride is looking away. The three-quarter-length and the head-and-shoulder portraits can then be taken in quick succession

following same sequence of looking at the camera, looking towards the bouquet and looking away from the camera. In a matter of minutes you will have finished all of the formal portraits of the bride.

4 The next series of images of the bride are usually seated. Again near the window, the bride is posed on the edge of a chair or couch. The pose is completed by having the body turned slightly away from the window to maintain detail on the dress around the bust; the hands can then be positioned so one holds the bouquet and the other is used to take the dress or veil to help the hand position. In a similar way to the classical standing pose, all of the weight should be on one side of the bottom, usually the far side. This pose will allow the head to either be turned towards the camera or turned away. Again, a short series of images can now be taken, starting with the full-length portrait and finishing with the close-ups. Using a reflector positioned just out of shot on the floor, can help to add a touch of exaggerated reflected light to the face, which is already lit from the window; this can add impact to the final image.

Above far left If there is a large window on the landing, try to choose a higher viewpoint to shoot down to the bride to make better use of the window light.

Above middle With the camera at the base of the stairs looking up to the bride, it is nearly always essential to add some flash to freeze the subject.

Above This classic bridal portrait would be followed by shots looking to the window and then looking down at the flowers.

Below With the bride at the foot of the stairs, I was able to use the natural light of a window far away by turning the bride's head towards the light.

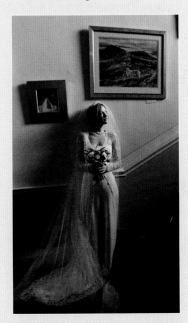

Bride with bridesmaids

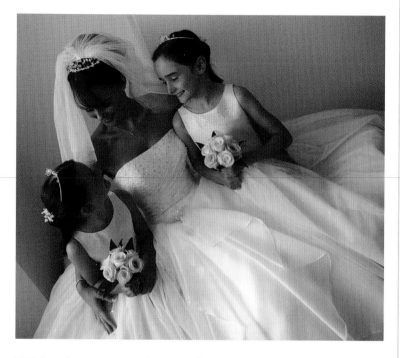

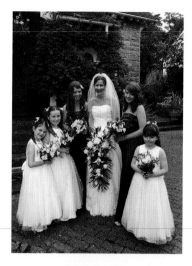

Still keeping an eye on the clock, you should have about 55 minutes left before the ceremony, and now you can spend five minutes shooting the bride and the bridesmaids. If the bride is still sitting on the couch then it is best to continue with the bride and bridesmaid portraits from there; if she is standing, then start the selection like that. A variety of images can be achieved by simply following the same sequence: looking at camera, then chatting to each other and finally looking away toward the window.

If you have posed the bride correctly in the bridal portraits, whether she is standing or sitting, the bridesmaids can be arranged around her for a good basic composition. Again, the triangle is a good foundation to build groups upon and the natural light is usually

Above Getting the bride and bridesmaids to interact with each other does not only look good, but it is also a safety net in case someone blinks.

perfect for lighting a small group. The bridesmaids' and the bride's bodies should be turned in towards the centre of the group, which is usually the bride herself. This makes everyone in the group look a little slimmer and hence makes for a more flattering portrait.

With the group arranged so that the bride gets the best lighting from the window, the sequence of shots can now commence. Because of the number of people in the image it is best to take at least two or three shots of every pose when the subjects are looking directly at the camera, in case anyone blinks. By taking a number of similar shots you give yourself the option of cloning eyes across from one picture to correct another image. The 'looking

Top The full-length portrait of the bride and her bridesmaids is an essential image. Remember to try and keep the bouquets lowered young bridesmaids often seem to want to hold them too high.

Middle I usually don't take the bride and her bridesmaids outside for portraits until after she is married, to ensure that she keeps her dress in perfect condition.

Above Be aware of any particularly special relationships between the bride and any of her bridesmaids.

at camera' shot can be followed by a shot of them looking at each other and then towards the light source. This technique will get you out of trouble if the subjects are blinking, as this can be hidden when looking at each other or looking away.

USING FLASH

Depending on how good or bad the light is, you may need to add flash to the portraits, especially if the group is turned into the room with their backs to the window, instead of towards the light source. When using flash, decide whether it will light the image independently – not relying on the room's ambient lighting to illuminate the group in any way – or whether it is to be used in combination with the room lighting and any natural light from a window to help lift the shadow areas in the picture. When using flash to light a group indoors, remember it is best not to use a burst of flash aimed directly at the subjects, as this will create harsher tones on the faces as well as distracting, well-defined shadows

behind them. Instead, soften the flash by either bouncing the burst off the ceiling, if it is not too high, or by bouncing it off a keylite card, if your flash unit has one built in.

Above right, right and below When working with the bride and bridesmaids, the easy option for grouping them is to sit them down. I usually place the bride in the middle of the group, but in this case I put her with the youngest bridesmaid. These shots show the natural progression from full-length portrait to three-quarters and then to the informal chatting shot.

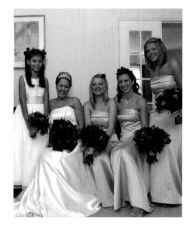

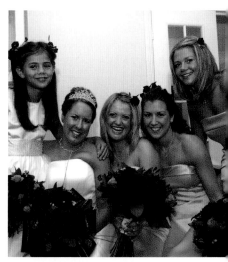

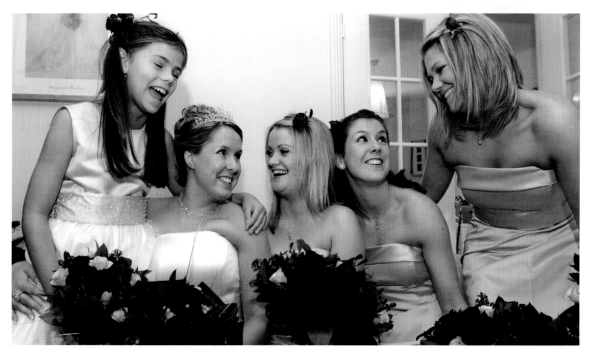

Bride and family

With about 50 minutes left before the ceremony, your attention should turn to the bride and her family. The formal photographs of the bride and her parents are a necessity at most weddings; if not for the bride, then the parents, as they will usually request the shots to be taken. Often the parents will request a formal image while the bride may have asked for a more relaxed and informal style, so you will have to cover both. Follow the same sequence of looking to camera, looking at each other and looking towards the light.

BRIDE AND FATHER

The bride is usually positioned on her father's right arm for the formal portraits. This will also be the arm that she traditionally takes to walk down the aisle. Just remember the father's buttonhole is away from the bride. Once the bride is in her

Below Normally the bride is positioned on the right arm of her father, but in this case, she is on the left.

traditional stance – three-quarter pose to camera with the weight on the back foot – a quick full-length and three-quarter-length portrait looking at camera can be followed by shots of them chatting to each other. One way to get a relaxed image is to ask the bride to adjust her father's flower, then, as she goes to correct it, tell them you were, joking and a response will follow.

BRIDE AND PARENTS

Add the mother to the shot, next to the bride, so the bride is now in the middle. This pose is perfect even if the parents are divorced or separated, as they can both be near to the bride without having to be too close to each other. Be careful when posing the mother next to the bride, especially if she happens to be wearing a large hat – it could catch the veil or get in the way of the bride's face. If this is the case, just get the mother to lean away a little at the waist. Where possible allow the mother's face to catch more light, as this will help soften age lines. They can be hidden by placing a reflector between the camera and the subjects.

Below Keeping the bride's arm between her and her mother creates a useful separation if they are wearing similar tones.

BRIDE AND FAMILY

If there are brothers and sisters of the bride still at the home, then, while the mother, father and bride are posed together, add them evenly to each side to balance the group out. Sometimes this shot can't be done as the bride's brothers are also groomsmen; but still capture the family group with those siblings who are present, and make a note on your list to get the completed group picture at the reception.

The **BIG** Day

Use your prepared list for the groups, as this will allow you to flow from one group to another, adding and subtracting people as necessary. Make sure that you are aware of any special circumstances, especially if parents are divorced and remarried, as this will complicate the groupings a little, but if you are aware of the situation it can be resolved with separate shots right from the start. The father is usually the first to be dressed, so he will already have been featured opening the champagne and making himself busy, perhaps by checking his speech and so on. He will be aware of what time you are planning to leave for the ceremony, so use him, if necessary, to get everyone moving a little quicker.

BRIDE, PARENTS AND BRIDESMAIDS

Now remove any brothers and sisters, unless they are part of the bridal party, and add the bridesmaids evenly around the bride and her parents to almost complete the formals.

BRIDE AND MOTHER

If you haven't already photographed the bride and her mother by themselves, then this is the time. Turn mother and daughter towards each other, which will of course naturally slim the torso in this classical pose, then follow through with a full-length, three-quarter and close-up series of images looking at camera as well as some informal shots of them chatting to each other. When photographing the mother using window light, a reflector is often essential, as the brim of her hat can obstruct light falling onto her face, darkening the eyes. The reflector is used to bounce soft light back up under the hat to illuminate the face.

Right Once again, after each formal image I follow it up with an interactive or informal image, which breaks up the style of images in the album.

Left Work quickly with young bridesmaids so that they do not become bored.

Right Try to get an overall shot of the bridal party, in case the bride is delayed later.

Above If the brothers are still at home, get some formal shots of the whole family.

Below The bride and mother shot should generally be the last you take before leaving.

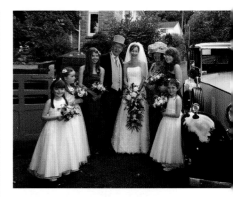

The **BIG** Day

Three quarters of an hour should give you the time to get to the ceremony to capture the groom and groomsmen arriving. Don't wait on at the house unless the bride insists, or the venue is less than 15 minutes away. If the bride is still not ready by this time you will only make her later, so unless the formal pictures at the house are imperative it is usually a good idea to suggest you get to the ceremony to at least capture some photographs. When you leave, double-check you have everything with you. It's easy to forget when you are under pressure.

CAMERA TIPS

ISO

Use a higher ISO or slower shutter speed to get apertures of around f/4–f/8 when shooting inside. This should give you sufficient depth of field for portraiture.

The first arrivals

Try to arrive at the ceremony with at least half an hour to spare before the scheduled start. If you have just come from the bride's home and you are running a little late, don't panic, take a deep breath and check your camera kit first to avoid any errors. If you have followed your schedule you should be arriving with enough time to shoot to the following plan. If you have been delayed by traffic or because the bridal party were not dressed you will only have a small window of time in which to shoot, so any detail shots can be left until after the formal shots of the groom, groomsmen and parents have been taken.

As I arrive at the church I normally shoot a 'walk-through' series of images, little details including the location, any signs that reference the venue, such as a church

noticeboard or even the road name. Special flowers and interiors are also a nice touch. The venues are often decorated with flowers, so make a special effort to shoot these as they have probably cost the couple quite a lot of money and taken a lot of time to arrange. Stained-glass windows always add a splash of colour to the photographs and allow for interesting design elements to be applied to the album. Be careful to remember these details, because they are often overlooked in favour of the bigger picture of the day – don't forget to record them so the couple can remember the whole event at their leisure.

Informal photographs of the guests arriving tell a tale by themselves. Don't be put off by wind or rain, as even umbrellas themselves can make a colourful feature on the day, as well as guests chasing their hats as they fly away in the wind! It is unusual to be asked to photograph all the guests as they arrive, but if this is the case I will employ an assistant or another photographer to shoot these so that I am not distracted from the task at hand. Don't try and do too much – I always believe it is better to do one job well than two badly.

If you plan to shoot a themed series of shots during the day, such as hats or shoes, buttonholes or even colours, the guests' arrival is a great time to start to observe and decide on what to shoot. Finally, keep an eye out for funny moments, especially those involving young children.

Above If the couple have made a feature of the doorway, remember to record the detail.

Far left Church interiors can be very dark. Decide whether you are exposing for the stained-glass window or the flowers on the pews; very rarely are you able to expose both correctly in the one shot.

The **BIG** Day

Go and say hello to the officiator. Remember to act professionally when you ask about their running order and rules during the service, especially the use of flash. Ask where the marriage certificate will be signed, as this can take place in a side room or near the altar; it's good to know when and where.

CAMERA COVER

Have a dry cover for your camera on wet days. Also, keep a spare camera out of the rain in case a disaster should happen with the main camera.

Left I like to shoot abstracts of the church; a clock is great as it will also set the time of day.

Right Stained-glass windows can be spectacular, especially when lit by strong sunlight.

Below Even if it is raining some colour can be brought to the scene by shooting some of the guests and their umbrellas.

Groom and groomsmen

The groom and his groomsmen usually arrive about half an hour before the ceremony, so if you are on time you should be able to shoot their arrival. They can be a little later, especially if there is a pub close by! If this is the case try to get some shots in the pub or as they leave, for a little humour to start with.

REPORTAGE

A series of reportage-style shots is usually a good place to start with the groom and groomsmen. Shoot them chatting naturally as they walk towards the church or venue. If there is little conversation between them, perhaps due to nerves or being camera-shy, I usually instruct the group a little, asking them to just chat to each other – even they are just talking rubbish – and to avoid looking at the camera if possible. Once you have the reportage series completed, launch straight into any formal images of the group that are needed; if you let them go now, the groomsmen will soon become very busy ushering guests into the ceremony and showing them to their seats, making it sometimes impossible to get this shot until after the ceremony.

Above *Don't be afraid to use unusual angles to help give a creative composition.*

Left *If the wedding is to take place in a busy city location, don't miss out on great shots by worrying about unwanted people in the background.*

THE BASIC SHOTS

Hopefully all the men are fully dressed, but look out for missing buttonholes, as the flowers for the men are often left at the church for them to put on. If this is the case take the chance to shoot the interaction between them, as this ritual usually leads to some humorous moments, especially between the groom and his best man. The basic groom and best man shot is the first to be arranged, using a location that offers a good quality of light as well as a clean background that will be not too fussy and spoil the picture. If there is an entrance arch or lych gate I will usually start here, as it will reduce any overhead light and give some direction to the natural light. The groomsmen are then added around the groom and his best man to start the basic curve of a group, turning the inside shoulders behind the next man to create a classic group pose. With the men in place and posed correctly start with the formal pictures looking at camera, and then relax the images once more by getting them to chat to each other or even all look in a certain direction. Apertures from f/5.6 to f/11 should be used to allow for a good depth of field. I take this series of images as quickly as I can, so I can release them as soon as possible to get on with their tasks.

Above *If you miss the original arrival of the groom and his groomsmen, you can always mock it up.*

Below *The lych gate is a good place to shoot the formal images of the groom and his groomsmen.*

The BIG Day

Try to avoid anyone other than the main bridal party from assisting in putting on the buttonholes, as they can often spoil the moment by being overzealous.

Groom's portraits

Above *Getting the groom and best man walking and chatting is a simple way of adding variety to a shoot.*

Top Left *Lych gates are superb as a location as they naturally restrict the overhead light, bringing dominance to the face. They are also a great option on wet days.*

Above *To add some interest into the formal groom shot I will often add the best man in the background to form a 'split' group.*

Below *Don't forget to capture some of the spirit of the occasion.*

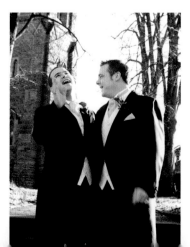

With 25 minutes to go you should turn your attention solely to the groom. He is usually very nervous when he arrives, so I find it better to take a 'hands off' approach, initially allowing him to interact naturally with his best man and groomsmen as they arrive. If there is a long walk from the entrance gate of the venue's grounds to the actual door I make an exception, as it will only waste time if he is allowed to make his way up to the doors, only to be dragged back to the gate for the formal shots.

Once the groomsmen have been released I usually shoot some more formal and informal groom and best man shots to keep him busy for a few moments. The groom will usually need a little distraction at this time as his nerves will really be kicking in by now.

The groom's portrait will often be rushed due to time constraints, with the arrival of bride and bridesmaids looming not far away, but if you choose a simple location with good lighting this variety of portraits will only need a few minutes anyway. Never be afraid of leading the groom away from chatting with his friends, as at this point time is precious. If it is a very sunny day I will often use harsh lighting in some portraits to give a more creative and dynamic effect, using the strong sunlight to spotlight the groom.

The basic full-length pose can be achieved once more by showing the groom how to turn slightly away from the camera with his feet and then place the weight onto the back foot. Check that the groom's trousers have not dropped slightly; this often happens with hire suits. Now attention should be paid to the torso, hands and the jacket. Traditionally the jacket is left open if the groom is wearing a waistcoat but if not the jacket is buttoned up; the bottom button is traditionally left undone on both jacket and waistcoat. The pose is completed by allowing the shirt cuffs to be seen coming out of the jacket sleeve, instead of the bare wrist when possible. Cufflinks are a

Right *The full-length portrait of the groom and best man isn't essential, but as I always start by posing every subject for a full-length shot it can quickly be included as part of a series.*

Below right *If you haven't done so already, check to see if the best man has the rings, just in case.*

Below *If there is time, a shot of the groom and his best man in the venue will complete the selection of images. Here stained-glass windows have lit the portrait dynamically.*

popular present from the bride to her groom for their wedding, so a detail shot is always a good idea.

Don't forget to pay attention to the tie or cravat, as sometimes the knot may be slightly loose and the tie slightly out of place. If the tie needs adjusting and you have the time get the best man to adjust the knot, this will give you another naturally candid shot.

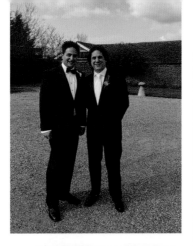

The **BIG** Day

CHECKING ATTIRE

- Trouser length – get him to pull them up slightly

- Tie straight and done up to shirt collar

- Cuffs visible between jacket and hand

- Buttonhole flower on and straight

- No lipstick on cheek from guests

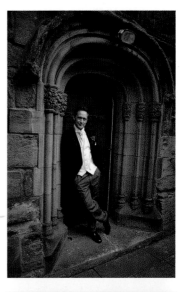

Above and left *This series of shots of the groom by himself shows the variety that I try and take in the space of a few minutes. It includes full-length, three-quarter-length and a range of more informal portraits.*

Groom with family

To make good use of the time, try and get the formal group shots of the groom and his parents about 20 minutes before the ceremony – before he goes in to meet the priest or person conducting it. Once he goes into the venue it is a hassle to get him back out again. Taking the pictures before he goes in, of course, depends on his parents arriving early enough, so this should be planned in advance.

In a similar way to the bride's formal photographs taken at home, I usually shoot the groom and his parents in a more classical location. Soft natural light is great for this style, only using flash as the last resort to lift any harsh shadows caused by strong sunlight. This can usually be avoided by turning their backs to the sun to give a rim-light effect around the bodies, or by positioning the small group in the porch doorway found at many churches and other venues.

If there is strong sunlight from above and I have been unable to avoid it, I follow the same exposure technique of metering for the face – although not the mother's if it is shaded by a large-brimmed hat. Then, with the exposure measured, set this on camera and add flash to help lighten the shadow areas. This method is better than leaving the

camera to set an automatic exposure, as it will often set the flash too bright, making the final result less subtle and creating darker backgrounds.

Position the groom between his mother and father for the first formal portrait, which again is ideal in the case of parents who are no longer married – remember that your list of shots should tell you this. For instance, a groom with separated parents may have a selection of groom with both parents, groom with mother, groom with mother and partner, groom with father and groom with father and partner – it can be very complicated, but you should be able to cope if you are prepared.

Above If there is strong sunlight falling on the subjects, then it is better if the highlight falls on the groom, as a young male can generally take harsher lighting.

Left When the couple have asked for specific shots of special people – as in this photograph of the groom, his brother and grandfather – make sure you remember to shoot it.

The **BIG** Day

Try to ensure that shirt cuffs are visible, as they help to give a good separation between hand and jacket

Once the formal portraits have been shot with the groom's parents you can add any siblings into the group in a similar way to the bride's selection. Then last but not least, add the grandparents. Shots with special friends would normally have already been taken, as the groom's special friends are usually the groomsmen, but you should always ask just in case.

Top right It is not unusual when you take the groom and extended family shots for some groups to just form naturally, so you should always be prepared to shoot the unexpected.

Above right If the groom's brothers are also groomsmen it is usually a good idea to shoot them together with their parents.

Right Once the formal shots are finished I try to stand back once again and observe the scene.

Bridesmaids' arrival

Roughly 10 minutes before the ceremony the bridesmaids will usually arrive along with the bride's mother; traditionally she will accompany them as their chaperone. Don't delay in shooting the bridesmaids, as the bride might be only a few moments behind.

The first pictures to take are the reportage selection as they exit the car and fuss with each other's dresses and hair, following the trip in the car from the bride's home. I try to catch at least one shot of each bridesmaid as they leave the car, especially any little ones. The secret is to allow them to have one foot on the floor before taking the photograph, as it is from this point that they will start to look up – not necessarily toward camera, but at least it is better than looking at the ground.

REPORTAGE

Once they are all out of the cars you can complete the series of reportage shots by stepping back and shooting the scene, where possible including the car and the church in the photographs. I will

Below Remember to capture the moment and not get too tied down with posing people.

usually turn these from colour to black & white in post-production as I often like to print story-telling images in monochrome.

FORMAL SHOTS

As soon as all the fussing about is finished, gather them all together to shoot a quick formal portrait: the bride's mother, bridesmaids (including any flower girls) and pages who might not have been at the bride's home getting ready. Again, your shot list will be telling you who should be in the groups. The bride's mother and chief bridesmaid are usually at the centre of the group with the others posed around them in height order to lend the group a natural composition. Once this formal shot is complete, some quick chatting shots are a good idea, coupled with a change of viewpoint for a little bit of variety.

With the bride's mother now asked to step out of the group you can complete the series by first shooting the group of all the bridesmaids, flower girls and pages formally. Shots are taken looking at camera and then once again talking to each other for the informal images. Finally, if you have time you can then shoot each person individually in both full-length and three-quarter-length portraits. This will save time later on at the reception, especially with young children, who will soon get tired and start taking off headdresses and ties.

The younger flower girls and pages can often be a little shy at first, so I usually start with the older bridesmaids, even though I might already have photographed them at the house. Then the younger

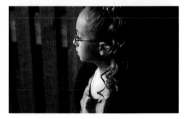

Above Try and shoot a series of images; they can look great in sequence.

Below When pageboys are a little older you can look for some fun shots.

children can see that being photographed is nothing to fear. In the worst-case scenario I will just opt for an informal image of very young children hanging on to a parent's leg, even including the parent of the child if they are being held for comfort. Play can often relax young children, so you should encourage interaction between the bridesmaids; even little games like

holding hands and running away towards the venue or forming a circle and spinning around can help create good images. However, you don't want them to fall down and get dirty – this would be a disaster as far as the bride's mother or the children's parents are concerned. Try to exercise some restraint with overactive children, and don't be afraid to ask parents for help.

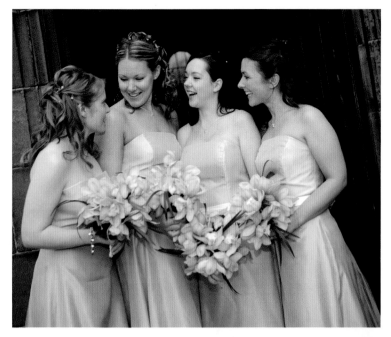

Above When shooting the formal group, go back to basics: turn the bodies in towards each other with the weight on the back foot, have the subjects looking to camera before allowing them to interact.

Right For the arrival of the bridesmaids stand back and observe. Shoot in a more reportage mode, and be prepared for any funny moments.

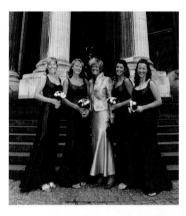

Top The mother of the bride is traditionally posed in the middle of the group and then the bridesmaids are staggered out in height order, unless one of the bridesmaids is another of the daughters.

Above If there is time try to get some interacting shots of any of the young bridal party in case they rebel later!

Right Often it pays to strike up a fun rapport with younger ushers or pageboys. This can lead to some lively images throughout the course of the day.

Bride's arrival

If the bride is roughly on time she will usually arrive anywhere from five minutes before to five minutes after the scheduled start of the ceremony, so some patience may be called for.

IN THE CAR
The photograph of the bride and father in the car is usually my first image of the bride at the venue. This helps to calm the situation, as many brides just want to jump out and get on with it, so before I start taking photographs I ask her and her father to remain in the car.

The photograph of the bride and her father in the car is taken by first of all measuring the natural light falling on the bride's face, preferably with a hand-held meter. This can be quite dark, depending on how far inside the car she is, as well as how much ambient light there is. This portrait is about the

bride, with her father in the background inside the car, so a wide aperture like f/4 or f/2.8 can be used as you are not trying to render the entire scene, including her father, sharp.

FROM CAR TO CEREMONY
It is best if a chief bridesmaid or even her father can help the bride out of the car, rather than a car-hire chauffeur or an over-eager dress designer. This event happens so fast that you will often have to move the camera position quickly because of someone getting in front of the bride from your viewpoint, so the secret is to be mobile and not use a tripod for these images.

The bridesmaids will soon take over, fussing about with the veil and the train of the dress. Once again stand back, initially to shoot the whole scene, quickly following that by interacting with the bride and father to calm down and

Top *Always make sure that you capture a shot of the bride getting out of the car.*

Above *The classic shot of a bride and her dad in the car is a crucial one. This requires careful balancing of ambient and flash light.*

CAMERA TIPS

Fill-in flash
It is often useful to have some fill-in flash due to the nature of the interior, but be careful in case it causes a shadow in the image because you are outside the car.

control the event. Before the bride and her father start to make their way to the church door I usually shoot a full-length shot from behind them, to show the scene with the venue in the background, followed by half and three-quarter-length shots of them looking back towards the camera. This is achieved by getting them to stop and turn a little towards each other and then look back at the camera. That shot will usually be followed by some interaction between the bride and her father, often resulting in a kiss on the cheek, so it is always worth being prepared for this.

As they walk towards the church try to capture images that again show more of the scene from behind the bride, from the side to show the bridesmaids, as well as from in front of the bride to get good expressions from everyone.

The last formal shot before the bride and her entourage go into the ceremony is the whole group: bride, father, bridesmaids, flower girls and pages – even the bride's

mother and the officiator if they are waiting for the bride outside. Starting in the middle of the group, you should construct it with the bride and her father in the very centre, then on the bride's side her chief bridesmaid, with the others scattered around in height order. The shot is taken looking at camera first, preferably without the veil over the bride's face. This last group shot can be followed by some more shots of interaction within the group as they make any last-minute alterations.

Top *Encourage the bridesmaids to carry the train; it makes a great picture and gives them something to do.*

Middle *Don't forget to shoot the bride and her dad with just the two of them in the frame as this is a special moment.*

Above *The formal shot is usually the last shot before the bride is ready to go into church.*

Left *Stand back and shoot the bride as she exits the car; if you are lucky or have a good rapport, your banter with the bride will get some great expressions.*

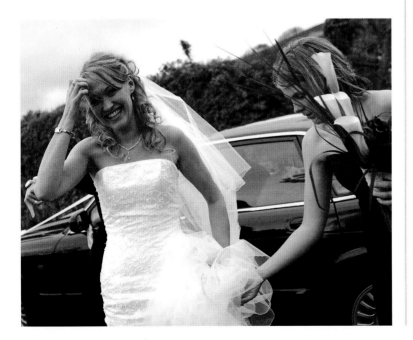

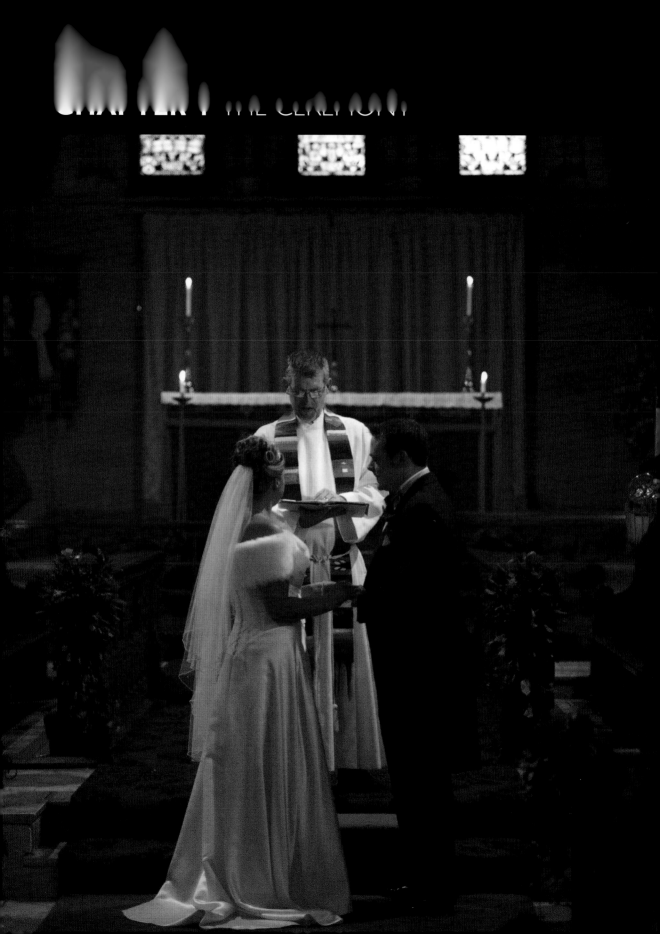

At this point the best pictures to take are generally reportage-style, as the final preparations to go in to the ceremony are often a little manic because of people's nerves. This chapter is dedicated to what happens during the ceremony, but make sure that you don't lose your focus on what is happening as the final preparations are underway.

If the preparations are taking place inside a porch, in some ways it is better to be inside as the light from the doorway will naturally frame and silhouette the scene. If clear expressions are to be seen, flash may have to be used to balance the light from behind the group.

Once you are within the venue itself your actions will largely be governed by the rules of the venue: whether photography is allowed at all and whether flash is allowed. You should also have a full understanding of the parts of the ceremony that the couple want covered, as it is, after all, their big day.

Start of the ceremony

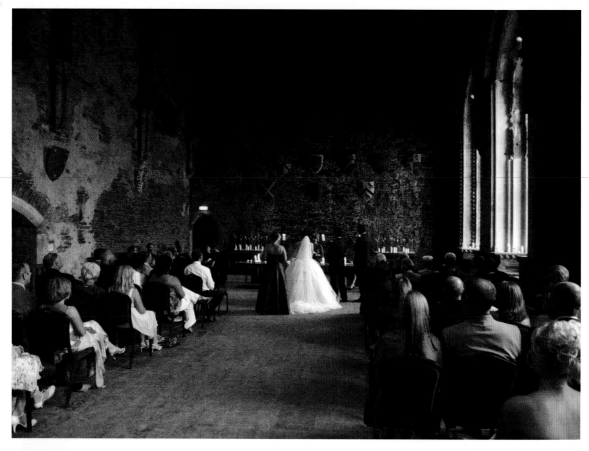

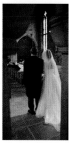

Capturing the entrance of the bride and her entourage is not essential, but a nice addition to the repertoire of images. I usually position myself inside the venue at the top of the aisle so I can capture the bride and her father coming in through the door, then shoot towards the altar as she passes me, showing the back of the dress and the interior of the venue before finally taking some images of the procession of bridesmaids.

Obviously the way in which you photograph will be largely dictated by any restrictions in place at the venue. Normally I use a blend of natural light and flash to capture the entrance of the bride. This requires a combination of a high ISO such as 800, so I can then use a shutter speed of around 1/125sec and an aperture of about f/4, which will usually be enough to bring out and record the lighting in the venue. The flash is then set to add just enough light to freeze the subjects as well as to bring a correct colour balance to the scene. If you are capturing a RAW file instead of a JPEG, you don't have to rely on getting this spot-on in camera.

Top *Take wideangle shots with natural light using a high ISO, if necessary, to set the scene.*

Below *If possible, shoot the full train and veil as the bride walks down the aisle, using flash if necessary.*

Left *If you are not allowed to shoot during the service, at least try to find somewhere to get a shot of the entry.*

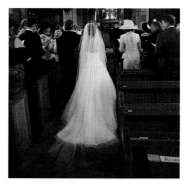

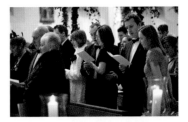

If the service includes hymns, concentrate on the reportage images to start with, shooting the guests singing as well as interacting with each other. Also try to set the scene for the wedding with wideangle shots looking down the aisle as well as from any balcony. By doing this you won't have to move around later on during the marriage to concentrate on the couple and bridal party at the front.

A detail like the order of service in the hands of a guest is a perfect example of what can be shot during the first moments in the venue as well as any stained-glass windows, flowers or even young children peering back at camera.

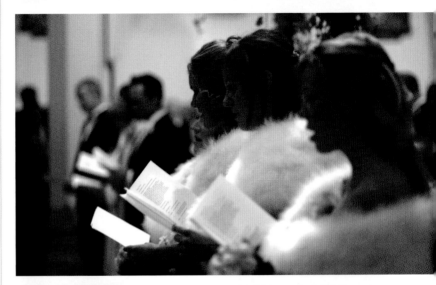

Top, top right and above right Try to capture different compositions of the guests and bridal party. Always remember that black & white is an alternative.

Right Be sure to capture the candid moment when the bride and her father first meet the minister.

Far right In this shot I used dual flash, one on camera and the other on the father's side to lift the image.

Below right Try to use natural light whenever possible.

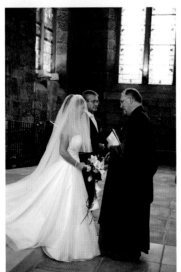

The ceremony

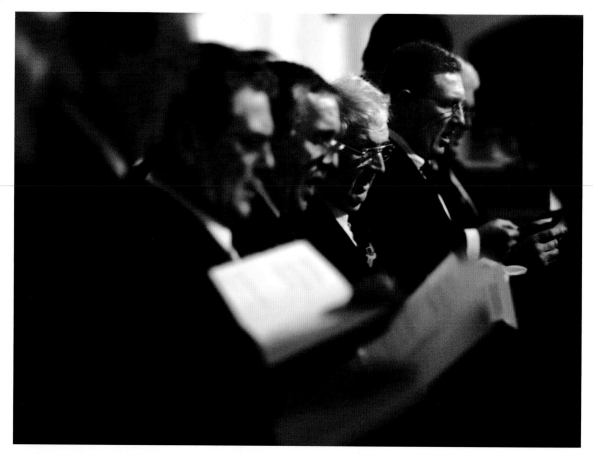

Depending on the rules of the venue, you may or may not be allowed to take photographs during the service. Some locations have a policy of not allowing photography, while others may just restrict the use of flash. This is why a quick visit to the person conducting the ceremony is important. It will enable you can find out what their rules and regulations are.

During the service it is common for a few members of the family or some special friends to give a reading. These will either be from the scriptures, from a favourite book of poems or something similar. If you have asked the right questions at the pre-wedding chat, your shooting list

will give you a guide to what is about to happen. It is better to find a place to stand during the final part of the first hymn or song, so that you are able to capture the readings at close

Above *Look for interesting viewpoints when shooting the choir.*

Below *Interesting abstracts like these candles add a great deal of variety to a wedding album.*

quarters, without having to move around and disturb the service. Whether you are able to use flash or not will depend on the venue as well as the couple's wishes. Even if you are able to take photographs you should be discreet, so that you don't intrude too much on what is a very important moment.

If the person conducting the ceremony asks you to be discreet when taking photographs during the service by choose a high ISO such as 1600, which, combined with a wide aperture such as f/2.8, should give you a fast enough shutter speed to shoot hand-held images instead of having to resort to a tripod. If you are in any doubt then you should use a tripod so you don't get camera shake. Also, always switch off your camera's beep during the service, as the noise many models make when they achieve focus is exaggerated when all else is quiet.

Top left *If you are allowed to capture the readings, especially those being done by family and friends, flash may be necessary.*

Top right *Make a note of any soloists that play so you can capture their performance, especially if they are friends.*

Right *During the vows never shoot with flash; it will only distract the bride and groom, as well as the officiator.*

CAMERA TIPS

WIDEANGLE LENS
Even shooting from the back of the venue with a wideangle lens, if your camera has a big enough resolution you will be able to crop into the image.

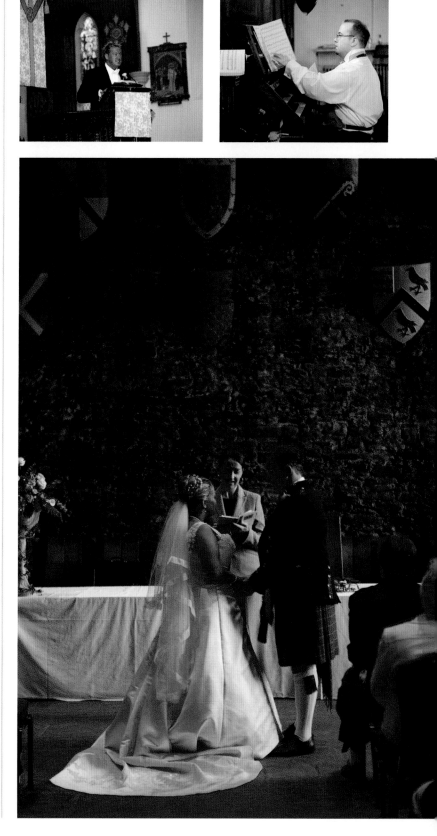

Exchanging rings

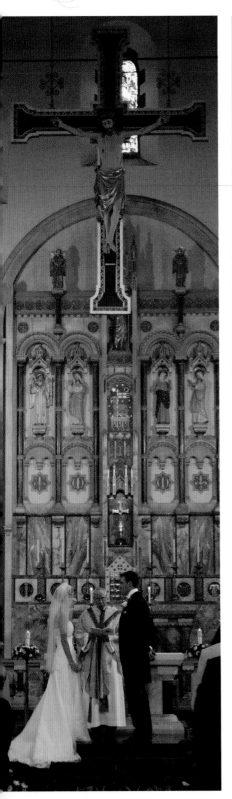

The secret to capturing the ceremony itself is to choose a location at the front so that you can see the bride's face. If possible, avoid shooting from the bride's side as, more often than not, you will just see her back; however, you may have no other option, as most brides are smaller than their grooms and if he stands slightly forwards of her it may obstruct your view.

The variety of images that you shoot should include a number that take in the overall scene showing the assembled friends and family. This wideangle shot will naturally include the interior of the church or venue, so again an exposure for the ambient light, whether it is the interior light or a combination of that and natural light spilling through a window, will bring out the detail if exposed correctly.

The variety of full-length portraits should include shots of the attendants who are involved in the actual ceremony – people like the best man and the parents. A perfect example is the moment when the

Above If you are limited to your location to shoot from due to church rules don't miss out on the full length shot from the back of the church.

Left Try to capture a full variety of images showing the, cropping imaginatively if necessary.

Below If you are unable to get close to the bride and groom always look for alternative viewpoints especially if you are lucky enough to have a balcony, just be quiet.

bride's father passes his daughter's hand to the groom; another moment worth recording is when the best man presents the rings to the officiator.

More closely cropped images should, if possible, include the actual exchange of the rings – a perfect lens for this is a 70–200mm zoom, if the lighting is good enough, as the far end of the zoom will allow you to crop tighter as well as naturally throwing the background out of focus. On the down side, longer lenses will also exaggerate any camera movement at slow shutter speeds, so be careful to avoid camera shake – a lens with optical stabilization can be useful.

Where possible I prefer to make use of any natural light coming through a window and hitting the couple, before resorting to flash. Although flash can be useful, it will often kill the ambience of an image.

Finally, don't miss the kiss! The best place to shoot this photograph is from the aisle looking toward the bride's and groom's backs; however, if you are to one side for the ceremony there is a possibility you may miss the shot as you move. My secret is to move to the aisle as soon as the first ring has been given and during the vows. If you are quiet and move quickly you can be in place before the second ring is called for, so you can get the shot of this being given and then be in the best location to shoot the kiss when it occurs later.

Above and right Think of the exchange of rings as a series of images, starting with the groom presenting his bride with her ring, then the reverse; this will usually be followed by the kiss, then by applause from the guests.

The **BIG** Day

Be ready for the kiss straight after the actual vows and exchange of rings. When you first arrive at the venue Check with the conductor of the ceremony whether the couple will be turned towards the front or towards each other, if it is the latter then you can shoot all the pictures from the aisle.

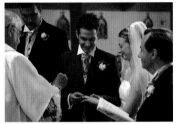

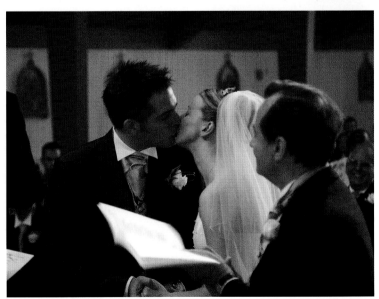

Key skills – signing the register

The signing of the register is a traditional photograph and one not to be missed. In a church wedding the signing of the registration certificate and witnessing will usually take place in the vestry or a side room, but at times it can take place near the dais or altar, so be sure to ask the conductor of the ceremony beforehand. In secular services a table will often be set off to one side at the head of the room.

If the signing of the register is done in a side room or vestry, setting up a formal photograph is quite simple as there will be only a few people in the room: the bride and groom, parents, bridesmaids, best man and, of course the person in charge of registering the marriage, which differs not only from faith to faith, but also from location to location. For instance, in Catholic and Methodist churches there is usually an appointed registrar, in a Church of England church the vicar will usually be in charge, and in certain faiths the wedding has to be first conducted in a registry office.

1 It is usual to let the actual signing take place and then, when everything is completed, the photographer is asked to step forward to take a formal photograph of the couple signing the document. It is quite common for the registrar or priest to turn to a blank page so nothing is altered by mistake.

2 A natural development from the shot of the bride and groom signing the register is to include the person who conducted the ceremony; and then add the parents and witnesses as well as the bridesmaids and the best man. In all

cases shoot some pictures looking at the camera with flash and some looking down at the certificate without flash, just in case someone blinks in the photograph.

3 When you are photographing the signing of the register using flash switch to low ISO settings, such as ISO 100 or 200, so you do not lose any quality due to the increased noise on faces as people as people are looking directly at the camera. When the couple are looking down at the register you don't need to use flash, so increase the ISO; around ISO 800 tends to be about right, as the noise is less

of a problem as it is not so obvious when the faces are not looking directly at the camera.

4 If there is a soloist playing or singing during the signing of the register you may be torn between following the bridal group to the signing, and staying to photograph the soloist performing. My secret is always to follow the bridal party, take a few quick reportage shots of the greetings when the parents and the other members of the party congratulate the bride and groom for the first time, then quickly go and grab some shots of the soloist. By shooting the series in this way

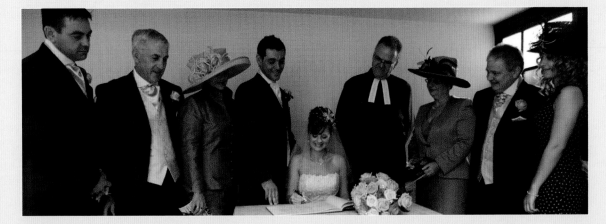

Above *If time is on your side, a nice end to the signing of the registers is a shot of all those taking part, including the parents.*

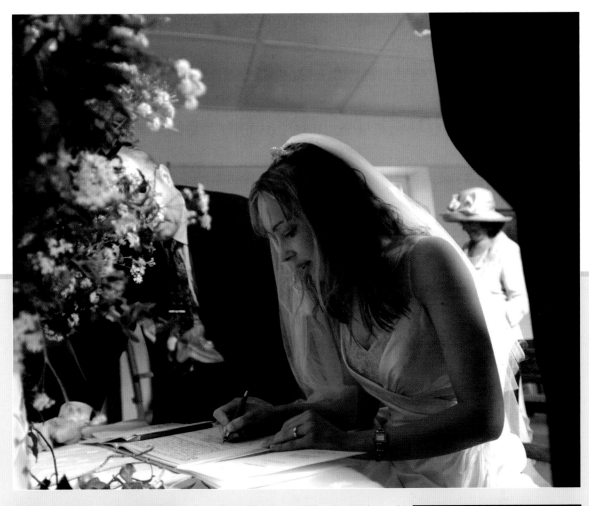

Above Some venues allow the actual signing of the register to be recorded. So, try to avoid using flash; instead, use a high ISO.

Left The most important part is the actual scene of the signing, where you are trying to soak up the atmosphere of the event. My preference is for an image lit with natural light and in black & white.

you can get the natural shots of the hugs and kisses, followed by the soloist that the bride and groom will probably hear, but never see, before going back in to the signing of the registers to set up and capture the formal photograph.

Left When setting up the signing of the registers, have the bride holding the pen and the groom leaning in. I always take one looking down as well as one looking at camera, just in case someone happens to blink.

Walking back down the aisle

The final impression of the couple walking down the aisle is one of the most traditional images in an album. There are two ways in which to shoot this: either catching them on the move walking down the aisle, or stopping them at a set point as they walk towards you.

The 'stop and shoot' image is the safest method, as you can practically guarantee perfect sharpness with no motion blur. It also relieves the pressure a little, because if your flash fails to fire or needs a higher power setting you can reshoot within moments. If you choose this method, try using a wideangle lens so you can stop the couple closer to you – this will allow you to bounce your flash off the keylite card.

Shooting the couple as they walk takes a little more skill, as you need to freeze any motion blur. It is always best to take the shot as they finish a step, as there is less forward motion. I prefer this type of shot, as it is a more candid style. Shoot three or four shots as the couple chat and acknowledge the guests on their way down the aisle towards the camera

and the door. I usually adopt a low viewpoint by kneeling on the floor; this should eliminate most of the over-eager guests moving into the aisle a little to take their own photographs.

Slow shutter speeds will always create a motion blur when subjects are moving, even with flash. The secret to minimizing this blur is to take the shot just as the couple complete their step.

Above left One problem with shooting the couple as they walk is that you cannot guarantee they will be looking at you.

Above If the background is very dark – which it usually is – take a test shot of someone near the point where you are going to shoot to see if you will need to use direct flash instead of bounce flash.

Below If you are in any doubt, tell the bride and groom while they are signing the register that you are going to ask them to stop .

Venue doorway

The couple's exit from the ceremony venue is the one of the most popular images and is often selected for the album by both the bride and groom and the parents. Maybe it's because these first few images of the married couple are the most relaxed and the most joyous, because all of the pressures leading up to the day have been released and the couple are now able to relax.

As the couple come through the doorway, ask them stop and turn a little towards each other, in the classical stance. They will probably have their arms around each other already, but don't correct this as you want the most natural expressions possible. With the couple now looking at the camera, proceed with a full-length, three-quarter, head-and-shoulders and finally an image of them kissing. If the groom is a little embarrassed I usually ask him to kiss his wife with a little more passion; this usually relaxes them and helps them to enjoy the moment a little more.

If the sun is very strong and shining fully on the couple, the photographs will have a lot of contrast caused by dark shadows, especially around the eyes. To solve this you can either use flash to lift the dark shadows or pose the couple just inside the doorway for a softer light on the faces. Just inside the doorway is also a good place to shoot on wet wedding days, as it will shelter the couple. Classically the bride is always on the groom's right arm coming out of church and for group shots, but I will always swap sides if the lighting is better for the bride when shooting the groups.

Once these simple photographs are complete quickly move them away from the doorway to allow the parents and the rest of the guests to leave the venue.

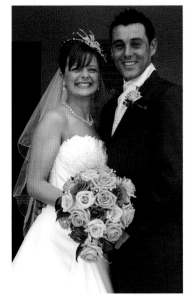

CAMERA TIPS

Overexposure

If the couple are set back in the doorway because of strong sunlight or rain, watch out for the dress being very overexposed because of the angle of the light. Recheck your ISO in case you have it still set high for inside the venue.

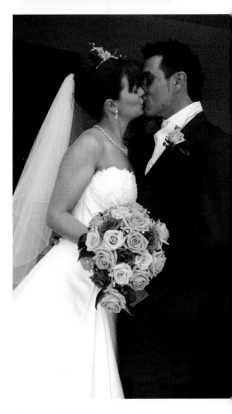

Above and left *The traditional shot outside the church door needs to be taken quite quickly so as not to block the doorway for too long. Start with a full-length portrait* *(above left)*, *then walk in or zoom in for the three-quarter portrait* *(left)*; *finally, ask the couple to kiss* *(above) to complete the series.*

Formal venue shots

If it is raining outside when the couple go to sign the register, it is now that you have to make any final decisions about where the photographs will be taken; however, you should have discussed this with the couple at the pre-wedding chat. Most will allow a small amount of time in the case of wet weather to shoot some bride and groom photographs, but it is more important, especially if the reception venue is not very big, to do the group images. The procedure in this case will be to announce that some photographs will be taken inside the venue following the conclusion of the ceremony and the walk down the aisle.

Speed, organization and time management are the key ingredients to shooting the formal groups at the venue. If you take the photographs of the key groups as soon as they exit the venue, the key formal groups of the parents and bridal party will be shot by the time the last of the guests has left for the reception.

Once you have shot the bride and groom in the doorway, move them and the bridal party away to a side location. This stops a jam of people at the doorway. If a small wedding of 100 guests each congratulates the couple for just 10 seconds it takes over a quarter of an hour from the first to the last guest; that will make for a very bored couple.

THE BRIDAL PARTY

With the bridal party at the side location you can now quickly position the parents around the bride and groom. Traditionally, the bride should be on the groom's right arm coming out of ceremony, the same for groups, but always be prepared to swap sides if the lighting is better for the bride on the opposite arm – this is with the exception of military weddings. The first formal group is with the parents; the mothers traditionally stand next to their child, and the fathers escort the opposite mother, so the bride will have her mother by her side who is escorted by the groom's father, and vice versa.

The next group is with the rest of the bridal party. The chief bridesmaid stands next to the groom's father, the best man next to the bride's father and the rest of the bridesmaids are then

Above, left and right *Just because this is the formal sequence of shots, it does not mean that people should not look like they are enjoying themselves. If you keep the atmosphere light and fun then this will be reflected in peoples' expressions.*

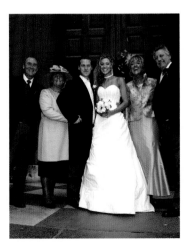

arranged equally on either side, trying to keep the bride and groom in the centre. Remember to turn every subject slightly in towards the middle to slim everyone, as well as to make the group more compact.

EXTENDED GROUPS

The groomsmen are then added to the wings of the group equally or asked to kneel in front if there is not enough room. The final formal group is the group of the bridesmaids, the best man and the groomsmen with the couple, but without the parents, so ask the parents to step out. Then close the group together to quickly finish the formal group shots.

I then like to release all of the bridal party to gossip and mingle with the guests. This makes for some great opportunities for candid images as the guests are at their most animated, with big arm gestures and lots of hugs as well as very natural expressions of joy.

If all of the groups, family and friends, are to be taken at the ceremony venue, do this as soon as possible once all the guests have come out, with any formal groups taken outside the main doorway as well. Use your list for the groups, as this will allow you to flow from one group to another, adding and subtracting people as necessary. Beware of any pubs near the venue if you are planning to shoot any large groups, especially shots of the bride's and groom's friends, as they are usually the first to disappear if they think you are keeping them waiting around for no reason.

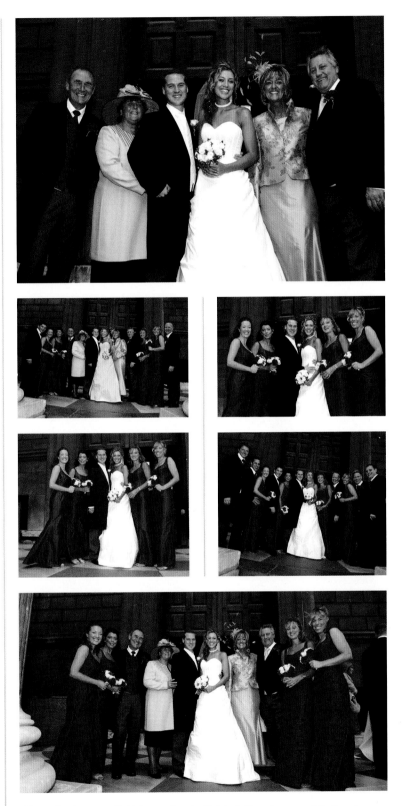

Above For this series of bridal group shots I pulled the bride and groom and the parents away from the church door so I could release the guests from the church while taking the formal groups. The entrance was up a steep row of steps, so it made sense to shoot the groups there.

Confetti and leaving

Once all the formal groups and candid shots of the guests have been taken, it is often left to the photographer to instigate the leaving of the ceremony venue to proceed to the wedding reception. If left to the bride and groom or the best man, precious minutes can be wasted through disorganization.

The guests will be itching to get to the reception, so a prompt to ask everyone to make their way to the gate or the car for the confetti shot will be eagerly received. While the guests are making their way to the gate it is a good idea to wait with the couple to get a few more intimate shots; either by posing them in a certain place, or by instigating a slow walk to the gate and shooting candid images on the way. Even then I usually prompt them to chat to each other, have a bit of fun and of course, not forget to kiss.

CONFETTI

The secret to getting a really good confetti shot is to organize a small group of confetti throwers and then bring the bride and groom into the middle. Once all the throwers are in place, the bride and groom can be brought into the group and the throwers then asked to gather closer to fill gaps. Then, on the count of two, I usually say 'Wait for it', as the anticipation usually gets some great expressions from the bride and groom as well as guests. Finally, on 'three', the air is full of confetti.

CAMERA TIPS

Flash

Do not use flash unless absolutely necessary, as it can cast ugly shadows on faces when the confetti is between camera and subject.

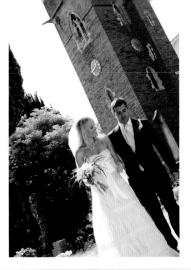

Above *While all the guests are gathering for the confetti throwing it is an ideal time to shoot the bride and groom alone.*

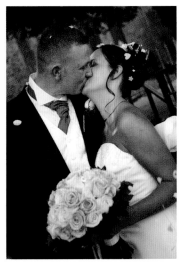

Above *Following the throwing of the confetti, ask the bride and groom to kiss for a great close-up.*

Above *The aftermath of the confetti throwing is a great detail.*

Left *Remember to change camera angle for a variety of viewpoints.*

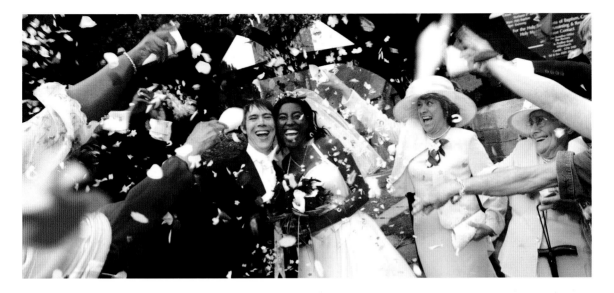

I usually take a series of three to four shots to capture the throwing of the confetti, but if it keeps going I will continue to shoot details such as confetti on the ground, any interaction between bridesmaids, guests' expressions and so on. Once it looks like the throwing is finished, I like to end with a shot of the bride and groom kissing. Wide apertures should be used to decrease the depth of field, separating the bride and groom from the confetti.

The **BIG** Day

Ask the confetti throwers to throw the confetti up in the air instead of throwing it at the couple, so the confetti drifts down gradually instead of straight in their faces. Watch out for overenthusiastic guests who might rush in front of the camera, or have hands in front of faces.

THE WEDDING CAR

The last shot before leaving the ceremony is the bride and groom sitting in the wedding car. I always sit the groom furthest away from me, so the bride can then lean into his arms naturally. I like to shoot with natural light, but often I am forced to use a little flash due to the dark interior or bright exterior.

Always shoot at least two shots: one looking at camera and one kissing shot to cover the chance that one of them blinks when looking at the camera. Then you should leave quickly to be ahead of any guests. There are exceptions, one being if the couple are in a horse and carriage, as you can shoot some candid leaving shots of the guests and couple waving to each other as they leave. I usually shoot these with a wideangle lens to capture the whole scene. If the bride and groom are stopping off en route for a series of location pictures, then make sure that the chauffeur knows where you are going.

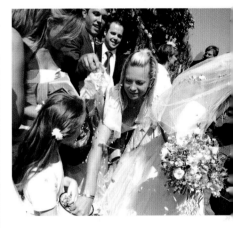

Top A wideangle lens is great for confetti shots as it brings more of the guests naturally into the photograph.

Above Don't forget the interaction between the key people during the confetti throwing, especially the bridesmaids.

Below The car shot does not just have to be just of the bride and groom; here the pageboys have added some humour by pretending to be the drivers.

Key skills – cultural variations

Because the wedding ceremony is such a central part of many people's spiritual lives, the variation of the form that it takes is of particular importance. As a wedding photographer it is important that you make yourself aware of any particular events that each ceremony involves. Obviously there are too many to list, but here are a few pointers from weddings that I have covered.

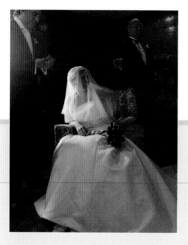

■ Jewish weddings

A core part of the ceremony that should be captured is the bedeken. This is the practice of the groom and his parents checking that the bride behind the veil is in fact the woman he is to marry.

The groom and bride are then escorted separately by their parents from the bride's room to the ceremony, which takes place under a canopy called the chuppah. When the bride enters she symbolically circles the groom seven times and then stands on his right side. Two cups of wine are used: one will be drunk from at the betrothal blessing at the start of the ceremony, and the second after the seven blessings towards the end. During the service the groom will place the wedding ring on his bride's right hand, and then the wedding contract will be read, followed by the seven blessings and drinking from the second cup. The conclusion, when the groom shatters a glass with his foot, should also be captured. Following a visit to a side room where the bride and groom end their fasting, a banquet is held, followed by a party.

Above left and below The bedeken ceremony, where the groom and his family check the bride is the woman he is to marry.

■ Muslim weddings

The groom will be paraded into the ceremony room with drums playing and his family and friends will escort him in. The first part of the ceremony will then take place without the bride but witnessed by her father, brothers and guests. Then, once the contracts of marriage have been signed, the bride is paraded in by her family to a joyous welcome and seated in the centre of the ceremony. Her attendants then have to be paid by the best man and the groom's family to allow the groom to be seated next to his bride. Following the ceremony a banquet is shared by all. The party is brought to a close as the bride leaves her family with her new groom and his family, this leaving parade is a bittersweet moment; and needs to be captured.

Top left, above and right
Although each ceremony is unique you can use your basic skills in most situations. These three shots of a Muslim wedding show the arrival of the bride, the signing of the wedding contract and celebratory music; all of which are elements that appear in different forms in many other ceremonies.

Greek Orthodox weddings

After the bride has been paraded into the church, almost immediately the rings are put on to the couple's fingers and exchanged three times by the priest. Following the joining of the right hands, the priest crowns the couple and again exchanges these crowns three times between the couple. The best men and the best women now attach a ribbon between the couple, then each of the best men and women write their names on the ribbon. Finally, after the priest has given the couple three sips of wine each, the bride and groom are paraded around the altar three times before the parents conclude the ceremony by kissing the crowns on the couple's heads. The party in the night is once again full of dancing and is a joyous occasion. Don't forget to shoot the ceremony when the bridal party and guests start to pin money all over the couple, as well as making chains of money for them to carry.

Catholic weddings

A Catholic wedding sometimes includes a Communion to finish the wedding ceremony. The bridal party and guests are invited to take Communion Mass, each in turn is given a blessing, the Communion wafer and a sip of Communion wine by the priest. Even those who are

not confirmed can have a blessing. This can take an extra hour, depending on the number of guests.

If you have not photographed a wedding of a specific religion before try and get permission to attend one, to just see the procedure. If you are unfamiliar with any ceremony, always ask for someone to act as your chaperone during the service.

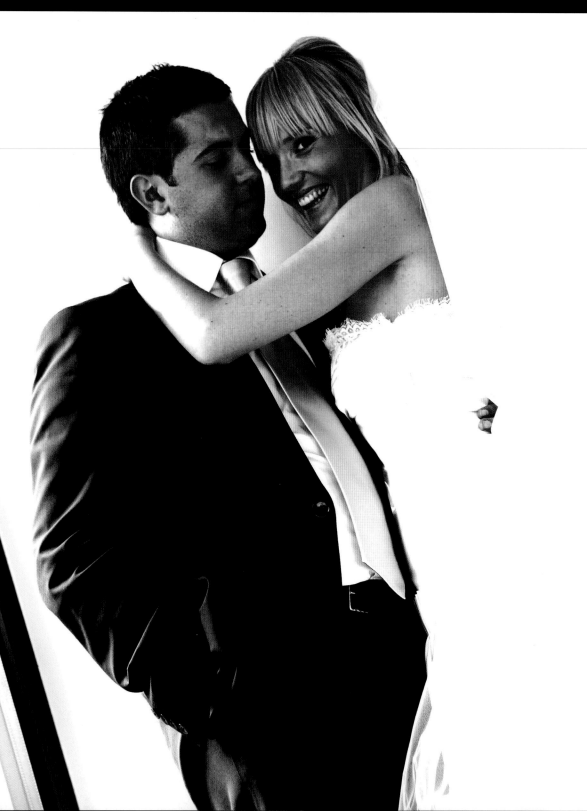

The bride and groom photographs should always be the most fun images of the day – they should tell the tale of the wedding all by themselves. They should be a classically beautiful selection shot under near perfect lighting conditions and in a great location, as well as a series of images that reflect the fun and passion between the couple.

I usually find that I get the best out of couples when they are away from the guests, even parents and friends, as they seem to be much more relaxed and more intimate with each other. That is why I usually stop off at a separate location when possible to take these portraits. The chosen location can be somewhere that is perhaps special to the couple, or just a great backdrop for photographs, but I always try and choose somewhere en route so as not to lose valuable time.

The variety of images is important, and the more experienced you get, the wider your repertoire of poses and styles will be; however, you should always get a combination of full-length, three-quarter-length and head-and-shoulder portraits, not forgetting images showing off the location itself as well as some with a creative use of light and a dynamic composition.

Expression can always kill an image if it isn't right, so I always try and have 15 minutes of fun instead of half an hour of boredom. In other words, long enough to get fantastic expressions, but not a minute longer, or expressions will soon start to look tired and uninterested.

Formal couple shots

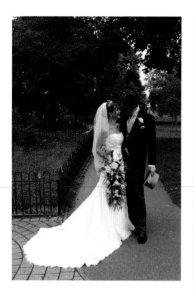

As with all portraits the pose starts with the feet of the couple. Their position will affect balance, either giving a solid stance or flowing lines to the overall pose.

The classical bride-and-groom pose is with their bodies turned slightly towards each other, filling the gap between them, with the body weight on the back foot for an easy and comfortable stance. This pose is completed by the bride holding the bouquet in both hands and the groom placing his right arm on his wife's back. This leaves his left hand to hang by his side, perhaps holding his hat if he is wearing tails, or even to grasp his sword if it is a military wedding.

Once this pose is complete the camera position can be moved closer for the three-quarter shots and closer still for the head-and-shoulders portrait, with only a change to the groom's outside arm, which should come to his wife's hand near the bouquet or to the three-quarter-length hat position (see page 47).

VARIETY WITH SPEED

After you have shot this classic pose looking directly at the camera, you can vary it by asking the couple to look off camera. Choose a spot and direct them so they both look at the same point. Follow this by asking them to look at each other, and finally ask them to kiss. Without the couple changing their pose at all, the camera can now be repositioned to the side, making greater use of the natural light and its direction, and then repeating the same sequences based on three

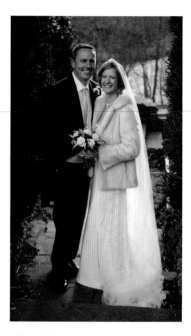

Far left For the full-length shot the groom should maintain a grip on the top of the hat with the gloves in place and the arm fully extended.

Above The classical pose for the bride and groom in full-length portraiture. Also note the wonderful light that is illuminating the bride's dress and lifting the image.

Below and below left When getting in closer, ask the couple to lean their heads towards each other a little more to complete the pose. Finish off the series with a head-and-shoulders shot of a kiss.

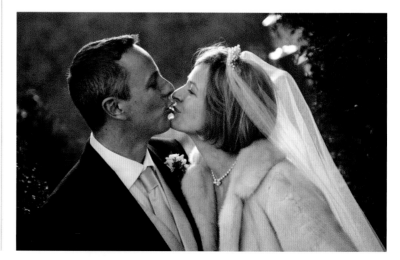

camera positions and the three looks, with the odd kiss being thrown in. By following this shooting pattern you can work through the basic bride and groom images, some 20 or more different shots, in a matter of minutes, allowing more time for the fun, relaxed, creative and artistic images to follow.

Make sure you tell the couple what you want them to do after each image, so they know precisely what is required – they will soon get into the rhythm. Make sure the dress and the groom's suit are tidy; even when working at a fast pace, you don't want to overlook the basics.

Work in sets of three for quick results: full-length, three-quarter, and head-and-shoulders portraits; then looking at camera, looking at each other and a kiss.

Right These three images are a perfect example of the use of this triptych technique. The looking-at-camera shot has terrible shadowing on the eyes and face due to the strong sunlight and is practically unusable, whereas the shots where the couple are looking at each other and kissing do not suffer for the shadows and contrast.

PORTRAITS

To move quickly between the photographs of the couple and shooting images of either the bride or the groom individually it is easiest initially to just ask the groom to step out of the photograph; this avoids having to reposition the bride's dress. Following the same pattern of looking at camera, looking down to the bouquet and then looking away towards the light, the full-length, three-quarter and head-and-shoulders portraits can again be completed within minutes.

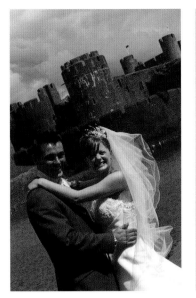
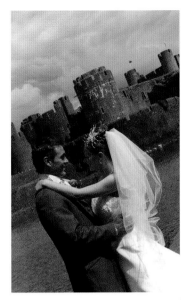
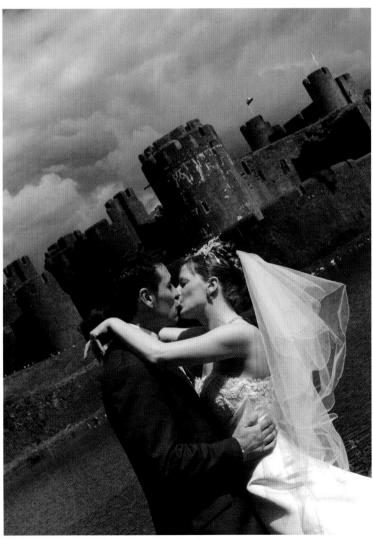

Informal couple shots

With the basic variety of images captured in a short space of time, you should find that the couple have really relaxed with you and are now really looking forward to shooting more images because of your efficiency.

The relaxed and fun images are just an extension of the formal pose and can be achieved by employing three simple tricks: a tilt of the camera, greater animation in the poses and more verbal interaction between bride and groom.

A quick trick to move from the formal style to a more relaxed and creative image is with a slight tilt of the camera to throw the horizon, or any vertical element, out of true. Get the couple to lean on each other more, or even lean away from each other, and the tilt will be made more effective.

With this simple change of pose a wide variety of pictures will crop up naturally. To make the most of the series, I try and get the couple walking away and running towards the camera. Again this can be varied by shooting from different camera heights and angles.

Allowing the couple to interact by themselves is a secret that many photographers never learn, but by setting the mood and allowing them to do their own thing you will often gain some great results. That said, however, most couples need some verbal prompting from behind the camera to set the mood.

Remember always to move the camera position before moving location, as a simple change of background will help. Sometimes it is possible to move all the way around the couple, which will give many different lighting effects and backgrounds. If a change of position results in the lighting looking flatter, avoid having the couple looking at the camera, as this will make them look heavier. If the sun is directly behind them don't be afraid of shooting a pose as a silhouette, but always shoot the faces in profile to distinguish features and not allowing the faces to touch fully when kissing as this will cause an indistinct effect.

When trying to obtain different expressions from the couple, it's easier to create some mood with a bit of banter. For fun images I usually tell the couple to 'Fake it!' This usually gets the expression I want, especially as I have been saying this throughout the day, so they soon get the meaning. For quieter images I tend to be subtler in tone – simply asking them to kiss or just chat to each other tends to do the trick.

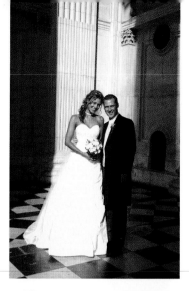

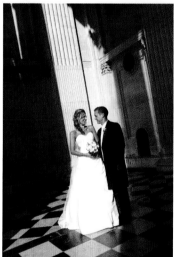

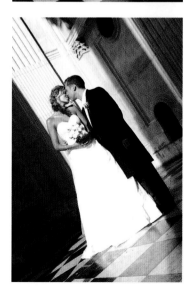

Top left *Don't miss the natural interaction between couples. Even though this photograph is slightly out of focus it speaks for itself.*

Above *This series shows how images can be simply adjusted to create variety with a slight tilt of camera or change of viewpoint.*

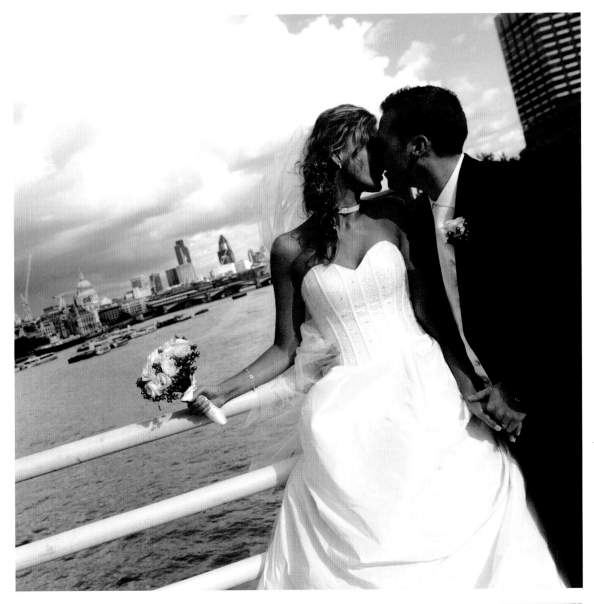

PORTRAITS

When moving between the photographs of just the bride or the groom an easy trick is for you to pose the groom in the background to add a secondary point of interest; however, the point of focus remains on the foreground subject at all times, with the exception of the close-ups, when focus can be moved between the bride or groom for creative effect and variety.

Above *The same couple kissing – just from two different camera angles. One gives dominance to the sky, the other gives dominance to the couple, both effects are exaggerated by the way in which they have been cropped.*

Key skills – architectural backdrops

Where possible I prefer to use a location with some architectural interest: an old ruin, a bridge, garage doors, even a modern brick wall if the location seems right for the couple. However, if you choose an unusual or striking background, choose a simple secondary location as well, to cover yourself in case the couple or family hate your choice of location. This rarely happens, but all the same you shouldn't take chances with a couple's special day.

The chosen location is always en route to the reception from the ceremony, unless specifically requested by the bride and groom. I like a location to have a little variety and not just one good backdrop, but that can easily be remedied by playing with depth of field or just getting closer to the architecture to change the look.

2 When working close to a wall or a building, take note of any textures caused by weather or age, like mossy or crumbling walls, or even flaking paint. These can be used creatively as a background for a page in a wedding album.

3 With architecture you can always try and give it a little twist. An old mansion house does not have to be shot all the time in a classical style. By the same token,

1 The first images to shoot are where the location is just a backdrop to the photograph. This is usually achieved by standing the couple far away from the feature and using a wideangle lens to exaggerate scale. The couple will then gradually be repositioned closer and closer to the backdrop so as to show only part of it using a longer lens to exaggerate the shallow depth of field, at times creating nothing but an abstract background of colours and shapes.

Top *A tight crop has rendered the striking background abstract.*

Above left *I used this chrome waterfall feature not only as a contemporary backdrop, but also to include the fantastic reflections of old and new architecture.*

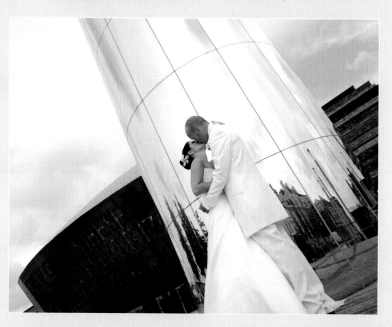

Above *When the lens is zoomed out to its shortest focal length – in other words its widest angle of view – you can start to see more of the detail in the background, so it is important that you take the whole of the scene into consideration.*

a modern location or sculpture can be made to look more abstract by shooting either through or across it. Think creatively and don't always give the viewer something they recognize, but something that is visually interesting. Try to look for different extreme viewpoints to add even more variety and creativity to your images. Change your camera height as well as the position to greatly increase the variety of your pictures without having to move the bride and groom.

4 Reflectors can be used to diffuse any unwanted sunlight, especially dappled light falling on the subjects near a building with foliage. If the bride or groom are posed in an archway that is reducing the light, remember to use a reflector to bounce good-quality light back to help light the five planes of the face. Don't be afraid to use strong sunlight to spotlight the couple as well as to cast long shadows.

5 Wide apertures can be used to decrease the depth of field and render the background a blur. This can create an almost three-dimensional effect with a long focal-length lens.

Top left Arches are perfect to lead the eye into a photograph.

Above When choosing a background, look for elements that give it some rhythm.

Left When shooting against the light the architecture can be used to hide unwanted details and help to direct the eye towards the subject.

Below When cropping in close to the couple, use the background to add interest to the image and not to distract.

Key skills – seaside backdrops

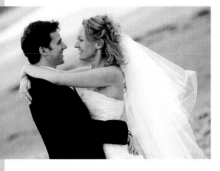

The beach is a superb location for the bride and groom pictures; whenever it is possible it brings a little fantasy to the photographs and the day itself. I think we all dream of walking hand in hand along the shore with the one we love, but remember that the bride's dress and the sea do not mix well!

The secret to shooting a bride and groom on the beach is keeping it simple. The pose should be made to look natural rather than very stylized – unless that is your preference. I tend to go for a 'natural stroll on the beach' as the theme, with a short stop for a sit down and a romantic moment.

1 Basic shots should be taken first, so start with the traditional pose with the groom furthest from the camera and turned to the bride. She should be turned towards him slightly, both of them with the weight on the back foot (which is the inner foot). The dress will look at its best if it is billowed to give extra shape to the back of the train, by holding the lower part of the train with open arms and gently but quickly lifting and then dropping it to settle into a better shape. In windy conditions ask the groom to hold a little of the veil at his bride's back, or ask her to hold the veil to stop it blowing. Always remember to stand the subjects with their faces into the wind so their hair flows away from the face.

2 Once the basic shots are finished I usually ask the bride to remove her shoes (if the beach is sandy and not pebbly) as they stroll along the beach away from camera, which gives a relaxed feel to the photographs and protects her shoes. Stay away from the wet part of the sand, because if the train gets at all damp it will become limp and drag instead of floating. If the location is rocky, suggest that the bride brings a pair of running shoes to change into before the shoot.

Top left The beach can be a really romantic location for some special shots.

Above left In special locations chosen by the couple, make sure to include shots of the view.

Above Don't forget to shoot little details, even when on the beach.

Left Turn the bride into the breeze to make the hair and dress flow from the face.

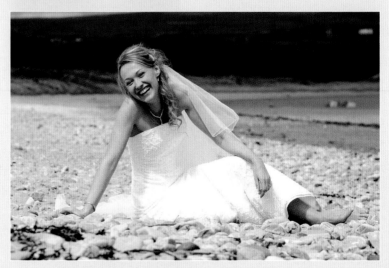

Above Remember to change your viewpoint as this will dramatically change the background.

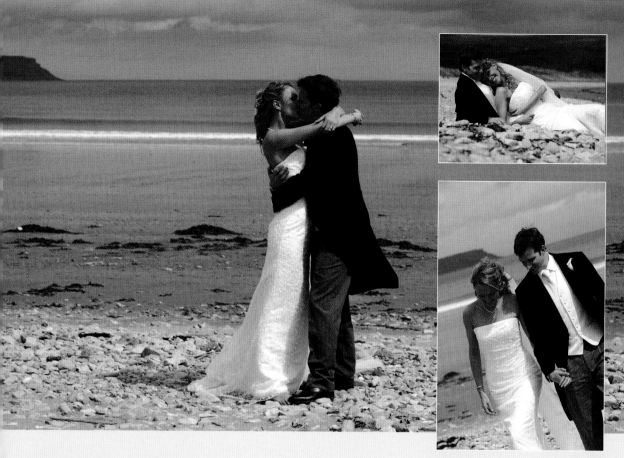

3 When finding a location to seat the bride on, choose a dry patch of sand. I usually carry a small blanket for the bride to sit on, which can be hidden by the wedding dress. If you have a reflector you can use that. The groom is posed first and asked to sit on one thigh instead of his bottom, as this pose will make him more animated; leaning on his hand or forearm will complete the pose. The bride is then seated, again with her weight on the thigh, and asked to lean in towards her husband, resting on her hand or forearm for balance. This will bring the couple very close and instigate a romantic mood. Normally the best photographs will be those in which they interact or look out to sea instead of towards the camera.

4 There is usually very little shelter on a beach, so it's an almost impossible location when it is raining or the wind is howling; look out for beach huts or lifeboat stations to shelter the couple, but remember it is always up to the couple to call off the location stop for photographs in bad weather. If it is windy, stand the bride into the wind so the veil and dress will naturally flutter away from her, but be careful that the groom does not end up running down the beach after his wife's veil!

5 Strong sunlight makes for fantastic photographs, especially when the sky is blue, as the increased contrast makes the images more dynamic as well as bringing out the colours of the sky and sand; but dark skies are equally as good, especially when turned to black & white.

Right Sometimes rain stops play, so make sure you have an umbrella at hand.

Main pic When shooting the formal image, try and keep the horizon straight.

Top If the pose is natural the expressions will be natural.

Above When the couple are walking towards camera it is more natural if they interact with each other, rather than looking at the camera.

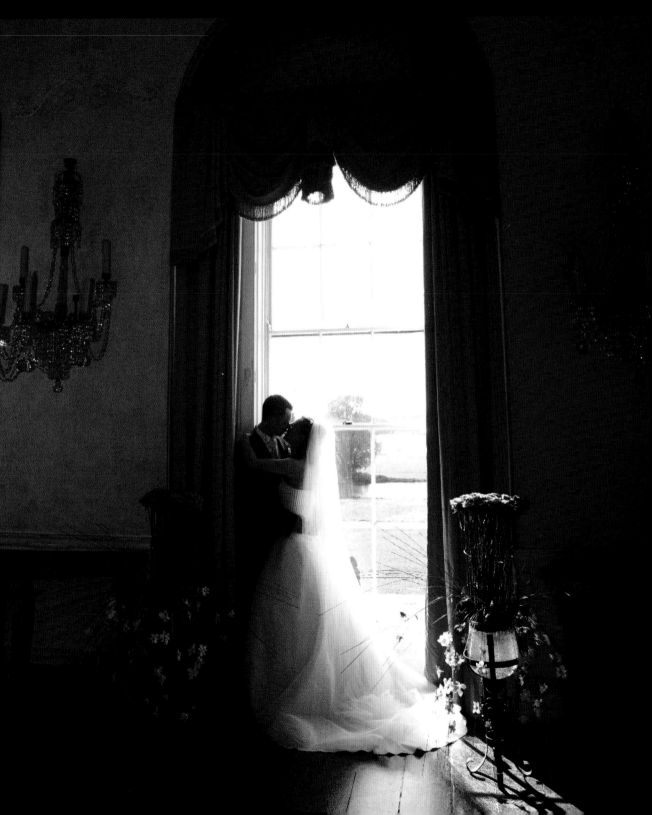

When the bride and groom arrive at the reception it is the start of the next chapter in the wedding day. Guests will naturally become more relaxed as they mingle and interact with each other, and the bride and groom will be really beginning to enjoy their wedding, as the pressures of the day are almost gone and the party is about to get under way.

For some people, however, the day is only just beginning. The best man will now be starting to panic about his speech, closely followed by the groom and the bride's father. The caterers will be winding up to full pace getting ready to serve dinner, and of course it is up to you, the photographer, not to take up too much time shooting the photographs.

Arrivals in the car

When finally the bride and groom arrive at the wedding reception they will be keen to go straight in and relax, but don't forget to take some photographs featuring the wedding cars, as up until now the only real shots of the cars will have been inside them, or candid images where they are not a central part of the scene.

If you have not shot the 'in-car' images yet, this is the time to do so. When the couple arrive, ask them to stay in the car for a moment and shoot a quick shot looking at camera, followed by a quick kissing shot. As the couple exit the vehicle you can get a few candid shots, again to set the scene for this stage of the wedding. The bride and groom are then positioned and posed towards the front side of the vehicle with the reception venue as the backdrop.

The groom is posed next to the car; this is to keep the bride and her wedding dress away from the wheels, which may be dirty or oily. Once the couple are in place, shoot a variety of wideangle shots showing the car and location. As the bride and groom are distant to the camera at this point, they are requested not to look at the camera, as their faces will be indistinguishable from this distance and any bad light on the face will be uncorrectable. So they can just chat to each other, and of course you can now shoot the series with them looking away towards the light source and eventually kissing for variety.

Above and top *Always shoot the details.*

The **BIG** Day

Some couples don't want to kiss very much on their wedding day. Sometimes this is through embarrassment and sometimes because they just don't show open affection, so be aware of this through their body language. I ask my couples at the pre-wedding chat if they mind kissing on the wedding day, as this can stop any embarrassing situations occurring at the time.

Once the 'scene' shots have been taken, follow up with some closer shots, first stepping closer and shooting the full-length portrait and then moving in to shoot the three-quarter portrait while still trying to feature a part of the vehicle. The secret to this is to choose a low viewpoint and always shoot with

the car in the camera frame, tilting the frame off square if necessary to add a more dynamic touch. If the lighting falling on the bride and groom is bad, then you can again simply avoid any looking-at-camera shots, with the closer up images, opting for more looking at each other, or looking away. Because you'll be relatively close to the couple, however, you can use a reflector to lift the shadows on their faces, or even use a large diffusion screen to subtract light from overhead or from the side if necessary.

The couple, at some point, will be presented with a drink, usually champagne, so the variety of images can be completed with one of a toast. If the car is a soft-top and the top can be lowered with little fuss, then shoot some of the images with the couple still in the wedding car. This can be especially effective if the seats are of a strong colour. Reflections in the car mirrors or in the chrome of the car can also make interesting shots.

Above and top Don't be afraid to give an image a little more help in Photoshop; some images can really become powerful if you exaggerate the effects slightly.

Left When shooting the bride and groom with the car, try and show some of the reception venue as well, to get a 'two in one' shot. Stand the groom next to the vehicle so the bride cannot get dirty. If the lighting is bad, discourage the couple from looking at the camera until you are up close and can control the light.

Bride and bridesmaids

Traditionally a lot of fuss has always been made of the bride and her bridesmaids. As long as in a few photographs they are all present and looking good, you can do almost anything you like photographically. The photographs are best taken as soon as possible in case younger bridesmaids get too tired or the older ones have too much to drink!

If the bridesmaids are coming to the location stop with the bride and groom, always try and shoot their pictures with the bride and even some with the groom first. This is not only in case of tiredness setting in, but also so you can concentrate on the bride and groom shots. If they are being photographed at the reception, try and shoot them as soon as they arrive so they can go off and relax with the other guests until they are needed again for group pictures.

The formal images of the bride and her bridesmaids will follow a similar theme as at the house before the wedding, with photographs of the whole group as well as individually with the bride if they are requested; but once these few photographs have been shot I prefer to shoot more relaxed and candid images, especially walking and talking. The young bridesmaids' photographs with the bride are not all 'little angel' shots, but also an opportunity to play around by perhaps playing 'ring-a-ring-o-roses' around the bride or running away from her and the camera, not forgetting when they run back as well. With the bride placed in the centre of the bridesmaids, get them to all link arms and then either run or walk with big strides towards the camera. Use a low camera angle and a touch of fill-in flash to illuminate the faces a little; because younger bridesmaids' gazes are lower, the light from above will naturally leave the illumination on their faces slightly dull unless corrected.

Below Don't be afraid to instigate some fun and animation, especially with young bridesmaids.

Right *Never be afraid to take control to get a great shot, as subjects can't be relied upon to put themselves in the right place with the right lighting.*

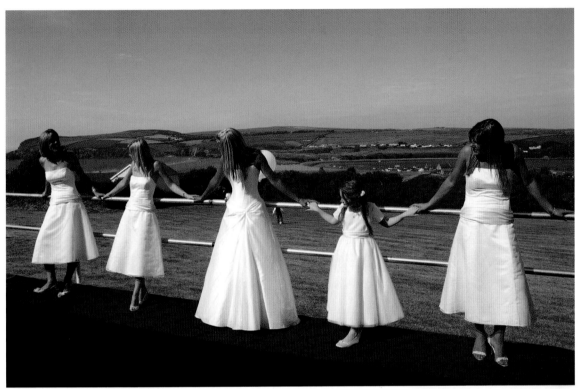

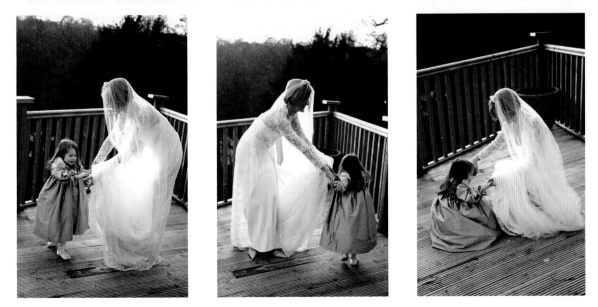

Above *Remember to work in a series of images, especially when movement is involved, as they look great on an album page.*

Drinks

Once the bride and groom have arrived at the reception and they have had their car shots taken, it is best to just let them go at this point, as you don't want them to get bored with photography.

CANDID SHOTS

If your timing is going to plan there should be no real panic at this stage, especially about shooting the formal groups – if they have not already been done at the ceremony venue.

The secret is to make the most out of this time. Wander around the guests shooting candid groups initially, as well as focusing in on specific members of the bridal party, such as the parents, the groomsmen and not forgetting the best man and bridesmaids. If I am shooting close-up features I usually opt for my 24–70mm zoom lens, as this is long enough to pick out key people but also able to zoom out quickly to shoot the bigger picture.

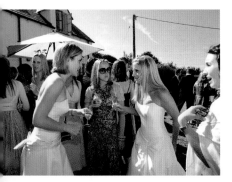

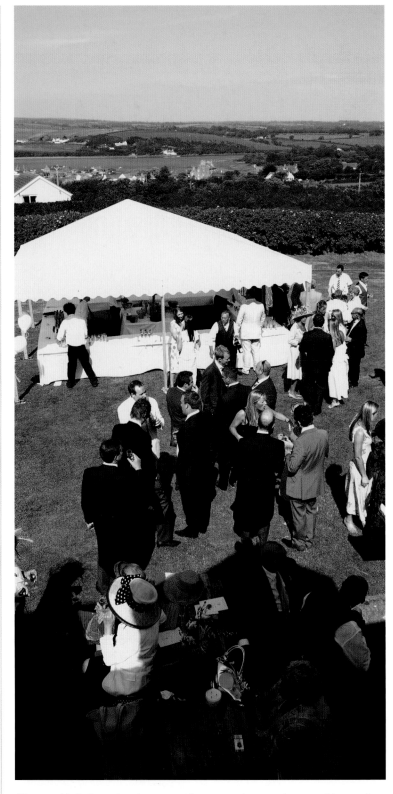

Above and left Remember always to set the scene so the images later on will have scale.

Top left The secret to creating a full picture of the day is always capturing the detail.

SMALL GROUPS

Once you have toured around the guests getting a general picture of the event as well as some candid shots of the key bridal party, you can then start to interact with the small groups of friends and family that have naturally formed. I just excuse myself and ask everyone to turn towards the camera, then the wider end of the zoom can be used to capture the guests quickly. Add some fill-in flash with the keylite card on the speedlight if you need to lift any shadows slightly, or in very sunny conditions point the flash directly at the subjects, with a wideangle diffuser over it to slightly soften as well as widen the flash illumination. After quickly taking a couple of shots of the group, thank them and then move on to the next little gathering. In a matter of about five minutes you can move through almost all of the guests, capturing a series of simply posed groups looking to camera, but try to make it quick so as not to disrupt the guests for too long.

Above It's great to capture those one-off shots. Here we see the mother in-law welcoming her new son into the family.

Below Even when I have released the bride and groom from their shoot, I always pay attention to what they are doing.

CAMERA TIPS

LENS SELECTION

Use a wide-ranging zoom to allow wideangle shots of groups or close-ups of individuals.

Below Remember that during the reception drinks you are not looking to embarrass anybody, just capture images of people having a great time.

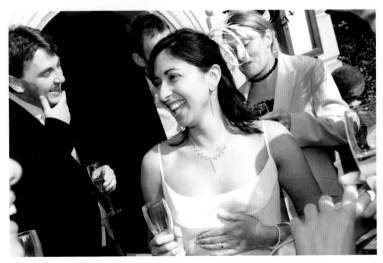

Informal groups

After shooting the small informal groups, try gathering them in closer to the bride or groom and then shoot the picture from a higher viewpoint, by just holding the camera above them and using a wideangle lens set on autofocus. It adds a bit of fun and variety.

Shooting informal groups is a natural progression from the candid shots, as the guests are relaxed and enjoying themselves. So simple, little groups that have been requested by the bride and groom can be taken among the party.

Most couples will request some pictures with some special friends; it may be a large group or just a single person. If these informal groups can be captured during the party, then valuable time is saved later on, but always do these just before completing any large formal groups, as it seems to fit right in the mood of the day – but of course each wedding is different.

A shot of the bride and her close friends is almost guaranteed to be requested, as is one of the groom and his friends. If this is the case, usually a chief bridesmaid will know

the specific people requested, as would the best man or one of the groomsmen, so you can simply ask them to gather the relevant people whilst you continue to shoot.

As an extension to the bride being shot with her friends alone, you can then ask the groom to step in and get all the girls to crowd around him. If the crowd is right, see how many girls can kiss him or get a hand on him at the same time. With the groom and his friends, bring in the bride after the first few shots have been taken; the boys are usually in good spirits and they usually oblige by picking her up or crowding around for a cuddle.

In wet weather, when the guests are inside, it is more difficult to shoot candid images if you rely on flash all the time. When the guests are just interacting with each other, try using a higher ISO and shoot without flash to soak up some of the atmosphere.

If you are asked to photograph a large group, try to use any steps or grass banks to slightly stagger the group. If there are guests behind the couple, this will naturally raise them higher. Any steps can also be used to relax a large group by

Top left *There are always some great characters at weddings, and often they are happy to play up to the camera.*

Above *Keep an eye on the bride and groom, as there may be some special friends that are on a list to shoot later on; if you do it while they are having drinks it will save you time later.*

Left *If you have ever wanted to feel like a paparazzi photographer, a wedding is the perfect place to step up to the plate, as you have to be in and out quickly, so as not to miss each expression.*

getting a guest to sit on the step instead of standing. To photograph everyone at the wedding try to find a window to shoot out of; because of the extra height everyone will be looking up at you and all will be visible to camera.

If there isn't a high viewpoint available, don't be afraid to ask the men to kneel at the front of the group, it's amazing how compact a large group can become. Always try to keep the bride and groom visible at the front of the group and avoid, if possible, anyone standing behind them, except where a high camera viewpoint is possible. Before asking the bride to move, remember there is no reverse gear in a wedding dress, so it's usually quicker to move the guests around her.

Top *Try and choose a high viewpoint where possible, especially in locations where the drinks reception is inside, as it retains more detail in the background, but more importantly allows any harsh flash effects to disappear behind the subjects.*

Above *As you wander around the outskirts of the guests, interrupt the little groups to shoot informal images. These are very popular for the final album.*

Key skills – formal group shots

Almost all couples will request that the bridal party is to dominate the group pictures. Even if you have already taken the formal group pictures at the ceremony venue, you once again gather the bridal party together to start off the rest of the group pictures. This is a good excuse to have a second bite at the cherry with these same people, but now with the opportunity to choose a better background than was perhaps available previously.

1 Now, with a different background and away from the ceremony, you can relax the sense of formality a little. Start with the parents standing next to their respective children, instead of being swapped, unless they are divorced or separated.

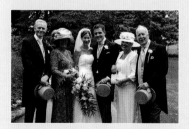

2 The second group is expanded in the same way as you did at the ceremony, with the addition of the bridesmaids and best man. Stand the best man next to the groom's parents and the chief bridesmaid next to the bride's parents; this group will usually include any flower girls or pageboys.

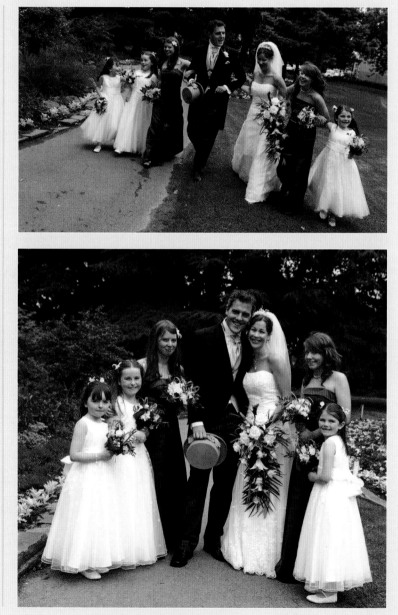

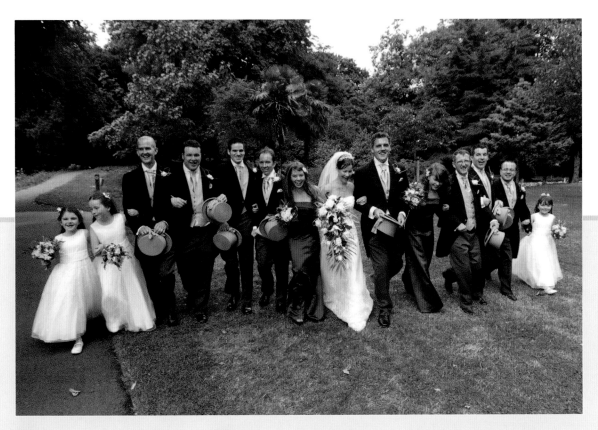

3 Groomsmen are then added to the line-up to complete the bridal party's last picture together. By restaging the bridal party formals you can gather all those who will play a role in the 'family and friends' shots later. This will help, as this group of people will know everyone at the wedding, so they can be used to go and round up specific people, making your job considerably easier.

4 Again, the parents are asked to step out to leave just the bride and groom and their attendants: the best man, bridesmaids, groomsmen, flower girls and pageboys. If there are very young children, try to complete their photographs now by shooting some images with just them and the bride and groom, just in case they get tired later on or start to rebel.

5 Traditionally, the formal shots are completed with the bride and groom and each set of parents: the bride and groom first of all with her parents, and then with the groom's parents. In each case pose the group boy, girl, boy girl; in short, the father or father-in-law next to the bride and the mother or mother-in-law next to the groom. Take each as full-length and three-quarter-length portraits.

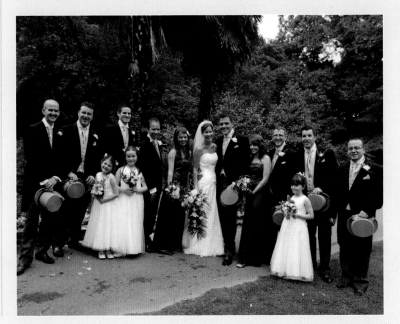

Key skills – group building

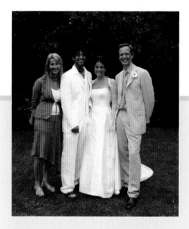

Both large and small groups photograph best when built from the middle, as this will put the important people next to the bride and groom in order, gradually stretching the wings of the group outwards equally with the additional people requested.

Far left Always start with the full-length shots; if you get the pose right here it is simple to build the groups.

1 Starting with the bride and groom as the middle of a family group, the family is usually added in the following way: first the bride's father next to her and her mother next to the groom, making the bride's parents the first wings of the group. The bride's brothers and sisters are then added evenly on each side, following a boy, girl, boy, girl pattern – when possible, place a brother next to the mother, and a sister next to the father. The immediate family is completed with the addition of the grandparents: the bride's father's parents on his side and the bride's mother's parents on hers. I like to make little exceptions, as I prefer the grandparents to have at least one grandchild on the outside of them, making them an inner part of the group instead of being at the edges of the wings.

2 The big family group, if it has been requested, is again evenly distributed to either side of the family group, retaining the boy, girl, boy, girl order if possible. When the family is very large – upwards of 50 people – request that all the men of the extended family (excluding the bridal party as they are already in position) stay in

front of the group while you can quickly reposition the ladies that are coming in; the men can then be repositioned in front of the ladies and asked to kneel. The gentlemen on your left kneel on their left knee and the gentlemen on your right kneel on their right knee – they soon get the point. If there are any young children they can be positioned in front but not obstructing the bride and groom. The process is then repeated for the groom's family.

Below While you are adding people to the group guests who have a special relationship with them will often greet the bride or groom fondly.

Above Come in closer for the three-quarter-length shot.

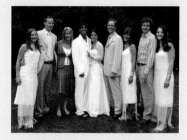

Above Add the brothers and sisters around the parents, turning their bodies inwards to keep the group compact.

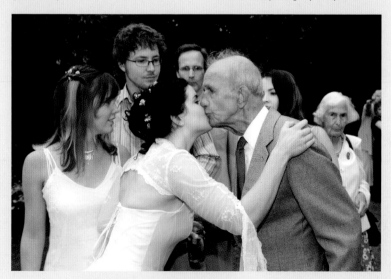

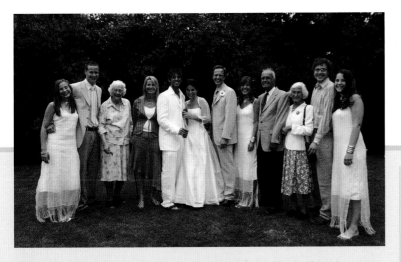

Above The only time I reposition people between other subjects is when I add grandparents into a group; I feel they should not be at the ends, as they are integral to the family.

Whenever possible avoid people standing behind other guests; this is distracting to the eye, and often results in someone being just out of sight, hidden behind another guest. When guests are joining the group, some will naturally want to interact and congratulate the couple; don't miss these candid moments, as they are simple to shoot and break up the monotony of lots of posed groups.

3 Friends of the family are not always requested in advance, but if they are requested it is best to identify whether just the friends of the parents are required or if they are to include the friends of the bride and groom as well. It is usually the first case, and if this is so make sure that you shoot two separate shots, one for the bride's parents and another for the groom's parents, so the groups will be more intimate.

4 A shot of the bride's and groom's friends is always a good idea, and I prefer to shoot them separately. It makes the groups smaller and easier to manage, but also creates more fun expressions compared to larger groups. I usually start with the bride and all her girlfriends, and then finish with then the groom and all his male friends. If the couple have requested some special friends in smaller groups, it is usually a good idea to do them after the larger groups.

5 If all the family and friends group shots are to be taken at the ceremony venue, do this as soon as possible once all the guests have come out, with any formal groups taken outside the main doorway. Use your prepared list for the groups, as this allows you to flow easily from one group to the next, including whoever is necessary.

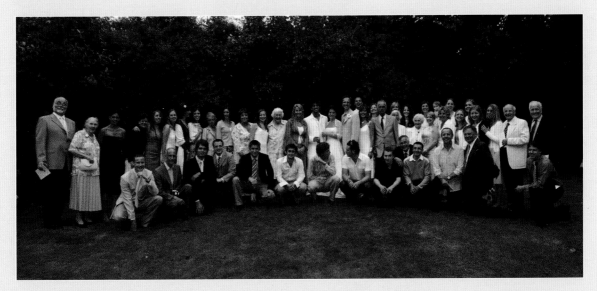

Above To complete the family groups, aunts, uncles and cousins are added in. If the group is too large for everybody to stand ask the men to come forward to the front of the group; once the ladies are organized, ask the men to kneel or crouch.

Key skills – group building **125**

Cake cutting

The cutting of the cake is one of the final official photographs to be taken. It is best mocked up before the actual cutting of the cake in front of guests, so you can control the event and avoid any camera mistakes.

To get the best out of the cutting of the cake you should shoot a variety of photographs, some with flash and others with just natural light. The groom is posed furthest from camera and, if possible, at about a 'one o'clock' position from the cake as looked at from the camera, to ensure he is not hidden behind the bride. The bride is posed to her husband's side with their inner arms around each other's waists. The groom is then given the knife, and finally the bride's hand, nearest to camera, is placed on top for a more feminine finish to the pose. If the cake is tiered, the knife is placed on a tier that feels and looks comfortable, remembering that in Christian weddings the top tier is never cut, as this is traditionally kept for the christening of their first child.

The first shot is usually full length and looking at camera, and if there is not a good quality of light from the likes of a large window, flash can be used in combination with the ambient reading. Again flash can be used on the three-quarter-length shot, which is a close-up including the full cake. To finish the series the flash is switched off for the 'looking at the cake' shot; this is always a good back-up in case a subject blinks when looking straight at the camera. A final tip is to avoid all four hands being placed on the knife – it just looks messy.

Above Don't forget to shoot the cake on its own; it is amazing how detailed it can be and how much work has gone into it.

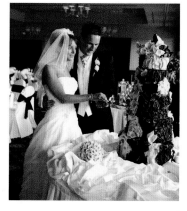

Top With the 'looking at camera' shot, if there is not enough natural light use fill-in flash combined with the ambient lighting available.

Above Natural light is used where possible to preserve as much of the natural atmosphere as possible.

Right As long as the couple don't look towards camera, you can shoot in any light conditions with a high ISO just to record the atmosphere.

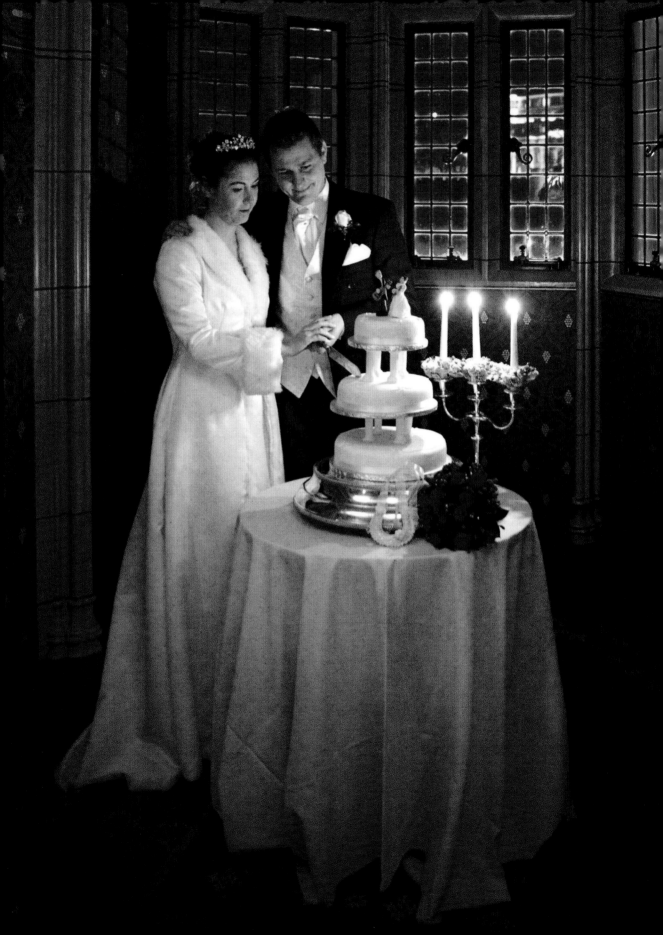

Details

Before all the guests come in for dinner, shoot the detail shots of the tables and all the decorations. Some weddings are very elaborate and others quite simple; in either case shoot both the overall scene and close-ups.

THE CAKE

The cake is a traditional detail of the wedding reception. It should be shot from several angles: the classical straight-on one with a little fill-in flash for the correct exposure, and then closer up or from above to show the fine details, using natural light where possible.

TABLE DECORATIONS

Flowers are usually found as the centrepiece to most tables, but each wedding is different. The tables are often decorated uniquely; I have even seen goldfish in bowls being used at times. The bride's and groom's place cards are a key detail to shoot, as is the menu with the location's name and logo, as well as the inside of the menu itself to show what the guests had to eat. Don't just shoot these details straight on; try shooting from an angle to throw the background focus out quickly when shooting details close up.

Don't forget to shoot the whole room, trying to include people in the room where possible so it looks alive. Even the bride and groom adjusting place cards or presents adds to the atmosphere. If you use a tripod with a slow shutter speed, the people will appear blurred, giving images a more abstract effect.

Top *A lot of work will have gone into the table decorations so these are great details to capture.*

Middle *As well as taking close-up shots of the flowers, make sure that you show them in context.*

Bottom *Place settings can help to capture a sense of the individuality of each wedding.*

Right *As well as the shots of the cake by itself and being cut don't forget to capture any little details.*

Meal and speeches

Depending on the wedding the meal itself may or may not be photographed, but coverage of events beforehand, such as the bride's and groom's entry, and after the meal, such as the speeches, may be requested.

When the bridal party first comes into the reception room the whole place seems to erupt with clapping and cheering, so some candid shots, both wideangles and close-ups of people's expressions, will set the scene. Then when the bride and groom are officially introduced to the room the place once again erupts; however, this time the camera should be aimed at the couple instead of the guests to capture their emotions. Once the room has filled I generally take my leave unless I am asked to photograph the speeches, which usually take place following the meal; however, there is a trend for speeches to start before any food is served. This is so the bride's father, the groom and the best man, who are the traditional speech makers,

can get the speeches out of the way and then fully relax and enjoy the meal. Be prepared by asking the couple in advance what they plan to do.

If you are staying on to shoot the speeches at the end of the meal as well as the party later on, always request something to eat in a side room in advance. By this time you may have been shooting for close to four hours, if you started the day at the bride's home, and you will be shooting for at least another three hours or even more, depending on what time the dances start, not to mention other events later such as fireworks. Taking time to refresh yourself so you can stay enthusiastic and creative is a crucial part of your time management.

The three main speeches can take anything from 20 minutes to one hour, depending how confident the speakers are; however, it is not unknown for additional speakers to spring to their feet and add extra time to the event. I use a

Above *Exposing for the ambient light and then adding a little flash prevents the shadows being overly harsh.*

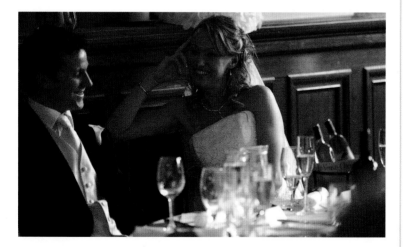

Above *Whenever possible you should try to shoot images under the ambient lighting. This will help to keep images looking natural and also preserve more of the atmosphere; it is also less intrusive than using flash.*

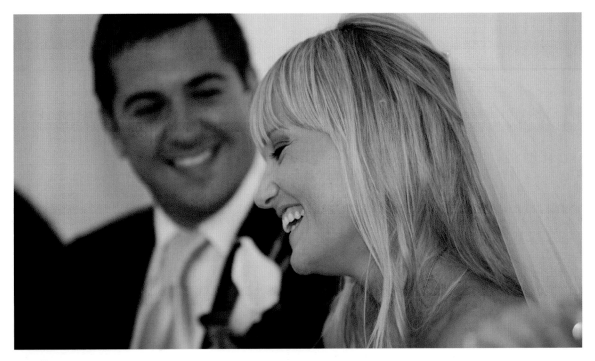

70–200mm zoom lens, which allows me to capture the speakers from a distance, instead of being too close and making them even more distracted and nervous.

The secret to shooting speeches is capturing a variety of angles for each speaker and a variety of close-up expressions to support each speaker, from the guests as well as the bridal party and the bride and groom. Speeches are not always funny, so be prepared for some solemn moments, especially if close members of family have passed away recently, or not been able to attend due to illness or so on. At this point you should use your instinct when deciding who and what to shoot.

A second flash unit can be used off camera to add directional light to create more dynamic photographs of the speeches. I get my assistant to hold the flash high and at 45 degrees to the camera and the subject. When used perfectly, this adds light to the five planes of the

speaker's face. If you don't have an assistant to hold the flash, put the secondary flash on a stand in a place that is suitable for all the speakers, to give variety to the lighting. When using flash, a great way to move away from the stereotypical flash-lit look is to turn a shot into black & white – the images seem to naturally come alive when shot using a reportage style and monochrome.

Right Always capture shots of guests looking happy and laughing.

Below right Gifts and flowers are often exchanged during speeches, so be prepared.

Below Setting the scene, using ambient light, will add variety to the speech shots.

Above In this case a close crop has added impact to a split composition.

Below The best man's speech is one of the most important, so make so you shoot it.

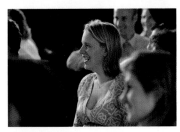

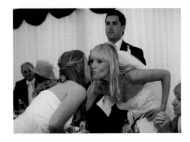

The party

If you are requested to shoot the party, be prepared to hang around for a while, especially if the wedding ceremony was early in the day. The first dance may take place hours after the end of the meal and speeches.

If there is a very long gap – two or three hours – between speeches and the evening reception, I often go back to the studio if it is within a 20 minute drive of the reception, so I can start to download and edit my images from the day. However, if the gap is less I usually stay at the reception and download to my laptop if there is time.

There are usually extra guests who arrive just for the evening reception, and this usually prompts some more group shots, especially for close friends of the bride and groom who have not been able to make the ceremony for some reason. If possible I like to know what groups to shoot, so I can schedule them accordingly.

THE FIRST DANCE

The first dance is a great event to photograph. Its timing varies, so check with the DJ or the band to see if they have an approximate time. During the first dance, shoot a variety of images, some with flash and some without; the ones without flash are for the scene or to capture the atmosphere, while those with it are to capture the couple. You will normally have to use a high ISO in this situation in order to allow a faster shutter speed so as to freeze the movement. The images taken with flash are again first exposed for the spotlighting and coloured lights, which is the norm in most reception

rooms; flash is then used to 'white light' the close-up shots of the couple, to bring back the natural flesh tones. To strengthen the colours of any lights, you should underexpose the scene slightly by using a faster shutter speed. Combined with a burst of flash this will freeze the couple, but also make the background scene darker.

Top Shoot against the light to silhouette the couple against the coloured disco.

Above Use slow shutter speeds and flash to combine freezing and blurring effects in the same image.

EVENING MEAL

If there is an evening buffet or even a sit-down meal, remember that the secret is in the detail, so shoot some still-life shots of the food as well as any different table arrangements.

FIREWORKS

Fireworks are a great end to the day and really finish off a wedding album well. Again, like the rest of the day, the secret to shooting the fireworks is preparation. Find out where and when they will take place so that you can locate the bride and groom accordingly for the best photographs. You can shoot three main styles of images: the couple and guests lit with flash to capture their expressions as the fireworks explode; the scene from behind the couple and guests to show silhouettes lit only by the explosions; and sky shots of just the fireworks. These can also be used as backgrounds to the pages in the album when appropriate. You'll need slow shutter speeds with fireworks to show more of the explosions, so a tripod is absolutely essential.

Above Fun food always makes for great detail shots. Try shooting between guests to bring extra interest to the scene.

Below Shots of special friends can be humorous to reflect the party atmosphere.

Above Faster shutter speeds freeze the explosion of fireworks; try 1/60–1/15sec.

Below Slow shutter speeds allow the guests to be silhouetted against the smoke.

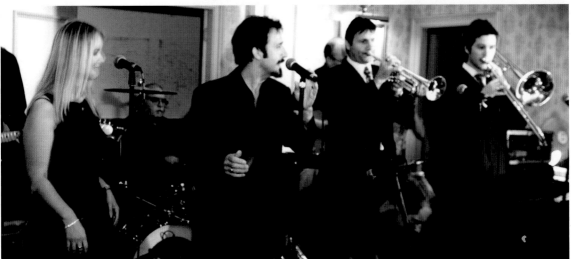

Above To make a flash-lit image more funky, turn it to black & white and then add a colour tone in Photoshop with the Image – Adjustments – Colour balance function.

part three 3

Now that the wedding day is over, the next stage of being a wedding photographer starts, with all the post-production work associated with digital photography.

The secret to post-production efficiency is keeping your workflow simple. To start with, make a new folder with the date of the wedding and the clients' names as the reference. This folder can be stored within the folder for your camera, or wherever you store your images on your computer.

The memory cards can now be downloaded one at a time into sub-folders which should numbered for each card – this is done via a card reader. I download each card into separate sub-folders in case I ever have any problems with a card or file. This is very rare, but it allows me to trace the file and the problem back to a specific card.

When all the wedding images are downloaded I recommend that you burn all the files to DVD and use these DVDs as your first point of back-up. Once you become proficient and confident with digital files you can postpone burning to DVD until after you have edited and renamed the files, but always remember to burn the files at least once before deleting them, just in case you make a mistake.

Selecting images

Once the images have all been downloaded you can now start to edit each card's-worth individually. I use Adobe Bridge, which is the file browser and manager within Photoshop, but each camera camera manufacturer has its own editing software, which is usually packaged with the camera, so you could use this instead.

In the Adobe Bridge window the thumbnail image of the file will be visible when each folder is selected. I use the slideshow view to select which images to keep and which to delete – similar tools are available in other programs. I attach a red label to the images I want to delete, making them easy to identify later.

Once the initial editing is done, it is usually a good idea to review all the images that are still left in the card folder and edit out any more undesired images before renaming those that are left.

When the editing is finalized, batch renaming of the images can be simply done from within Adobe Bridge using the Tools – Batch – Rename function. You can perform this task individually within each card folder or, better still, drag each edited selection of images into a new subfolder called 'original files'.

Above *The contact-sheet-style view within Adobe Bridge is the most popular; the thumbnails can be made smaller or larger using the slider bar at the bottom of the screen.*

Step one – left *The slideshow mode within Adobe Bridge is simple to use and is quick to apply a colour label reference.*

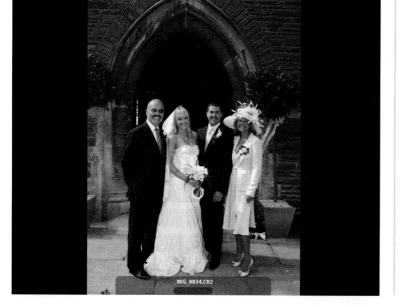

CAMERA TIPS

Elements

Photoshop Elements is a cheaper alternative to the full version of Photoshop. It has editing facilities and some retouching options as well.

Step two – left Back in the contact sheet mode, you can select the labelled images quickly from the edit menu.

Step two – left Back in the contact sheet mode, you can select the labelled images quickly from the edit menu.

Step three – below Alternatively you can choose to view just the images with the red label in the filtered option.

Step four – below Now that you have all the red-labelled images selected, they can be quickly dragged to the Deleted folder with their original camera filenames intact.

Once the images have been all moved into this folder, batch renaming can take place. This option is also available in many other programs.

These same techniques can be used to edit JPEG files within Adobe Bridge. Always keep any files that are similar to the one that you wish to keep – just in case if someone in the group has blinked or looked away. This will make the cloning of expression or opening the eyes simple to do later in Photoshop.

Step five – far left If you have been using multiple cameras on the wedding day and have set them with identical date and times, use the View – Sort – By date created function to sort the images according to the time when they were taken.

Step six – left When the Batch Rename dialogue box appears, I use a combination of two letters, then a space and then a three-digit number to rename the files.

Correcting colour

If you follow my lead and shoot RAW files, corrections to colour and exposure are very simple and can all be achieved within the Camera RAW section of Photoshop, or even from within the Adobe Bridge window. These correction techniques can also be made within camera manufacturers' proprietary software that is typically bundled with the camera.

When correcting colour fully, it is essential to have a calibrated monitor; otherwise you may be correcting a colour cast that is actually only due to your screen. If you do want to see exactly what you will get from a photo lab or from your inkjet, then some monitor calibration is essential.

Within Camera RAW the 16-bit files can be adjusted individually or as a group, applying correction across selected files at once. This makes colour correction and exposure corrections much easier and, more importantly, quicker.

Step one – top By default, Adobe Camera RAW takes over exposure by applying auto adjustments to exposure, shadows, brightness and contrast. This may be good for some photographers, but I prefer to have a tighter control of my images, and you probably will too, with experience.

Step two – above By shift-clicking a group of nine similar images from the thumbnails – all in a similar location and hence of a similar tone, you can correct them all together. Switch off all the automated boxes in the adjustment panel, then, by selecting the white balance tool you can quickly give a corrected white balance to the images by clicking on the bride's veil.

CAMERA TIPS

JPEG actions

For simple corrections to JPEG files make and use automated actions from within Photoshop to make adjustments to density and colour more convenient and much quicker.

Step three – left and below One of the most powerful benefits of using RAW conversion software is the ability to correct exposure, especially in images which have been dramatically overexposed. Here you can see the 'before' and 'after' examples of exposure corrections. This correction can now be applied to the other overexposed images listed as thumbnails at the side. If these images had been shot as a JPEGs, all the detail in the bride's dress as well as her veil and the side of her face would have been burnt out with no detail; even with some correction within Photoshop, all the images would retain very little detail in the highlights.

Step four – below Now, by selecting the other images in the group, you can apply synchronized changes from the adjustments made to the initial image.

Step five – below If you are planning to crop your images, the synchronization can be used to apply a set crop to a number of images; however, remember to uncheck the Exposure and White Balance boxes and just have the Crop box ticked. As well as set ratios, you can create a custom crop to your desired size and shape.

Batch processing RAW files

To turn the fully editable 16-bit RAW file into a workable image you have to process the RAW file into either a PSD, TIFF or JPEG. The JPEG format is the most common because its compression makes it smaller – suitable for emailing or posting on the internet – but it is also the most universally accepted file type and can be opened in practically any program. TIFF files are larger, but better for storage because they are not compressed, while other formats such as PSD files include layer information, but need to be opened by more specialized software such as Adobe Photoshop.

Once all your corrections have been applied the RAW files can be batch processed. Unlike a processed film, a RAW file can be processed time and again, applying different corrections without altering the underlying image.

Step one – above RAW files need to be processed into a workable file such as a JPEG or TIFF, to be cropped or enhanced further within Photoshop or to be opened in other software.

Step two – below I have made a new folder called 'JPEG files' to hold the processed files.

Step three – left **Step three – left** Once the folder to which you want to save the files to has been selected, you can press the Save button to start processing the files.

Step four – above While the first batch of images is being processed you can start to colour correct, crop or enhance the next batch before beginning to process them.

Below Even when you close the Adobe Bridge window Camera RAW continues to process the images.

Step five – below Once you are confident colouring and editing your images you can use the File – Scripts – Image Processor to process the RAW files all at once, with the added benefit of being able to save to more than one file format at a time, as well as being able to apply an action to further automate the processing.

Proofing the images

Proofing a wedding album can be an expensive exercise if you go straight to print. Some photographers do print all the selected images to album size and then use them in the actual album, but I find that the prints soon get damaged and some of the proofs have to be reprinted anyway. I prefer to go to a 'soft-proof' stage, in other words giving my clients the chance to view images on screen either via a DVD or on a website.

SOFTWARE SOLUTIONS

A simple and cost-effective way of proofing images is soft-proofing via a DVD or CD. You can use specialist software such as ProShow Producer or ProShow Gold; although many computers come with DVD creation software loaded as part of the package. These programs can create simple but effective DVDs from which the couple and their families can view and select their images.

VIA THE INTERNET OR A WEBSITE ON A DISK

Another simple way to proof images is to build a quick website from within Photoshop itself. The selected images can be automatically transformed into a website – even a website with Flash capabilities – to enhance the viewing experience. You will find this function in Photoshop under File – Automate – Web Photo Gallery, where you can select from multiple design layouts.

CAMERA TIPS

ADOBE ENCORE
Also check out Adobe Encore DVD, which is software that will easily build professional slideshows to show off your images in a menu-driven DVD.

Step one – top There are many DVD creation programs on the market, this screen shot shows the basic layout of ProShow Producer. The images to the left with the green ticks have been dragged down to the bottom slideshow window. A standard slide viewing time, which is shown on the slide, is automatically set; however, this can be adjusted, as can the dissolve time shown between two slides.

Step two – middle In this second screen shot you can see the Options palette from which you can set the dimensions of the show, and information on any sound tracks that you have selected, which can be dragged down to the Soundtrack bar in the Slideshow dialogue box. Most importantly in the Show Captions dialogue you can add studio information as well as the filename, and of course the most important feature for any professional: the option to add copyright information.

Step three – bottom Because of the number of images I shoot, I find it beneficial not to make one big show, but normally six smaller chapters, basically mini-shows. Each of these shows is then made into a project and finally burnt to DVD. The software makes a video file of the show, making it look fantastic on any television; however, the images can look soft if viewed on a PC.

CAMERA TIPS

WEB HOSTING
There are many hosting sites that will host your images for a monthly fee, as well as allowing you to accept orders online, again for a small fee.

Above A simple clamshell cover packages a DVD, with a slideshow or website on, attractively and protects it from scratches. I use printable CDs and DVDs which go through my small inkjet printer to make labelling more convenient.

Step one – left To create a website in Photoshop select File – Automate – Web Photo Gallery to launch the dialogue box.

Step two – below left When the Web Gallery dialogue box appears, select the style of gallery you want from the drop-down menu – this includes some Flash galleries. There are other options that can be set, such as site name, copyright information, contact information and so on.

Step three – below When complete, a gallery will be automatically launched on your screen. This gallery and its images can now be burnt to CD or uploaded via your internet service provider to a website.

Mark Cleghorn Photography
01633 681671 debbie@markcleghorn.com
T- 01633 681671 Mark Cleghorn Photography
debbie@markcleghorn.com
10/11/2006

AM 198.jpg

Proofing the images (cont.)

Contact sheets are a cheaper alternative to having all the photographs printed, especially when you shoot as many as I do at a wedding. A quick way of doing this is to use Photoshop's Contact Sheet Builder to make the basic contact sheets and add a copyright layer over the top via a previously made action.

Step one – top *In Photoshop select File – Automate – Contact Sheet II.*

Step two – bottom *A pop-up dialogue box will appear where you set the width, height and resolution, as well as how many columns and rows you require. You can also select whether or not you wish to have a file name on the contact sheet as well. When I proof to contacts I print a 16 x 12in (40 x 30cm) sheet at a resolution of 300dpi. I select four columns and three rows to give me 12 images per sheet.*

Step three – top *When all the contact sheets have been made they are left on the desktop in a layered format ready to be flattened into one layer and saved or further enhanced.*

Step four – bottom *As you can see, on the finished contact I have copyright information all through the contact sheet. This is based on a previous template I made up using a variety of copied layers created via the text tool in the desired size and font. This is connected to an action (see page 156) to copy and paste onto the contact sheet, before flattening and saving it.*

Step five – above Once all the layers of text are in the correct place, merge them together and then reduce their opacity to between 8 and 15% depending on the effect required. This file is then saved in a folder dedicated to templates and where later my action will be pointed to. Make sure that the file that the text layer is the one highlighted before you save and close it, this will allow the action to run smoothly.

Step six – above right An action is made to first open the template file, then copy all of the text layer before shutting the file down and then paste it on the open contact sheet. The contact sheet can then be flattened and saved to a location, and then closed before the action stops itself and resets.

Left The finished contact sheet is very effective. You can add more text and contact information by simply adjusting the template file first.

Below I present my contacts in a binder as this looks much better than a number of loose sheets.

Cropping and enhancement

The use of Photoshop has revolutionized the imaging industry. Almost every function has been digitized and this has transformed the process of making corrections. They can now be carried out in a fraction of the time, with more accuracy and consistency.

Photoshop allows you to fine-tune the composition of your image by either cropping freehand, or to a set size and shape. If you have shot in RAW format the image can be cropped before processing within Adobe Camera RAW or by using your manufacturer's own software.

You are also able to adjust the resolution at the same time. If no resolution is set, only the physical dimensions of the image will change. When you set a resolution, the crop will alter the actual number of pixels, creating new ones to make the image larger or deleting them to make it smaller.

Step one – top Select the crop tool from the palette or press 'c'.

Step two – above right To perform a freehand crop, without setting a print and resolution size, just drag the crop tool over the image. Then fine-tune your crop by adjusting the edges of the box.

Step three – right To set the desired size to crop input the height and width in the tool palette. The resolution can also be set in the relevant box.

Step four – bottom right To straighten an image quickly, draw along a straight edge with the Measure tool from the tool pallette, then go to Image – Rotate – Arbitrary and the rotation will be set.

Step five – far right When the image is rotated in this way the background area will increase to fill the page.

CREATE A VIGNETTE

Creating a vignette, a darkening or lightening of the edges and corners of the frame, can help to draw the viewer's eye to the subject.

Step one – right *In Photoshop go to Filter – Distort – Lens correction. Select the vignette slider and move it to the negative end of the slider, when satisfied press OK. When you have finished doing this, remember to flatten the layers of the image, as the vignette is initially created as a separate, invisible layer.*

Below *The slightly vignetted corners stop the viewer's eye from getting distracted by any messy edges, concentrating their attention on the main subject.*

Step two – below right *Move the slider right for a high-key effect.*

Below *'Before' and 'after' images of a high-key vignette.*

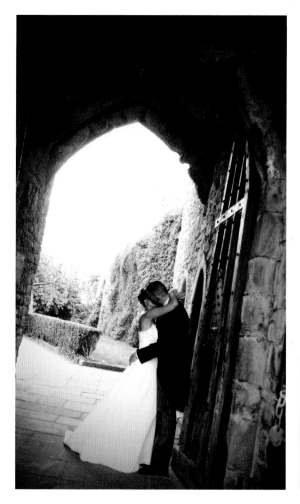

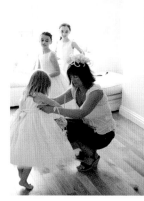

Converting to black & white

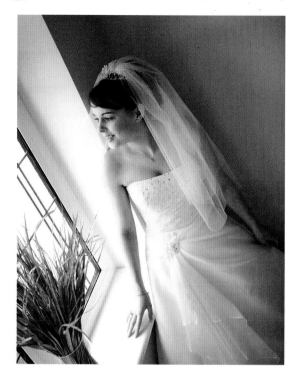

Step one – above *Choose image – Adjustments – Channel Mixer*

Step two – below *Check the Monochrome dialogue box, then alter the tones by changing the Red, Green and Blue sliders.*

To turn a colour image into black & white couldn't be any easier than with Photoshop. As with most effects within Photoshop, there are several ways to achieve the same result; certain techniques will be better suited to different images, while some are more straightforward or others time-consuming.

Personally I find that the best black & white conversion tool is the Channel Mixer adjustment. Even though the Desaturate and Greyscale options are quicker, the Channel Mixer technique offers far more control, while still being easy to manage. To start go to Image – Adjustments – Channel Mixer.

Top left *Having the option to convert images to black & white allows you to add variety to an album.*

Right *If you need to improve the tones of an overexposed or high-key image try setting Red +50, Blue +25, Green +25 as a starting point.*

Avoid turning your image to greyscale as it will be slower to drag and drop onto a wedding album page later on as most of the images will be colour RGB files.

When using Channel Mixer for the first time make a new adjustment layer, as this will be fully editable. By double clicking on the layer icon the Channel Mixer dialogue box will be launched for readjustment. This is especially useful for more difficult images, and you can even drag the adjustment layer to other images to apply the same effect.

BLACK & WHITE IN RAW

If you want to turn images into black & white at the RAW stage, open the RAW image in Adobe Camera RAW and set the saturation to –100. Now the temperature slider adjusts the monochrome tones instead of the colour. Adjust your image with the Contrast, Shadow and Brightness sliders and save the settings. You can now apply these to any number of RAW images, either via Adobe Bridge, by right clicking on the selected images, or by applying a saved setting in Camera RAW. Similar corrections can be carried out in proprietary programs.

Step one – above Set saturation to –100 to remove the saturation from the image completely, changing it to monochrome.

Step two – above Once the saturation has been removed you can adjust settings such as the colour temperature, tint, exposure, contrast and so on, to fine-tune the monochrome effect.

Left Once you are happy with the final image, you can save both it and its settings. This will allow you to apply exactly the same monochrome effect to future images.

Adjusting contrast

The first point of any correction to an image should be its contrast, as this will have an effect on the depth of colour in an image, but not its tone or saturation. Once the contrast has been set using this adjustment, the colour can be corrected as any colour cast will be more intense.

Setting the density and the contrast of an image is best done within the Levels adjustment in Photoshop. This offers a live preview so you can see the effects of the changes that you are making as you go along.

Step one – above *Image – Adjustments – Levels*

Step two – right *When the Levels dialogue box appears it shows a histogram – which looks like a black 'mountain range' – that relates to the amount of information at each tonal value in the file. This particular image shows a lot of information in the mid-tones, but drops off to the left and right side. This means that moving the black and white sliders inwards, will increase the contrast, without losing any information.*

Step three – below *The image can be made darker by moving the left slider towards the middle, this is the adjustment to the black point. Then the white point can be adjusted by moving the right slider, in this case inwards. When making these adjustments be careful not to overdo it, as you risk blocking up shadow detail or blowing out highlight detail. Once you are happy with the effect, click OK.*

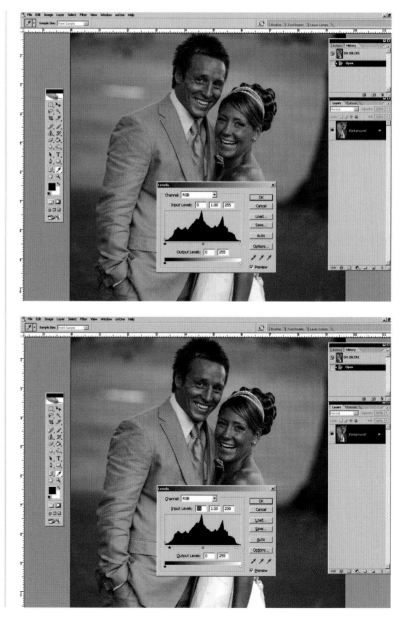

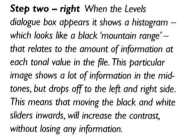

CAMERA TIPS

ACCURATE ADJUSTMENTS
To set your black and white points accurately, press the alt key while moving the black and white points. This will show the parts of the photograph that will be blocked up or blown out.

Adjusting colour

If you have shot a JPEG file on camera you will have to adjust colour in Photoshop. This is a much slower technique than adjusting colour en masse with RAW files. At the same time as correcting the contrast in levels, colour can be corrected in the image; selecting the middle grey picker tool in the levels palette does this for the mid-tones.

Another way to change the overall colour in an image with little variety of colour tone is to select the Image – Adjustments – Hue/Saturation tool. Firstly in the Hue/Saturation dialogue adjust the master hue to a negative value to add warmth slightly often –3 or –4 is enough.

When shooting RAW files, adjust the colour in the RAW software. When you are more experienced in Photoshop, colour can be adjusted in many ways: try selecting the individual colours within the Hue/Saturation dialogue box, or for greater accuracy use Image – Adjustment – Channel Mixer.

CAMERA TIPS

COLOUR
When first trying to learn about colour and what adjustments to make in Photoshop go to Image – Adjustments – Variations. This is a traditional wheel of colour which can be used for small or large adjustments, it's a good tool to learn about colour.

Step one – left To neutralize an overall cast in an image select Image – Adjustments – Levels.

Step two – below Select the grey point picker, the middle of the three sliders at the bottom of the histogram, then choose a part of the photograph that has a neutral grey tone, perhaps something white that is in shadow.

Step three – above Clicking the top of the bride's dress has removed the blue colour cast.

Colour touch

'Colour touch' is a term for adding a single colour to a specific part of a black & white image. Traditionally this was done with coloured dyes on a black & white print, but today it is a simple effect that can be easily achieved with the use of Photoshop.

The simplest way to achieve this effect is to start with a colour image on screen. Turn this image into black & white as previously explained on pages 150–1. Double click on the Zoom tool in the Tools palette to view the image at 100%. Now select the eraser tool (press e) and check the Erase to history box – in the tool options .

Now use the eraser over the part of the image where you wish to bring back the colour. If you have brought back some colour you do not want use the sponge tool (press o) on the tools palette and set its option to desaturate and then paint over the area of unwanted colour.

Step one – top Convert your chosen image from colour into black & white using the techniques described on pages 150–1.

Step two – above right With a small-diameter eraser brush selected, erase the parts of the image you would like to be back in colour.

Right The final image combines a splash of colour with the classical simplicity of a monochrome image, and this makes it an extremely popular choice for albums.

Retouching

Retouching an image in Photoshop can help create a more flattering portrait. Retouching is quick and can be used either to correct photographic mistakes or to enhance the subject's features or make flaws disappear.

There are several ways to retouch an image in Photoshop. Each tool is suited to different situations, although some are not available on all version of Photoshop.

Below The clone stamp tool (s) is the original retouching method in Photoshop. It is present on all of the versions of Photoshop and is simple to use. When the tool is selected from the palette, select a brush size from the top, tool options palette as well as its edge hardness or softness. Press and hold the alt key to select the area to copy from, this can be from another image as well, click to select.

Above The spot healing brush (press j) is relatively new to Photoshop, and is used to heal an imperfection from the surrounding areas of the brush. This makes it perfect for cleaning up any dust on the sensor, or an unwanted piece of litter on the floor. Select a brush size that is slightly larger than the affected area and then move the tool slightly as you click to heal.

Above right The patch tool can be selected from the drop-down menu under the spot-healing tool. This is my preferred tool for retouching the face, especially any lines under the eyes and any spots. Simply select the tool, then draw a selection around the area to be retouched. Once happy with the selection, drag the selected area to the area that you want to patch from. Photoshop will do the rest; it really is that simple.

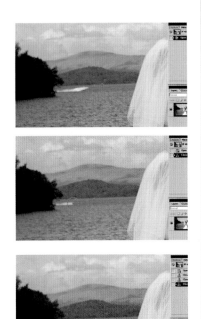

Above If you plan on spending a lot of artistic time retouching, invest in a pen and tablet, which will make retouching a lot easier – especially the art of making selections.

Photoshop actions

Using actions to change contrast and colour automatically is just the start of being able to harness the power of actions in Photoshop. Making an action is simple and will save time in the long run, especially when you link these actions together. Actions can be made to do almost anything. To make an action first select the Actions palette, if it is not visible, launch the palette from Window – Actions from the drop-down menus.

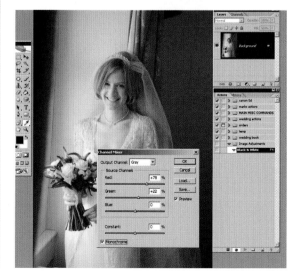

Step one – above top and bottom *If the palette has many colours, the actions are in Button mode, and to make an action you need switch this off. Do this by selecting the small arrow at the top of the palette, then click on Button mode to switch the option off.*

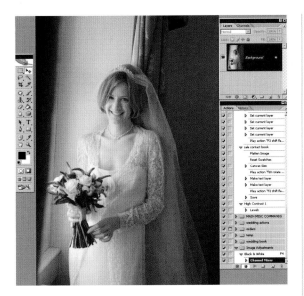

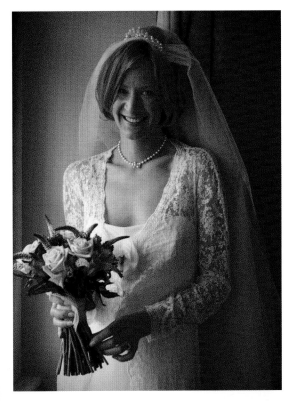

Step two – above left Click the arrow again to open the drop-down menu, and select New Set. It is a good idea to store actions in different sets so you can delete or reload sets when saved. Name the set Image Adjustments.

Step three – left Again click the arrow and select New Action. name it, for this exercise 'Black & White', as this is an action to automatically make a colour image monochrome. Set the function key to F4 and choose a colour: in this case red.

Step four – below left Notice the Record icon at the bottom of the Actions palette is now red. This indicates that Photoshop is now going to copy everything you do until you stop it..

Step five – above Once you have made the alterations you desire, in this case converting the image to black & white, press Stop – the button to the left of the Record icon.

Step six – left and below Now any image can be altered to monochrome, either by selecting the 'Black & White' action and pressing the play icon or in Button mode by pressing the red button labelled 'Black & White' or by simply pressing a short-cut key that you have assigned to the task.

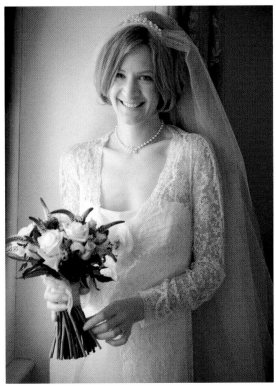

Above The two images here show how what would otherwise be relatively complicated and lengthy alterations, in this case from colour to monochrome, can be applied quickly using actions.

Using layers

Layers are used in Photoshop to make retouching and the blending of images together simpler and more effective. When working in multiple layers, a retouched or altered layer can have its opacity changed to make the layer semi-transparent. It is also possible to choose a blending mode to change the effect.

Step four – below Use the opacity in the layers palette to change the transparency of the layer.

Step three – below Select the background layer and play the Black & White action. Notice how the top layer is still in colour.

Step one – both images above Open an image, then select the marquee tool and then drag a selection onto your image.

Step two – above Now select Edit – Copy, then Edit – Paste; notice in the Layers palette how the copied section of the image has been pasted as a new layer.

Step five – above right Use the Layer Blend mode in the drop-down on the Layers palette menu to change the image instantly. The layer's blend mode changes the way the top layer interacts with the bottom layer.

Step six – above Choose a combination of blend mode and opacity, here the hard-light blend mode and then a change of opacity is applied to make the top layer slightly transparent to pick up more of the black & white background layer.

Using effects filters in Photoshop

An image can be quickly transformed with artistic effects by applying one or more filter effects, but be careful not to waste a great image by overdoing the effects. A filter should always be used to enhance an image and not detract from it, so choose the filter carefully. There are hundreds of effects that can be applied, especially since in Photoshop the filters can be combined to make a completely new effect. Here are some of my favourites:

Cut out

Dry brush

Noise

Diffuse glow and film grain

Diffuse glow

Water paper

Above *Filters can now be combined for different effects in Photoshop CS2 and later editions.*

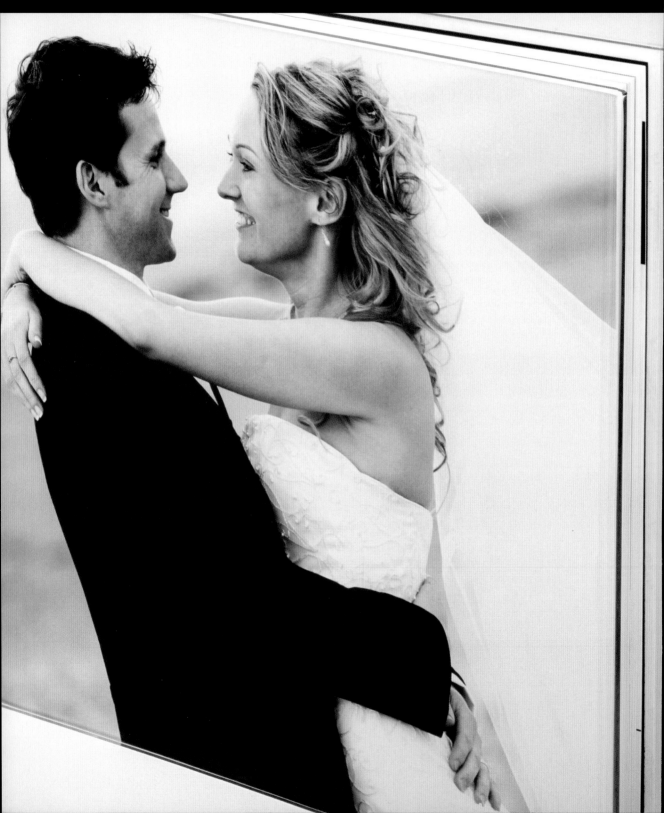

Finally, the bride and groom have selected the images for their wedding album as well as for gift prints and perhaps the wall. Weeks or even months may have passed since the wedding day, but now at long last the images will really come to life with a few final adjustments, as well as any additional retouching if it is requested.

The way the prints are displayed will add the final flourish. If a traditional album has been selected by the bride and groom, the images will go behind an overlay before being fixed into an album, but if the couple have chosen a creative album the images can be laid out in a magazine style to create an additional enhancement.

Page layout for overlays

Using overlays is the traditional way that wedding albums have been put together. The print overlay was originally designed to prevent opposite prints chemically reacting with each other and sticking together when the album was closed; originally prints were protected by tissue.

Different album manufacturers have different overlay designs from which you can select. This allows the photographer or the bride and groom to use them in a creative way when designing the layout to present the

images. Some manufacturers have their own software to make album layout quicker, as it can be a time-consuming job. This software allows you to lay out the images by selecting and dragging them onto a template; and then the overall sheet is printed so that the overlay can be put on top.

To lay out a page in Photoshop, first measure the size of overall page overlay, the steps of my layout, which is used for the example below, are based on a 16 x 12in (approximately 40 x 30cm) page.

Step one – below Set the width, height and target resolution – in my case 300dpi, as that's what my photo lab, Loxley Colour, prints at, and that is suitable for most applications.

Step three – below Now open the image which is the largest in the layout, and crop it to the desired size and resolution, in this case 12 x 7in (30 x 8cm) at 300dpi. Then drag this image onto the new page layout and centre it on the vertical guide.

Step two – below Next, drag guides into the middle from both rulers, to give you a clear centre of the page. I also drag guides near to each page edge to help keep the pictures within the layout.

Step four – right I add a five-pixel black line around the image via Edit – Stroke. Set the width of the line in pixels and choose the colour by clicking into the colour palette and selecting a new colour if needed.

CAMERA TIPS

CORRECTIONS

I only ever fully correct an image when it is selected for an album or reprint this saves valuable time correcting every image initially.

Step five – left For this page layout I wanted to add three pictures along the base. I opened the images, set the crop tool to 5 x 3in (13 x 9cm) at 300dpi, cropped each image and then dragged them to the page layout, adding a stroke to each to define the edges.

Step six – left Align the images using the guides to complete the page. Notice that the magenta-coloured smart guides that appear when moving the layers. Finally, flatten the layers and save the page with the number in which it will appear in the album.

Above I have an action made to quickly add a 5-pixel black line around an image layer, with the F3 key set as its short cut.

Left Some of the many designs that are available for the Jorgenson wedding albums. An additional benefit is that each overlay can be custom-cut to whatever design I need.

Digital art albums

When I went fully digital, so did most of my album layouts. By that I mean that their presentation began to move more and more away from the traditional page and overlay design to a more graphic, almost magazine style. The relaxed and reportage-style images are perfect for the digital layout as they offer a greater picture variety, but a very traditional wedding selection can also be improved.

The digital albums I use are the Loxley Colour 'Bellisimo' range. They are available in a range of sizes including 8 x 6in (20 x 15cm), 12 x 12in (30 x 30cm) and 16 x 12in (40 x 30cm). The albums can be designed via dedicated online software from companies such as ROES. The ROES software is easy to use and makes album design simple. Web-ordering companies like this even do the colour corrections for you if you want them to.

COVER DESIGN

When the software is launched, you typically select the album range you desire and choose a jacket template. By simply dragging and dropping an image from the picture bar, the image is scaled to size. Then by clicking in a text window you can simply type any text that you wish to appear on the jacket cover.

Step one – top *By selecting one of the creative page templates to the left-hand side of the screen, attractive page layouts are simple to achieve. By dragging and dropping each picture in turn to the position on the page, an album is soon built.*

Step two – bottom *For more sophisticated page layouts a black background can be selected from the options palette on the right-hand side – you can also alter its opacity.*

Step three – top left For a double-page layout I have selected the 24 x 16in (60 x 40cm) page layout on the left and then dragged the image in. It intelligently scales it, but remember that if you are working from a small file size then some softness may occur.

Step four – top right In this layout I have first selected the large image, which is layer one on the options palette on the right-hand side, and clicked Black & White, then I have clicked layers two, three and four in turn and applied a blue tone.

Step four – left I have chosen an ideal layout for groups. I have turned layer one, the top left image, to black & white; layer two, the top right image, to a blue tone; and I have kept the two lower layers in full colour. I personally feel that mixing more than two colour styles on a page does not enhance the layout, so I would have to choose the rest of the colour images to be in either blue or black & white.

Step four – below The zoom bar at the bottom of the middle palette allows the image to be selectively cropped, which is a useful feature.

CAMERA TIPS

EFFECTS
Remember that any effects that you apply to the images, or use as part of the layout of the digital art album, should support the images rather than dominate them.

Digital art albums (cont.)

I prefer to design each album individually in Photoshop, as I like all my brides and grooms to have a unique album to reflect the unique nature of each wedding.

My experience with Photoshop makes album design quick and creative – once you know the software a little and start to add some automation with actions, a creative album can not only be fast but great fun to do. It makes me think of all those hours I used to spend in a darkroom on projects.

This layout is based on a 12 x 12in (40 x 40cm) Bellisimo album, but the steps apply to almost any digital art album.

Step three – above *Open Adobe Bridge and select the folder of images to be used in the album. Select the relevant images for the double-page spread and open them in Photoshop.*

Step one – above *Create a new file of the correct size and resolution for a double-page layout.*

Step four – above *Select one or more images to be the background and drag them onto the page. Now transform the image by selecting Edit – Transform, or check the box on the top tool bar called 'Show transform controls'. Press and hold the shift key while dragging a corner of the image to make it transform in proportion. Move the image if necessary for better composition.*

Step two – above *Drag the centre and edge guides to their relevant positions.*

CAMERA TIPS

SAVING
Save a copy of any basic page layout on your computer, with all the guides in place, then to start each new album simply open the saved template to save time. This album page would be saved as '24 x 12 Bellisimo' in a folder called 'Templates'.

Step five – above *Because I have enlarged the image so much in the transform, the image will appear softer: to disguise this I will first add some grain to the image in the form of noise, Filter – Noise – Add Noise. Click Monochromatic and Gaussian to apply random black dots, adjusting the amount as necessary.*

Step eight – above *The Layer Options dialogue box will be open. Simply drag the shadow from under the image or set the angle and distance manually.*

Step six – above *Finally, for a wash effect on the background image, adjust the opacity of the layer down to around 20%.*

Step nine – above *Rearrange the layers as desired; this is quickly done if the Auto Select Layer box is checked. If the cropped images are too large, to avoid having to recrop select the relevant layers by holding down the shift key and clicking on the relevant layers; this will group them. Now with the Transform command press and hold the shift key and shrink them down as needed. Avoid making the layers bigger as this will make the images appear soft.*

Left *Assigning actions to the function keys saves a lot of time and effort. My F3 key is set to play the action for a line at 5 pixels in black and outside the image, while my F11 key is set to apply a drop shadow to a floating layer.*

Step seven – above *Crop the images to be used to the desired size at 300dpi. Drag the cropped images onto the page one at a time and add a stroke line to border the image; a drop shadow adds to the effect. To add the drop shadow select the black 'f' icon on the layers palette.*

Digital art albums (cont.)

Step ten – above To rotate a layer, first select the layer by clicking on it or by selecting it on the Layer palette, then with the Show Transform controls on, hold the cursor near a corner and the cursor will change to a rotate function; the layer can now be rotated as desired. After rotating or transforming always press Enter to confirm the command.

Step eleven – above The final two images are cropped to the desired size and then dragged onto the page, with a line and a drop shadow added. Each image is then rotated as desired, with the bottom picture overlying the top picture. To reverse these images so the top picture sits on top of the bottom picture, simply select the layer – in this case layer six – and reposition it in the Layers palette so it is above layer seven.

CAMERA TIPS

Managing files

Move all the images that the couple have requested for their album into a new folder marked 'Album Images'. In this folder make a new subfolder called 'used'. By doing this album design is quick, as you only have the images visible that will be in the final album itself.

Managing your images and workflow like this is a very important part of any digital photography discipline, but particularly wedding photography, as you will be under pressure to deliver good results to a challenging schedule. Keeping your workflow simple but effective will free up your time to concentrate on the creative side of things.

Other page design ideas

There are many different things that you can do to make images stand out on the page; they can also add variety and interest to an album. Here are a few of my favourites:

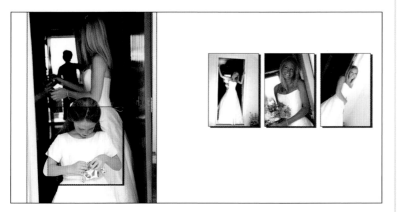

Above Image within Images – the large image has had a selection made in the middle, then I chose Select – Inverse followed by Mono to create this effect.

Above Squares – this page is kept simple by using one large image then cropping nine other images smaller, adding a keyline, then aligning them.

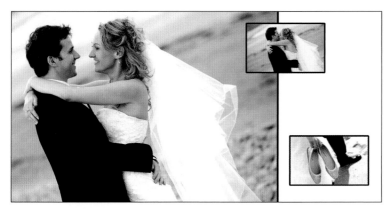

Above Heavy keyline – the inset images have been given a thicker keyline by pressing the action key several times for each.

Above Image stretched over two pages – the image has also been given a dramatic increase in contrast and saturation.

Above 2:1 ratio images – images are cropped to a 4:2 ratio with a keyline inside and stacked in random orders.

Above Overall wash – the large image has had its opacity lowered. The other images were then cropped and positioned on the page by eye, with the middle image set to mono to make it stand out on such a colourful page.

Above Coloured backgrounds – a part of the background was selected and the Paint Bucket tool was selected to paint the area with a mauve that was selected from the colour palette. Noise was then applied to break up the solid colour.

Montage prints

A montage of images in a frame has always been popular. Traditionally, the selection of prints would have been presented behind a cut mount with apertures and then framed. However, since the advent of digital technology it has been popular to have the images looking as though they have been scattered together and then framed. You can go one step further and give the bride and groom the empty aperture and frame for the wedding day so the guests can sign around the mount with their good wishes and funny comments.

Step one – above *Making up a montage image. My standard montage is a print size of 16 x 16in (40 x 40cm) with an overall frame and overlay of the same size, so a new file is opened up in Photoshop. Guides are dragged in for reference.*

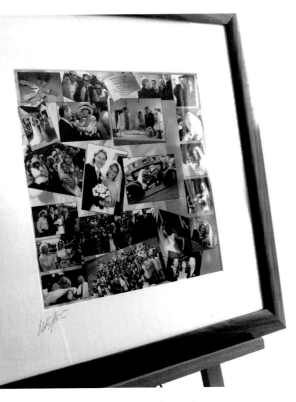

Above *Gathering together a selection of images to create a montage from the different events that take place throughout the day, as well as the various friends and family who attend the ceremony, is an effective way to tell the story of a couple's wedding day.*

Step two – above *A selection of around 20–30 images is opened in Photoshop. Each image is cropped and then dragged onto the new page, applying a stroke line when it is dragged on. The images are then arranged and, with the Transform Controls switched on in the tool palette, images can be made smaller as desired.*

Step three – right *The finished montage can be flattened from a multi-layer file to be saved as a JPEG; otherwise the file will be very large and take up space on your hard drive.*

Reprints and wall prints

Reprints are better if they are presented in a slip-in folder; presentation folders are readily available in a variety of colours.

For a deluxe presentation, I prefer to use a hand-cut mount that is ready for framing.

Top *The beauty of reprint folders is that they can either be self-standing or go behind glass in a frame.*

Above *Deluxe presentation double-mount board with two sizes of apertures for a look of sophistication.*

Below *Though these parents' albums are just shown in black leather, there are upgrades available to metals and woods, again in a range of sizes.*

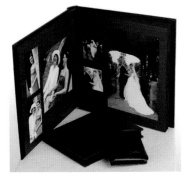

Parents' albums are very popular, so I offer a range of different-sized albums in square, portrait and landscape formats and in a range of quality leathers and metals, as well as more economical synthetic leather. Gift albums are usually bought and presented to the bridesmaids and even some best men; the most popular is the mini album which contains a dozen 3.5 x 2.5in (9 x 6cm) prints.

The wrapped gallery canvas prints, shown bottom, are often bought by the couples themselves as they offer a presentation style that suites a contemporary home.

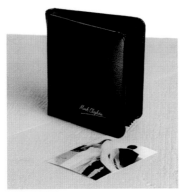

Top *3.5 x 2.5in (9 x 6cm) prints are a very popular gift for bridesmaids.*

Above *My most popular item is the wrapped canvas print, which is designed to be displayed unframed. Even though this image shows a white border on the edges, this style of presentation can have the image wrapped around.*

I still offer mounted and framed prints behind glass as well as framed canvas prints, which are the most popular with parents of the bride and groom.

Above *Both of the images above show finished signed montage prints, these can be simply made, but add a great deal of value to a wedding package.*

Useful websites

Adobe
Software including Photoshop and Photoshop Elements
www.adobe.com

Bowens
Lighting and accessories
www.bowens.co.uk

Calumet Photographic
International retailer
www.calumetphoto.co.uk
www.calumetphoto.com

Canon
Cameras and accessories
www.canon.co.uk
www.canon.com

Elinchrom
Lighting and accessories
www.elinchrom.com

Epson
Printers and inks
www.epson.co.uk
www.epson.com

Fujifilm
Cameras, accessories and consumables
www.fujifilm.co.uk
www.fujifilm.com

Hasselblad
Medium-format cameras and accessories
www.hasselblad.co.uk
www.hasselbladusa.com

Jorgenson Albums
Photographic albums
www.jorgensen.com.au

Kodak
Cameras, printers, accessories and consumables
www.kodak.co.uk
www.kodak.com

Lastolite
Studio equipment and reflectors
www.lastolite.com

Leica
Cameras and accessories
www.leicacamera.com

Lexar
Memory cards
www.lexar.com

Loxley Colour Labs
Remote album ordering
www.loxleycolour.com

Lyson
Inks and papers
www.lyson.com

Mamiya
Medium-format cameras and accessories
www.mamiya.co.uk
www.mamiya.com

Manfrotto
Tripods and accessories
www.manfrotto.com

Mark Cleghorn
Website of the author and photographer
www.markcleghorn.co.uk

Metz
Portable flash units and accessories
www.metz.de

Nikon
Cameras and accessories
www.nikon.co.uk
www.nikon.com

Olympus
Cameras and accessories
www.olympus.co.uk
www.olympus.com

Pentax
Cameras and accessories
www.pentax.co.uk
www.pentax.com

Permajet
Inks and papers
www.permajet.com

Samsung
Cameras and accessories
www.samsung.com

Sandisk
Memory cards
www.sandisk.com

Sekonic
Light meters
www.sekonic.co.uk
www.sekonic.com

Sigma
Lenses and accessories
www.sigma-imaging-uk.com
www.sigmaphoto.com

Tetenal
Inks and papers
www.tetenal.com

Tokina
Lenses and accessories
www.tokina-usa.com – Lenses

Quantum
Portable flash units and accessories
www.qtm.com

Wacom
Pen tablets
www.wacom-europe.com

Zeiss
Lenses and accessories
www.zeiss.com

Glossary

Adobe Photoshop A widely used image-manipulation program.

Adobe Photoshop Elements A cut-down and cheaper version of Adobe Photoshop.

Ambient light Light that originates from existing sources, whether natural or artificial, as opposed to that added by the photographer.

Angle of view The angle of a the cone extending from a lens that a lens takes in. A wideangle lens has a wide angle of view, while telephoto lenses have a narrow angle of view.

Aspect ratio The ratio of the width to the height of a frame.

Backlighting Light coming from the far side of the subject, towards the camera lens.

Ball-and-socket head A basic type of tripod head, this involves a sphere around which the head pivots, with a handle to lock it in place at the desired position.

Bounced flash The process by which light from a flash unit is bounced onto the subject – from a ceiling, wall or reflector – in order to 'soften' or hide shadows.

Bracketing The process of exposing a series of frames of the same subject or scene at a series of slightly different exposure settings.

Buffer The in-camera memory of a digital camera. This is where the images are stored before they are written to the memory card.

Burst rate The number of frames per second that a digital camera can record.

Burst size The maximum number of frames that a digital camera can shoot in a row before its buffer becomes full.

Cast The abnormal colouring of an image.

CCD (charge-coupled device) A microchip made up of light-sensitive cells and used in the majority of digital cameras.

Centre-weighted metering A type of metering system that takes the majority of its reading from the central portion of the frame. This is suitable for portraits or scenes where the subjects fill the centre of the frame.

CMOS (complementary metal oxide semiconductor) A microchip made up of light-sensitive cells and used in digital cameras for recording images – most notably on the Canon EOS range of DSLRs.

Colour temperature The description of the colour from a light source when comparing it with the colour of light emitted by a theoretical perfect radiator at a particular temperature expressed in Kelvins (K). Note that 'cool' colours such as blue have high colour temperatures and vice versa.

Compression The way in which digital file sizes are reduced. There is usually some payoff between the quality of the image and the degree of compression.

Contrast The range of tones between the highlight and shadow areas of an image. Also the difference in illumination between adjacent areas.

Cropped sensor A digital sensor that is smaller than a 35mm frame.

Depth of field The amount of the image that is sharp enough to appear in focus. This is controlled by the aperture (f-stop) setting – the smaller the aperture, the greater the depth of field; the distance from camera to subject – the further the distance, the greater the depth of field; and the focal length of the lens used – the shorter the focal length, the greater the depth of field. Depth of field extends one third in front of and two thirds behind the point of focus.

Diffuser An object used to diffuse or soften light; in other words to lower the contrast.

dpi (dots per inch) A measure of the resolution of a printed image.

Exposure The amount of light that is allowed to act on a sensor.

Exposure compensation A level of adjustment given to auto-exposure settings. This is generally used to compensate for known inadequacies in the way a camera takes meter readings or records the image.

Fill-in flash Flash combined with daylight in an exposure. Used with naturally backlit or harshly sidelit or toplit subjects to prevent silhouettes forming, or to add extra light to shadow areas.

Flare Non-image-forming light that scatters within the lens system. This can create multi-coloured circles or a loss in contrast. It can be reduced by multiple lens coatings, low-dispersion lens elements or the use of a lens hood.

Flash sync The flash sync speed is the fastest speed at which a camera with a focal plane shutter can work with flash. At speeds faster than the sync speed, only part of the film shot with the flash will be lit.

Focus lock A mechanism that allows the distance of focus to remain constant while the image is recomposed.

Frontlighting Light shining on the front surface of a subject. This can produce dull, lifeless photos, although it is good for picking out surface detail.

Hotshoe An accessory shoe with electrical contacts that is normally mounted over the optical axis, allowing synchronization between the camera and a flashgun.

Incident-light meter An exposure meter that measures the light falling on the subject, rather than the light reflected by the subject.

ISO The international standard for representing film sensitivity, this has been extended to the variable settings of digital sensors.

JPEG A standard compressed image file developed by the Joint Photographic Experts Group.

Kelvin (K) The scale used to measure colour temperature.

Memory card Removable storage device for digital cameras.

Metering Using a camera or light meter to calculate the amount of light that is either falling on or being reflected from a scene and calculate the required exposure.

Monobloc A studio flash unit which includes the capacitor as an integral component.

Multi-segment metering A metering system that uses a number of variably sized and positioned segments to detect brightness levels and calculate an exposure value.

Noise The digital equivalent of graininess, caused by stray electrical signals either due to long exposures or high sensitivities.

Overexposure A condition in which too much light reaches the sensor. Detail is lost in the highlights.

Pan-and-tilt head A tripod head allowing movement in three axes.

Pixels Abbreviation of picture elements. The individual units which make up an image in digital form.

RAW A flexible file format in which parameters are attached to a file but remain unapplied until later on computer.

Red-eye When photographing people using flash close to the optical axis, the light from the flash can bounce off the blood vessels in the retina of the eye causing the pupil to look red in the final image.

Red-eye reduction Some flash units can be set to fire a sequence of preflashes causing the pupil to contract and the amount of light reflected be diminished, reducing the appearance of red-eye.

Reflected-light meter A light meter measuring light reflected from, rather than light falling on, the surface of a subject.

Reflector A surface from which light is reflected for use in balancing the direction of a light source.

Sidelighting Light striking the subject from the side, relative to the position of the camera.

SLR (single lens reflex) A type of camera that allows you to see through the camera's lens as you look in the viewfinder.

Snoot A circular attachment for studio flash units that creates a small circle of light.

Softbox A shoot-through attachment that softens the light from a studio flash unit.

Spot metering A metering system that measures from a very small area that is either in the centre of the frame or under an autofocus point.

TIFF Tagged Image File Format: An uncompressed digital image file.

Umbrella A studio flash attachment that diffuses the light.

Underexposure A condition in which too little light reaches sensor. There is detail lost in the areas of shadow in the exposure.

Vignetting The cropping or darkening of the corners of an image. This can be caused by a generic lens hood or by the design of the lens itself. Most lenses do vignette, but to such a minor extent it is unnoticeable. It also refers to darkening an image's corners for aesthetic purposes.

Index

A full list of titles published by Photographers' Institute Press is available by visiting our website, www.pipress.com
All titles are available direct from the Publishers or through bookshops and specialist retailers.

To place an order, or to obtain a complete catalogue, contact:

PIP, Castle Place, 166 High Street, Lewes, East Sussex BN7 1XU, United Kingdom

Tel: 01273 488005 Fax: 01273 402866

E-mail: pubs@thegmcgroup.com Website: www.pipress.com

Orders by credit card are accepted